Breath of Heaven, Breath of Earth

ANCIENT NEAR EASTERN ART FROM AMERICAN COLLECTIONS

Trudy S Kawami

John Olbrantz

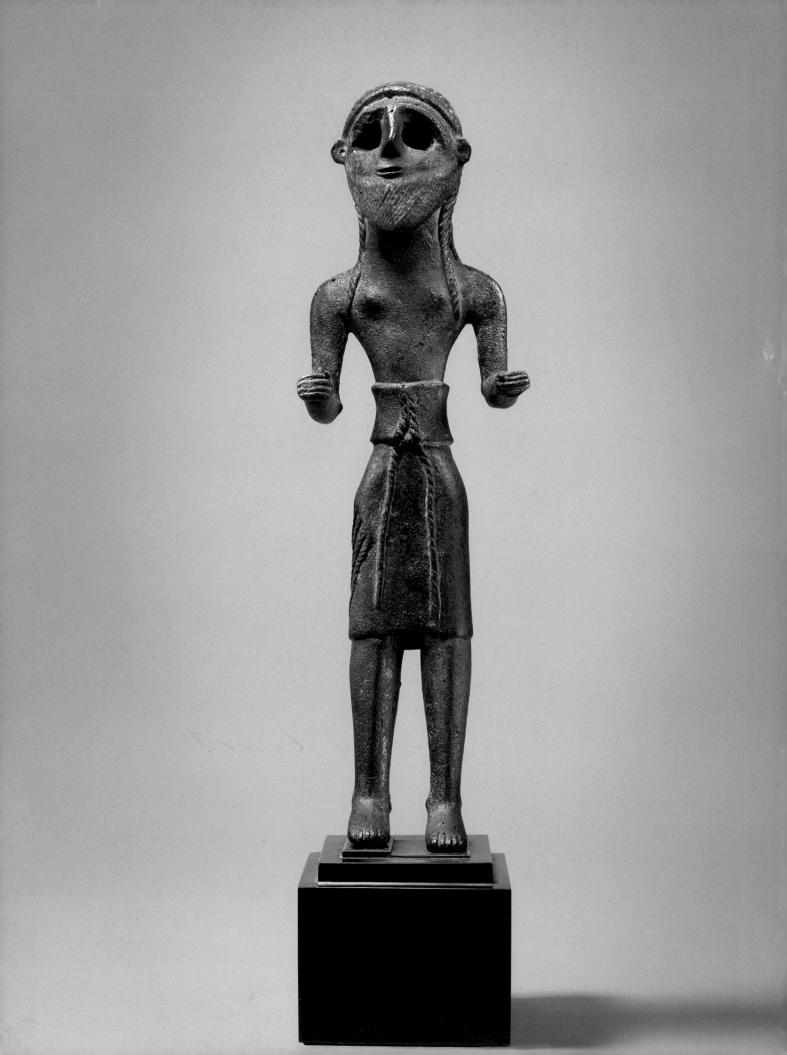

Breath of Heaven, Breath of Earth

ANCIENT NEAR EASTERN ART FROM AMERICAN COLLECTIONS

TRUDY S. KAWAMI AND
JOHN OLBRANTZ

HALLIE FORD MUSEUM OF ART
WILLAMETTE UNIVERSITY
2013

DISTRIBUTED BY
UNIVERSITY OF WASHINGTON PRESS
SEATTLE AND LONDON

This book was published in connection with an exhibition arranged by the Hallie Ford Museum of Art at Willamette University entitled *Breath of Heaven, Breath of Earth: Ancient Near Eastern Art from American Collections*. The dates for the exhibition were August 31–December 22, 2013.

Financial support for the exhibition and book was provided by an endowment gift from the Hallie Ford Exhibition Fund and an "Art Works" grant from the National Endowment for the Arts, as well as by general operating support grants from the City of Salem's TOT funds and the Oregon Arts Commission. Additional support for a lecture and film series was provided by the Center for Ancient Studies and Archaeology and the Department of Art History at Willamette University.

Designed by Phil Kovacevich

Editorial review by Sigrid Asmus

Printed and bound in Canada by Friesen's, Inc.

Front cover and Plate 30, page 132: Male figure; Iraq, excavated from the Nintu Temple, Level VI, Room Q 44: 151 at Khafaje, Mid-to-Late Early Dynastic Period, 2700–2500 BCE; alabaster, shell, and lapis lazuli; H: 9 in. (23 cm), W: 3⅛ in. (8 cm), D: 2¾ in. (7 cm); University of Pennsylvania Museum of Archaeology and Anthropology, Joint Bagdad School/University Museum Expedition to Mesopotamia, 1937, 37-15-28.

Back cover and Plate 54, page 169: Sherd with stags; Turkey, excavated from Alishar Hüyük, 800–700 BCE; ceramic with slip; H: 6 in. (15.3 cm), W: 7⅜ in. (18.8 cm); The Oriental Institute of the University of Chicago, A10266.

Endpapers: Panoramic view of Göbekli Tepe, Turkey.

Frontispiece and Plate 14, page 96: Standing male figure; Lebanon, from Jezzine, late 3rd–early 2nd millennium BCE; copper; 13 ½ in. (34.3 cm), W: 4 in. (10.2 cm), D: 2 in. (5.1 cm); Private collection, New York.

Page 6 and Plate 32, page 134: Relief fragment with a battle scene; Iraq, excavated by William Kennett Loftus in August of 1854 from the Southwest Palace of Sennacherib at Nineveh, Neo-Assyrian Period, reign of Sennacherib, 705–681 BCE; limestone or gypseous alabaster; H: 10 in. (25.4 cm), W: 8 ½ in. (21.6 cm); Seattle Art Museum, Eugene Fuller Memorial Collection and Hagop Kevorkian, 46.49.

Page 12 and Plate 57, page 172: Statuette of a monkey; Iran, first half of the 3rd millennium BCE; limestone; H: 2⅛ in. (5.4 cm), W: 1 ⁷⁄₁₆ in. (3.7 cm), D: 1 ¾ in. (4.5 cm); Brooklyn Museum, purchased with funds given by Shelby White, 1991.3.

Pages 16–17 and fig. 1.13, page 32: View of the excavations at Kish, with Field Director Charles Watlin and workmen in the foreground, 1928–1929.

Pages 58–59: View of Alalakh, Turkey, from the northeast at moonrise.

Pages 106–107 and fig. 2.2, page 60 (middle): View of Hattuša (modern Boğazköy), the Hittite capital, central Turkey.

Pages 144–145 and fig. 4.6, page 152 (top): View of the Lion Gate at Hattuša (modern Boğazköy), Turkey, 15th–13th century BCE

© 2013 by the Hallie Ford Museum of Art at Willamette University

Essay © 2013 by Trudy S. Kawami

Essay © 2013 by John Olbrantz

Library of Congress Control Number 2012947128
ISBN 9781930957688

Distributed by
University of Washington Press
P.O. Box 50096
Seattle, WA 98145-5096

Contents

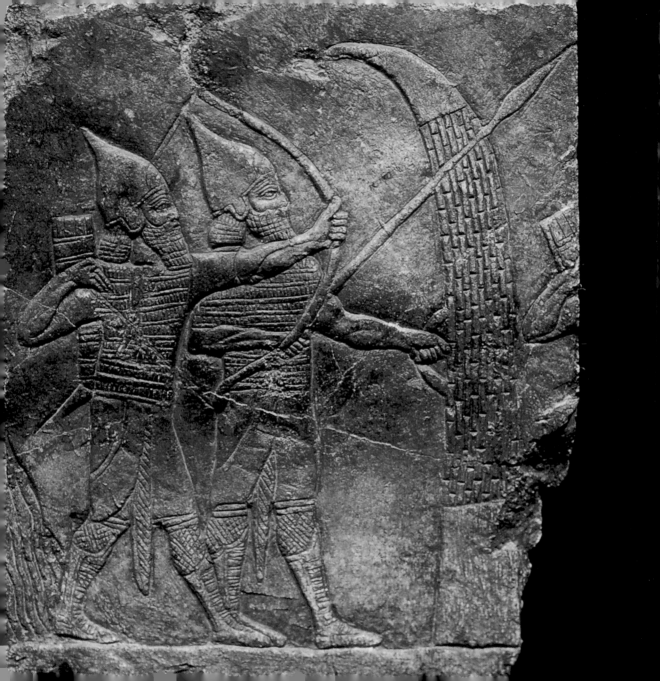

Preface

It seems as if I have been working on *Breath of Heaven, Breath of Earth: Ancient Near Eastern Art from American Collections* forever, or at least thinking about it forever. The genesis of the exhibition had its origins in 2002 when the late Jim Romano, curator of Egyptian, Classical, and Ancient Near Eastern Art at the Brooklyn Museum, and I co-organized an exhibition of Egyptian art at the Hallie Ford Museum of Art entitled *In the Fullness of Time: Masterpieces of Egyptian Art from American Collections*. Jim was my best friend for twenty-five years (I was the best man in his wedding and we would always spend time together when I traveled to the East Coast or he traveled to the West Coast) and we both agreed that working on the exhibition and its accompanying book was one of the highlights of our professional lives.

As we were working on the project together, we talked about organizing a sequel on the art of the ancient Near East. As with the Egyptian exhibition, the ancient Near Eastern exhibition would focus on objects from American collections. The objects would be of high quality but smaller in scale. The exhibition would be scholarly in nature and would be organized to introduce visitors to some of the key ideas and themes in ancient Near Eastern art. Finally, the exhibition would be designed to introduce audiences in the western United States to important yet rarely seen examples of ancient Near Eastern art. Tragically, Jim was killed in an automobile accident the following summer and, at least for a time, the second exhibition that we envisioned with such excitement and enthusiasm was set aside.

For several years after Jim's death I thought about the exhibition often and finally decided to revive the project in his honor and memory. Fortunately, I had an opportunity to meet Trudy Kawami when I gave the eulogy at Jim's memorial service in 2003. Trudy is Director of

Relief fragment with a battle scene

Iraq, excavated by William Kennett Loftus in August of 1854 from the Southwest Palace of Sennacherib at Nineveh, Neo-Assyrian Period, reign of Sennacherib, 705–681 BCE; Limestone or gypseous alabaster; H: 10 (25.4 cm), W: 8 ½ in. (21.5 cm); Seattle Art Museum, Eugene Fuller Memorial Collection and Hagop Kevorkian, 46.49.

Research at the Arthur M. Sackler Foundation in New York and had organized an exhibition of ancient bronzes from the Asian grasslands that we presented in 2006. I invited Trudy to lecture in conjunction with the exhibition and discovered that she and Jim were good friends and had worked together on a couple of projects. As we talked and got to know each other, I discovered that she has a PhD degree from Columbia University in Ancient Near Eastern Art and Archaeology, and when I asked her if she would consider working with me on the exhibition and book, she enthusiastically agreed.

Breath of Heaven, Breath of Earth: Ancient Near Eastern Art from American Collections features sixty-four objects on loan from some of the most distinguished public and private collections in the United States. The title of the exhibition comes from a verse in the Sumerian flood story where Enlil remakes the world using that phrase. Didactic in nature, the exhibition encompasses the geographic regions of Mesopotamia, Syria and the Levant, Anatolia, and Iran, and explores several broad themes found in the art and cultures of the ancient Near East: gods and goddesses, men and women, and animals, both real and supernatural. Objects have been selected because they are of high quality although smaller in scale, and because they reveal a wealth of information about the people and cultures that produced them: their mythology, religious beliefs, concepts of kingship, social structure, and daily life.

An exhibition and book of this magnitude would not have been possible without the help and support of a number of individuals and institutions. First and foremost, I would like to thank my friend, colleague, co-curator, and collaborator Trudy Kawami. Trudy is a brilliant scholar and dear friend and the current exhibition and book would not have come to fruition without her help and support. Over the past six years, we have talked weekly on the telephone (sometimes daily), updated checklists repeatedly, bounced ideas off each other on a regular basis, and participated in marathon meetings during my frequent trips to New York. I know Jim would be honored and pleased that Trudy agreed to co-curate the exhibition with me.

As always, I would like to thank graphic designer Phil Kovacevich for his beautiful and spacious design of the book and Sigrid Asmus for her careful and thoughtful editorial review of our essays. Photographer Ian Cohn and archaeologist Jason Ur graciously donated the use of their photographs of the Middle East because of their belief in the project. I am further indebted to the University of Washington Press for agreeing to distribute the book on a worldwide basis

and to Director Nicole Mitchell for her ongoing interest in our exhibitions and accompanying books. At Willamette University, I would like to thank President Steve Thorsett and College of Liberal Arts Dean Marlene Moore for their support of the Hallie Ford Museum of Art, and Pat Alley (grant writer extraordinaire!) for providing further editorial review for my essay.

In addition to my acknowledgments, Trudy would like to express her thanks and appreciation to a number of individuals for their help and advice with various aspects of the project: Pauline Albenda; Katherine Blanchard from the University of Pennsylvania Museum of Archaeology and Anthropology; Marc Cooper from Southwest Missouri State University; Peter Daniels; Jean Evans from the Nippur Project at the Oriental Institute of the University of Chicago; Ulla Kasten from the Yale University Babylonian Collection; Renee Kovacs; Karen Rubinson from the Institute for the Study of the Ancient World at New York University; Ron Wallenfels; Karen Wilson from the Field Museum of Natural History; and K. Aslihan Yener from Koc University in Istanbul and the University of Chicago.

Breath of Heaven, Breath of Earth: Ancient Near Eastern Art from American Collections would not have been possible without the friendship and support of a number of institutions and individuals around the country who agreed to lend objects to the exhibition because they believed in the importance of the project and, for those who knew Jim, who wanted to honor him.

I would like to express my thanks and appreciation to Ulla Kasten at the Yale University Babylonian Collection; Ed Bleiberg, Ann Russmann, Elizabeth Largi, Elisa Flynn, and Ruth Janson at the Brooklyn Museum; Carole Ann Fabian, Lillian Vargas, and Roberto Ferrari at Columbia University; Susan Braunstein, Stacey Traunfeld, and Jannette Mina at the Jewish Museum; Joan Aruz, Kim Benzel, Tim Healing, Sarah Graff, and Emily Foss at the Metropolitan Museum of Art; Sidney Babcock, John Alexander, Catherine Burns, Charlotte Trautman, and Marilyn Palmeri at the Pierpont Morgan Library and Museum; Elizabeth Sackler, Trudy Kawami, and Stephanie Morillo at the Arthur M. Sackler Foundation; J. Michael Padgett and James Knopp at the Princeton University Art Museum; Richard Zettler, Holly Pittman, Katy Blanchard, Anne Brancati, Alex Pezzati, and Maureen Goldsmith at the University of Pennsylvania Museum of Archaeology and Anthropology; Alex Nagel, Becky Gregson, and Betsy Kohut at the Freer-Sackler Galleries of Art; and Marden Nichols, Barbara Fegley, Danielle Bennett, and Ruth Bowler at the Walters Art Museum.

I am further indebted to Peter Schertz, Mary Sullivan, and Howell Perkins at the Virginia Museum of Fine Arts; Peter Nisbet, Timothy Riggs, Anita Heggli-Swenson, and Scott Hankins at the Ackland Art Museum at the University of North Carolina at Chapel Hill; Jack Green, Helen McDonald, Monica Velez, and John Larson at the Oriental Institute of the University of Chicago; Bill Parkinson, Alan Francisco, Karen Wilson, and Melissa Anderson at the Field Museum of Natural History; Robert Cohon, Julie Mattsson, and Stacey Sherman at the Nelson-Atkins Museum of Art; Alex Barker, Benton Kidd, and Jeffrey Wilcox at the University of Missouri Museum of Art and Archaeology; Eric Lee, Patty Decoster, and Patty Tainter at the Kimbell Art Museum; Nancy Thomas, Ali Mousavi, and Amy Wright at the Los Angeles County Museum of Art; and Chiyo Ishikawa, Sara Berman, Lauren Tucker, and Matt Empson at the Seattle Art Museum.

There are a number of other friends and colleagues who were extremely helpful during various stages of this project. I would like to express my thanks and appreciation to Jim's widow, Diana Craig Patch, acting associate curator-in-charge of Egyptian art at the Metropolitan Museum of Art, for her friendship and support over the years, and to Jim's two children, Michael White and Julia Craig Romano, for carrying on his legacy and memory. I would like to thank Jim's former colleague at the Brooklyn Museum, Richard Fazzini, for his support of the project before he retired in 2006, and to thank my friend Robert Edsel of Dallas, Texas, for introducing me to the art treasures of the Kimbell Art Museum. I am further indebted to Gary Vikan, director emeritus of the Walters Art Museum, and Regine Schulz, former curator of ancient art at the Walters and currently director of the Roemer- und Pelizaeus-Museum in Hildesheim, Germany, for their support of the project during its early stages.

At the Hallie Ford Museum of Art, I would like to thank collection curator Jonathan Bucci, education curator Elizabeth Garrison, exhibition designer/chief preparator David Andersen, membership/public relations manager Andrea Foust, administrative assistant Carolyn Harcourt, front desk receptionists Elizabeth Ebeling and Bonnie Schulte, safety officer Frank Simons, and custodian Cruz Diaz de Estrada, for their help with various aspects of the project. As I've said many times before (and will keep saying many times in the future), I am truly blessed to be able to work with such a talented and dedicated staff.

Finally, and by no means least, I would like to thank the many sponsors of the project. I would like to express my thanks and appreciation to the National Endowment for the Arts

for providing an "Art Works" grant to help offset the costs of the exhibition and book, and to the City of Salem's Transient Occupancy Tax funds and the Oregon Arts Commission for their ongoing support of our operations and services. I am further indebted to the Center for Ancient Studies and Archaeology and the Department of Art History at Willamette University for their support of the accompanying lecture and film series.

Major financial support for the exhibition and book came from the Hallie Ford Exhibition Fund, and I am most grateful to the late Hallie Ford for her help in creating an endowment fund to support the organization of a major art historical exhibition and publication every few years. It was a major gift from Hallie that allowed Jim and me to co-organize the Egyptian art exhibition in 2002, and it is somehow fitting that *Breath of Heaven, Breath of Earth: Ancient Near Eastern Art from American Collections* be organized and supported with funds Hallie provided.

John Olbrantz
The Maribeth Collins Director

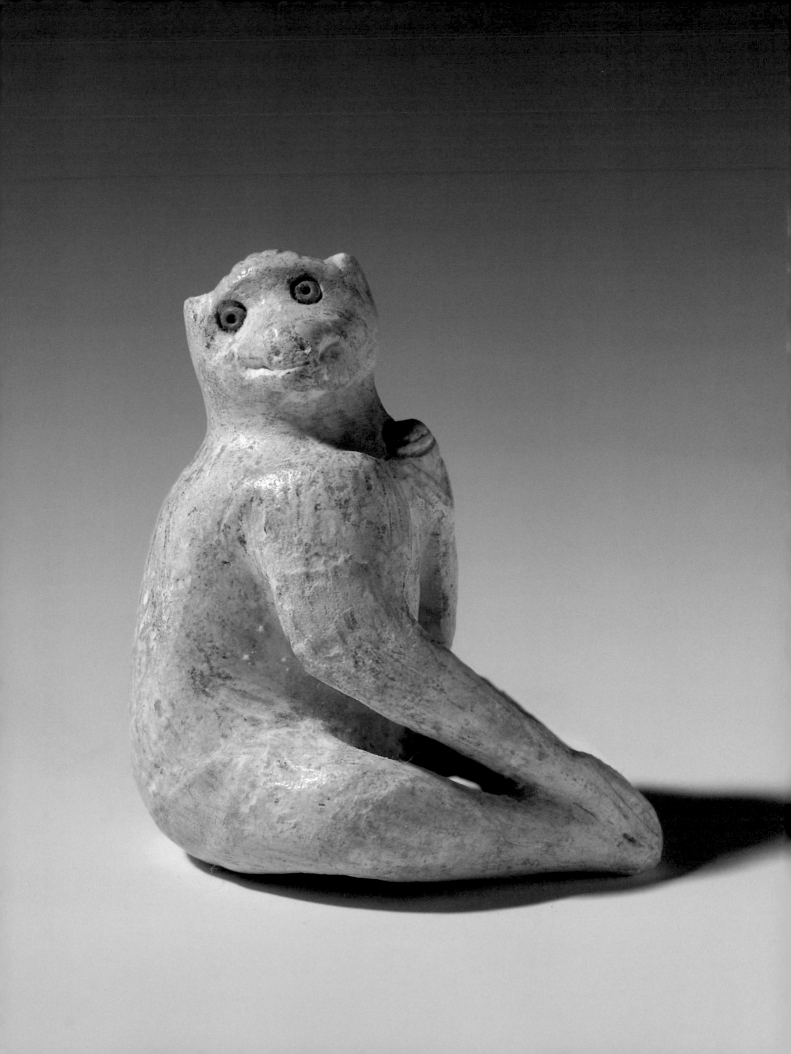

Dedication

Someone once said or wrote that if you could number one or two people in your lifetime as really good friends, you were a very lucky person indeed. I consider myself a very lucky person because, for twenty-five years, Jim Romano was my friend. In fact, for twenty-five years Jim Romano was my best friend. Whenever I traveled to the East Coast or Jim traveled to the West Coast, we would almost always try to spend time together. We would talk on the telephone at least once per month, and one of our spring rituals was to make our predictions about who was going to win the World Series.

I first met Jim in 1978 when I arranged to borrow an exhibition of Egyptian art from the Museum of Fine Arts, Boston. The exhibition was intended to coincide with *Treasures of Tutankamun*, which was being presented at the Seattle Art Museum at the same time. I had written a National Endowment for the Humanities grant to bring the exhibition to the Bellevue Art Museum (where I was the director), and I had included in the grant funds for a major lecture series that would feature some of the foremost Egyptologists from throughout the United States.

Statuette of a monkey

Iran, first half of the 3rd millennium BCE; limestone; H: 2 ⅛ in. (5.4 cm), W: 1 ⁷⁄₁₆ in. (3.7 cm), D: 1 ¾ in. (4.5 cm); Brooklyn Museum, purchased with funds given by Shelby White, 1991.3.

I spoke to a friend of mine, Cynthia Sheikholeslami, who was working as the Project Egyptologist for the Tutankamun exhibition in Seattle at the time, and asked her to recommend someone to speak on daily life in ancient Egypt. Cynthia said she thought it would be a good idea to bring one of the Egyptologists from the Brooklyn Museum to lecture. She said it didn't matter which one: all of them were equally skilled and qualified. By the time I got around to calling the Egyptian Department at Brooklyn, however, I had forgotten their names and who was who.

"Could I speak to the one who's Italian?" I asked the person who answered the telephone. "Who do you want?" the voice said on the other end. "Richard Fazzini, Bob Bianchi, or Jim Romano?" "Well, could I speak to the one who went to New York University?" I asked. "Who do you want?" the voice replied. "Richard Fazzini, Bob Bianchi, or Jim Romano?" "OK, OK," I said. "Could I please speak to the one who was recently divorced?" Chuckling, the voice replied, "Who do you want? Richard Fazzini, Bob Bianchi, or Jim Romano?" By this time, I was laughing too, and I said, "I don't care; just connect me with one of them."

As it turned out, Jim was answering the telephone that day, and thus began a beautiful and immensely rewarding friendship. Jim came to Bellevue and delivered an absolutely riveting lecture on daily life in ancient Egypt, and over dinner that evening at Benjamin's Restaurant in downtown Bellevue we spent hours talking about life, children, happiness, antiquities, baseball, and a host of other subjects near and dear to our hearts. Maybe it was the wine or the recent uncertainties that we had both experienced, but Jim and I struck up a friendship that was to endure over the decades and miles. I felt that in Jim I had found a true kindred spirit.

Jim was born in Far Rockaway, Queens, grew up in nearby Hewlett, and went to college at the State University of New York at Binghamton, where he earned his BA degree in anthropology. At the time it was known as Harpur College, and Jim used to like to tell me that if you said it fast enough, whoever you were talking to (or wanted to impress) might just think you were saying Harvard College. Jim went on to earn his MA and PhD degrees from the Institute of Fine Arts at New York University in Egyptian and Ancient Near Eastern Art, where he studied with Bernard V. Bothmer and Henry G. Fischer, among others. In 1976 Bothmer, who was curator of Egyptian art at the Brooklyn Museum at the time, hired Jim as a curatorial assistant, and over the next twenty-five years, he would rise through the ranks of the department to eventually become a curator, with particular responsibility for their ancient Near Eastern art collection.

As a scholar and curator, Jim was a person of extremely high personal and professional standards who valued quality over quantity and scholarship over showmanship. He spent a lifetime trying to dispel a host of popular misconceptions about Egyptian art, including the belief that the ancient Egyptians were obsessed with death or that Egyptian art was static and never changed. In fact, I think *In the Fullness of Time: Masterpieces of Egyptian Art from American Collections*, the exhibition he and I worked on together in the early 2000s, was quite possibly the perfect Jim Romano exhibition in that it emphasized those values that Jim and I so greatly

admired. Moreover, the accompanying book demonstrated his brilliant scholarship, fluid writing style, and keen sense of humor. I mean, who else but Jim Romano could incorporate the Grateful Dead, the "Fonz," Cookie Monster, and Princess Diana into a scholarly essay on Egyptian art!

Beyond his contributions as a curator and scholar, Jim was a remarkable person. He was a devoted husband and father. His wife Diana was the love of his life and his son Michael and daughter Julia were his pride and joy. He was a person who valued his friends and cared deeply about them. Whenever we talked, Jim never failed to ask me about my wife Pam, my son Aaron, and my daughter Sarah. Jim was warm and engaging and always made me laugh. In the early 1980s I introduced him to the joys and virtues of Hawaiian shirts, and before too long he had initiated Hawaiian Shirt Day at the Brooklyn Museum in honor of Don Ho's birthday. Jim was one in a million. Although he was highly esteemed in academic circles, he never lost touch with his working-class roots. In addition to our shared passion for ancient art and archaeology, Jim and I shared a mutual love of baseball, museums, college football and basketball, rock and roll music, Hawaiian shirts, bold ties, drive-ins and diners, American history, and our families.

Jim Romano has been gone for ten years, and yet there's not a day that goes by that I don't think about him. He was a remarkable person who was larger than life, and I loved him as the brother I never had. While his life was cut short by a senseless automobile accident, he leaves an amazing legacy of professional and personal achievements. If the measure of a person is represented by the contributions they have made and the lives they've touched, Jim was one of the luckiest and most successful people in the world. Although he may be gone from our midst, he lives on in our hearts, in our minds, and in our souls forever, and it is to his memory and friendship that we dedicate this exhibition and book.

John Olbrantz
The Maribeth Collins Director

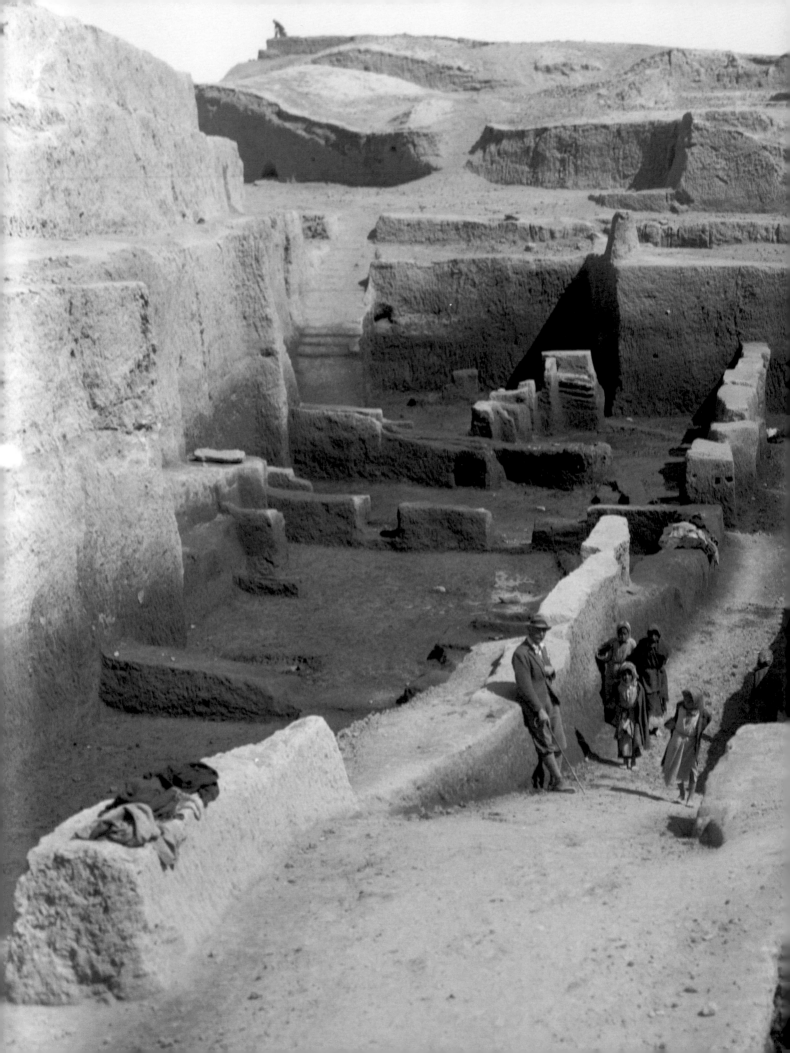

Part One:
Civilizations in the Sand:
Archaeologists, Collectors,
and the American Discovery of
the Ancient Near East

ROYAL TOMBS OF UR RICH IN TREASURE

Crowns and Cloak of Queen Shub-ad Marvels of Artistic Work.

KING'S GRAVE A SHAMBLES

Fifty Persons Sacrificed to His Spirit—Wife's Piety Led to — Tomb's Desecration.

Civilizations in the Sand: Archaeologists, Collectors, and the American Discovery of the Ancient Near East

By John Olbrantz

I'll tell you everything I can
If you will listen well:
I met an erudite young man
A-sitting on a Tell.
"Who are you, sir?" to him I said,
For what is it you look?"
His answer trickled through my head
Like bloodstains in a book. . . .

He said: "I hunt for objects made
By men where'er they roam,
I photograph and catalog
And pack and send them home.
These things we do not sell for gold
(Nor yet, indeed, for copper!)
But place them on Museum shelves
As only right and proper" . . .

– Excerpt from "A-Sitting on a Tell,"[1]
Dame Agatha Christie Mallowan

Introduction

The civilizations of the ancient Near East date to the dawn of recorded history and gave Western civilization such concepts as cities, writing, literature, schools, laws, poetry, philosophy, medicine, economics, and metallurgy, as well as two of the world's great religions: Judaism and

Christianity. Indeed, the peoples and cultures that emerged in the lands of the Fertile Cres-cent[2]—Sumerians, Akkadians, Assyrians, Babylonians, Hittites, Phoenicians, Canaanites, Isra-elites, and Persians—played a central role in the Old Testament narrative. European interest in the Middle East began with the Crusades in the eleventh and twelfth centuries and continued into the Renaissance as merchants and traders sought overland routes to India and China; dur-ing the eighteenth and nineteenth centuries, England and France sought greater military, politi-cal, and economic control of the region because of its strategic position between Europe and the Far East.

The European exploration of the Middle East began in the eighteenth century with the Danish cartographer and explorer Carsten Niebuhr. He was soon followed by diplomats and soldiers who took a keen interest in the art and history of the region.[3] Often brilliant linguists and Ori-entalists, these British and French adventurers were for the most part amateur archaeologists, smitten with the romance and allure of the Middle East and propelled by a powerful curios-ity. Over time, they would expand our knowledge of these ancient civilizations in their race to secure art treasures for their nations. Americans would enter the race late, and while they would make their own contributions to scholarship in the field,[4] the first American travelers to the Middle East were Protestant missionaries from New England, keen on "promoting the spread of the gospel in heathen lands."[5]

American Missionaries in the Middle East

The arrival of the earliest American missions to the Middle East developed against the back-drop of a number of Christian evangelical revivals at the beginning of the nineteenth century.[6] Referred to as the Second Great Awakening (the first Great Awakening occurred in the 1730s and 1740s), it emerged in the 1810s and 1820s in reaction to the deism of the Enlightenment (the belief that reason and observation of the natural world are sufficient to determine the exis-tence of God) and a general decline in religion in America. The "awakening" had a galvanizing effect, fostering an increase in church memberships and the foundation of several benevolent societies and missionary organizations.

In the midst of the Second Great Awakening, the American Board of Commissioners for For-eign Missions (the first American Christian missionary organization) was born. In the fall of 1818, the ABCFM determined to send missionaries to Western Asia in order to establish a mis-sion in Jerusalem and to bring Protestant Christianity to the people of the Middle East. Two recent graduates of Andover Theological Seminary in Massachusetts, Levi Parsons and Pliny Fisk, were appointed to lead the first American mission to the Holy Land. In time, American missions were established in Malta, Beirut, Jerusalem, Izmir, and Mosul.

Austen Henry Layard and the Discovery of Nineveh

As American missions were being established in the Middle East during the 1830s and 1840s, one of the great archaeological discoveries was about to be made. Austen Henry Layard (fig.

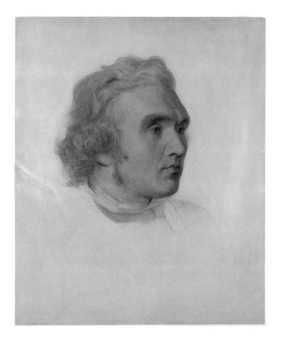

Figure 1.2. George Frederic Watts (British, 1817–1904); *Sir Austen Henry Layard*; ca. 1852; black chalk on paper; H: 23 ⅜ in. (59.3 cm), W: 19 in. (48.2 cm); National Portrait Gallery, London, gift of George Frederic Watts, NPG 1006.

1.2), a British archaeologist, explorer, and traveler, obtained a permit (*firman*) to excavate a number of mounds in Mesopotamia.[7] From 1845 to 1847, he excavated the sites of Nimrud on the Tigris River, and the great mound of Kuyunjik, near Mosul, which had already been partially excavated by the French archaeologist Paul-Émile Botta. At Nimrud, he unearthed the Palace of Ashurnasirpal II, while at Kuyunjik he discovered the Palace of Sennacherib as well as the Palace and Library of Ashurbanipal with 22,000 cuneiform clay tablets. He returned to England for two years, and in 1849, returned to Mesopotamia to explore the ruins of Babylon and southern Mesopotamia.

Apart from the archaeological value of his work in excavating the ancient Assyrian city of Nimrud and identifying the mounds of Kuyunjik and Nebi Yunus as the site of ancient Nineveh, Layard wrote two excellent books[8] on his discoveries, which fueled European and American interest in the ancient Near East and, for the first time, provided historical validity to the Bible. Place names and actual sites mentioned in the Old Testament had finally been brought to light, adding an authenticity and veracity to the Bible that had heretofore not been confirmed. In addition, over a period of ten years, he dispatched to England thousands of objects that would form the foundation of the splendid Assyrian art collections in the British Museum.

Assyrian Reliefs in New England

One of the first Americans to express an interest in Layard's work was the Reverend Dwight Whitney Marsh, Williams College class of 1842, whose appointment to the mission in Mosul in 1850 brought him in close contact with Layard.[9] Layard offered him two reliefs, an eagle-headed and human-headed genius (Assyrian protective spirits), which were cut into six pieces and shipped to Williamstown in 1851. Between 1852 and 1860, a number of Assyrian reliefs were shipped to New England colleges, universities, and seminaries, including Amherst College in 1853 and 1856, Yale University and Union Theological Seminary in 1854, Dartmouth

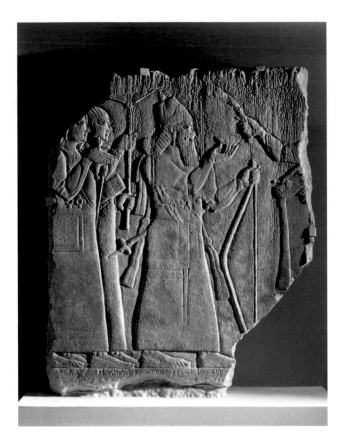

Figure 1.3. Relief of King Ashurnasirpal II with attendants; Iraq, from the Northwest Palace of Ashurnasirpal II at Nimrud, Neo-Assyrian Period, reign of Ashurnasirpal II, 883 to 859 BCE; limestone or gypseous alabaster; H: 35⅞ in. (91.2 cm), W: 28⅞ in. (73.3 cm); Bowdoin College Museum of Art, gift of Dr. Henri B. Haskell, 1860.5.

College in 1856, and Bowdoin College in 1860 (fig. 1.3), among others.[10] These appear to be the earliest examples of ancient Near Eastern art in American collections.

The Assyrian reliefs that were acquired by American missionaries for their respective colleges and seminaries were excavated by Layard from the Palace of Ashurnasirpal II at Nimrud in the years 1845–1847 and 1849–1851. When they finally arrived in the United States—after long journeys across deserts and oceans that often took many months—they were received with great excitement and were viewed by many as a further defense against the wave of secularism that was sweeping across America at this time. Edward Hitchcock, President of Amherst College, boldly proclaimed in 1857 that "Every new discovery of these lost cities is a new testament to the truth of Scripture. . . . Blessed be God that He opened this new source of Biblical History just at the period when infidelity supposed that history was proven to be false."[11]

University of Pennsylvania Museum of Archaeology and Anthropology

While these newly acquired Assyrian reliefs played an important role in the training of students and seminarians, American colleges and universities were going through a radical transformation in the 1860s and 1870s. Curriculums began to be modernized and to diverge from their previous religious or classical focus. A host of new areas of study began to emerge, from the arts and humanities to the social and natural sciences. At the University of Pennsylvania, a dynamic and visionary new President named William Pepper set out to prepare the university to enter the twentieth century as a modern research institution and a fitting heir to the dreams of its founder, Benjamin Franklin.

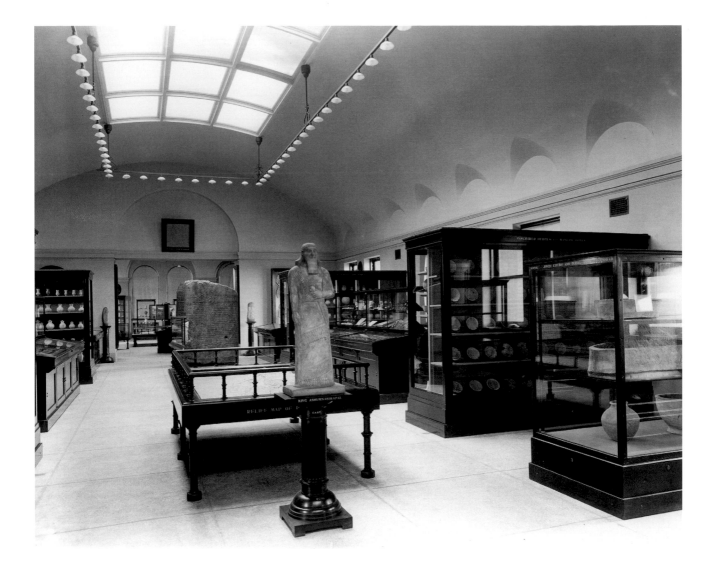

Figure 1.4. Ancient Near Eastern objects on display on the upper floor of the University of Pennsylvania Museum of Archaeology and Anthropology, 1899.

William Pepper was born and raised in Philadelphia and educated at the University of Pennsylvania School of Medicine. In 1868 he joined the medical school faculty and in 1881 was appointed Provost (the traditional Scottish title for President) of the university. A civic-minded academic, he served as the medical director of the United States Centennial Exhibition in Philadelphia in 1876 and founded Philadelphia's first free public library. At the University of Pennsylvania, he introduced a number of new courses into the curriculum, established the concept of graduate education, built the first University Hospital and the Wharton School of Finance, and presided over the construction of new classrooms, laboratories, and libraries on campus.

Pepper's personal interest in archaeology, anthropology, and ethnography led him to create the first professorship in anthropology at an American college or university. In 1886 Daniel Garrison Brinton was hired as a professor of anthropology and linguistics at the University of Pennsylvania, a year before a similar position was created at Harvard. The following year, two new fields of study were introduced when Pepper hired Hermann Hilprecht, a German scholar, as professor of Assyriology, and Morris Jastrow, Jr., a Philadelphia native, as professor of Semitic languages and literature. Together, they established what would become of one of the great centers for the study of the ancient Near East in the United States.

Figure 1.5. The Reverend Dr. John Punnett Peters, Professor of Hebrew at the University of Pennsylvania, no date.

One of Pepper's top priorities was to create a museum of archaeology and anthropology to serve as an intellectual and scientific hub for Philadelphia and the campus, and in 1887 he persuaded the Board of Trustees to erect a fireproof building to house the objects from an upcoming expedition to the ancient site of Nippur in Mesopotamia.[12] During the 1890s, collections were housed in the recently built library on campus, but from Pepper's retirement as Provost in 1894 until his death in 1898 he continued to work to create a permanent building to house the university's growing archaeological and anthropological collections (fig. 1. 4). His dream was finally realized in 1899 when the original building was completed.

The University of Pennsylvania and the Holy City of Nippur

In 1888, the University of Pennsylvania Museum of Archaeology and Anthropology launched an archaeological expedition to Nippur in southern Mesopotamia, the first American-led expedition to the Middle East.[13] The Reverend Dr. John Punnett Peters (fig. 1.5), a professor of Hebrew, served as field director, while Hermann Hilprecht served as epigrapher. John Henry Haynes was appointed field manager and expedition photographer. The expedition was delayed while waiting for a permit from the Turkish government, and when excavations finally began the following year they got off to a calamitous start. Peters and Hilprecht were constantly arguing (they almost came to blows on several occasions), they uncovered meager finds, and when a local Arab was killed by a Turkish guard, Peters wrote that "our camp was burned, we were robbed, and a blood feud was established against us. So closed our first year."[14]

Nevertheless, there was sufficient excitement back in Philadelphia to support another season, and the following year Peters and Haynes returned to the site while Hilprecht remained in Istanbul. Soon after the excavations started, the two archaeologists made a spectacular discovery. They uncovered the temple of Enlil (fig. 1.6), a leading deity of the Sumerian pantheon who had, according to the Sumerian Creation Myth, separated the earth from the heavens with

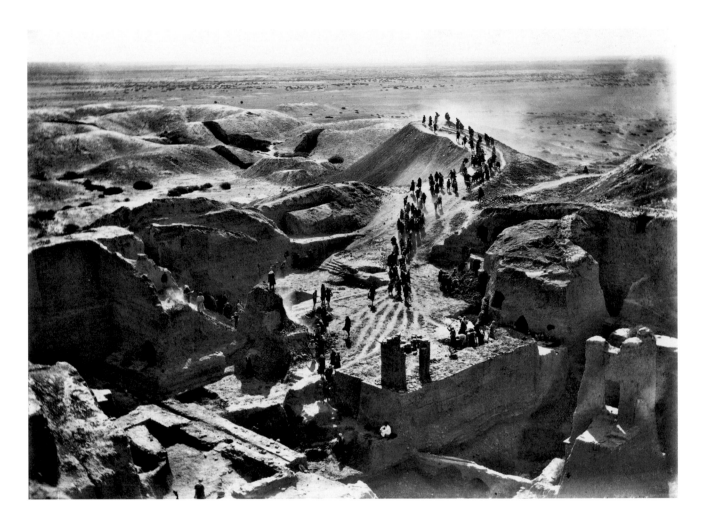

Figure 1.6. View of excavations as seen from the top of the ziggurat, the central temple of the Sumerian city of Nippur, 1899–1900.

the phrase "breath of heaven, breath of earth." After two seasons Peters left the excavations, but during the next decade Haynes would discover thousands and thousands of cuneiform tablets whose contents appeared to be the product of a scribal school: myths, epic tales, hymns, lamentations, proverbs, and fables. Indeed, most of what we know about Sumerian literature comes from this discovery.

James Henry Breasted and the University of Chicago

As the University of Pennsylvania in Philadelphia was excavating the site of Nippur in southern Mesopotamia, philanthropist John D. Rockefeller was laying the groundwork for the University of Chicago. In 1891 he selected a young professor of Hebrew from Yale University, William Rainey Harper, to assist him in organizing the University of Chicago, and shortly thereafter Harper was hired as its first president. Harper set very high standards in terms of faculty and student recruitment. He elevated the salaries of faculty members above those of ordinary schoolteachers, for example, and thus was able to attract the best scholars and minds to Chicago. One of Rainey's most brilliant faculty hires during this time was the American Egyptologist James Henry Breasted.

James Henry Breasted (fig. 1.7) was arguably the finest American-born historian of ancient Egypt of his time.[15] Born and raised in Rockford, Illinois, he initially studied theology at the

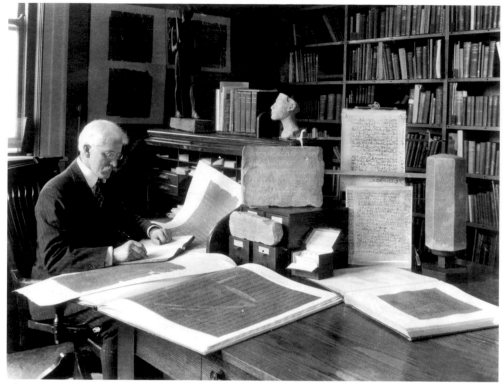

Figure 1.7. James Henry Breasted in his office at Haskell Hall, University of Chicago, 1931.

Chicago Theological Seminary but soon transferred to Yale University where he studied Hebrew with William Rainey Harper, who was laying the groundwork for the University of Chicago at the time. Harper told Breasted that if he studied Egyptology in Germany he could have the first American professorship in Egyptology at the University of Chicago upon his return. Determined to capitalize on this golden opportunity, Breasted sailed for Germany in the fall of 1891, earned his PhD in Egyptology at the University of Berlin under Adolph Erman in 1894 (Breasted was the first American to earn a PhD in Egyptology), got married, traveled to Egypt on his honeymoon, and took Harper up on his offer when he returned to the United States.

During the late 1890s and early 1900s, Breasted taught Egyptology at the University of Chicago, published a number of scholarly articles and books in the field, lectured to service and social organizations throughout the Midwest, and served as assistant director of the Haskell Oriental Museum, the forerunner of the Oriental Institute. The Haskell Oriental Museum had been founded by Harper to house the University of Chicago's small but growing collection of Egyptian and ancient Near Eastern art (fig. 1.8). A $100,000 gift from a wealthy Chicago widow, Caroline E. Haskell, who was seeking an opportunity to honor her late husband, enabled the university to construct the building. At its formal dedication, the Reverend Dr. John Henry Barrows, Mrs. Haskell's pastor, stated, "This, I believe, is one of the first buildings dedicated to oriental studies, those studies from which so much spirited and intellectual light has come to mankind, and from which so much illumination is still further expected."[16]

In 1902 President Harper approached John D. Rockefeller about setting up a research fund to support scholarly and archaeological research in the Middle East, and to Harper's immense satisfaction and delight Rockefeller agreed. In 1903 the University of Chicago sought a permit from the Sultan in Istanbul to excavate a group of mounds at Bismaya in southern

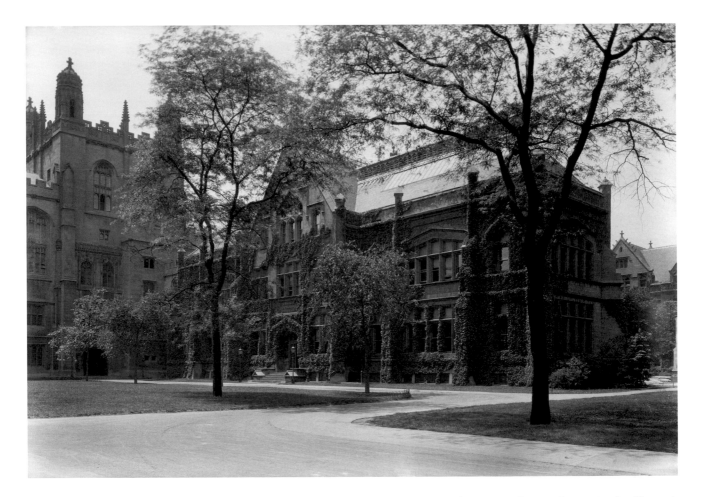

Figure 1.8. The Haskell Oriental Museum, University of Chicago, 1928.

Mesopotamia, a day's journey southeast of Nippur. The Reverend Dr. Edgar J. Banks (fig.1. 9) was appointed field director in association with President Harper's brother, Robert Francis Harper, a professor of Assyrian and Hebrew at Chicago. Over a period of six months, Banks proved that the mounds covered the ancient city of Adab, an important city during the reign of King Shulgi of Ur.[17] In addition to a ziggurat (a rectangular stepped tower, often surmounted by a temple), a temple, buildings, walls, and graves, Banks uncovered more than 1,500 cuneiform tablets that provided a fascinating glimpse of daily life in southern Mesopotamia at the end of the third millennium BCE.

George Reisner at Samaria

While American exploration of Mesopotamia waned during the first decade of the twentieth century after Chicago's excavation of Bismaya in 1903 and 1904, David G. Lyon, who was serving as director of the American School in Jerusalem at the time, obtained a permit from the Turkish government for Harvard University to excavate the ancient city of Samaria.[18] With the financial support of Jacob Schiff, a wealthy American banker, businessman, and philanthropist, the mound at Samaria was excavated by George A. Reisner (fig. 1.10), Clarence S. Fisher, and David G. Lyon in 1909 and 1910. Reisner, in particular, was one of the most outstanding field archaeologists of his day, having excavated in Egypt between 1899 and 1905 at several sites in Upper and Middle Egypt on behalf of the University of California and with the financial support of Phoebe Apperson Hearst, widow of the former senator from California.

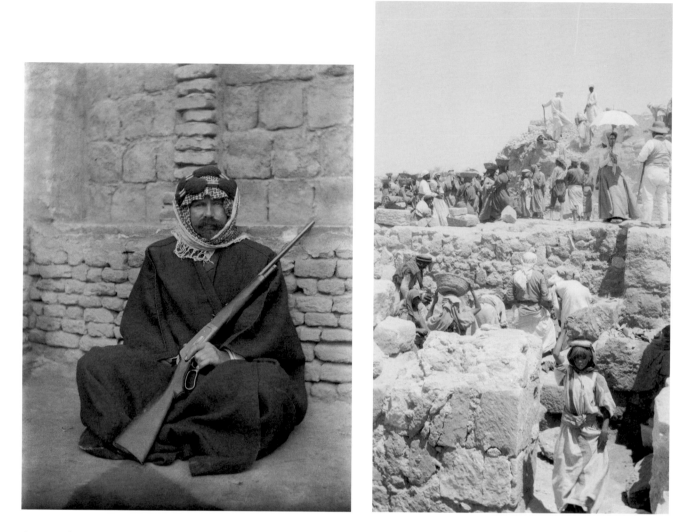

During the course of Reisner's excavation of the site from 1909 to 1910, he unearthed a magnificent city set amid the Samarian hills that was built by King Omri in the ninth century BCE. Working with a trained staff of surveyors, architects, photographers, diggers, and archaeologists, he was able to unearth a citadel strategically situated atop a hill and surrounded by two fortification walls, an inner wall built by Omri and an outer wall built by his son Ahab. The citadel contained a number of buildings, including a storehouse with sixty-three ostraca (pottery shards with writing on them) recording the delivery of oil and wine. Reisner, Fisher, and Lyon eventually wrote a multivolume report on their excavation at Samaria, but it would not be published until 1924.[19] World War I intervened, and American excavation in the Middle East would not resume until the early 1920s.

Figure 1.9. The Reverend Dr. Edgar J. Banks, Director of the University of Chicago excavation at Bismaya, in native dress at the dig site, 1903–1904.

Figure 1.10. George A. Reisner (in pith helmet) and an unidentified woman (with parasol) at the Harvard University excavations at Samaria, 1910.

The Birth of the Oriental Institute of the University of Chicago

During World War I, James Henry Breasted continued to lecture, write, and teach, and in 1916 published *Ancient Times*, his popular textbook for young people. Still, by most accounts, he was frustrated; at fifty-four he felt old and weary and bored by the iteration of teaching and

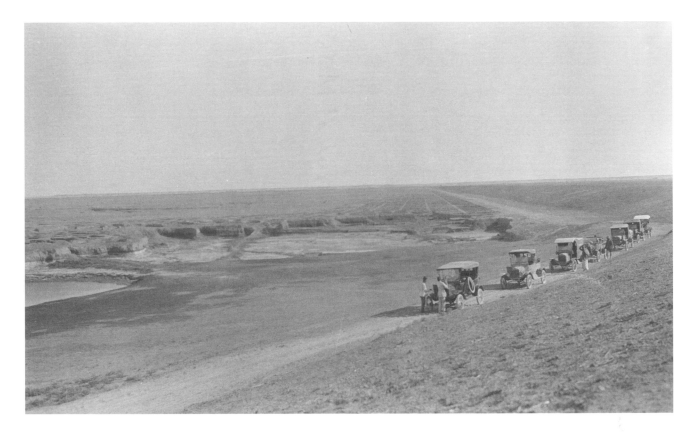

Figure 1.11. The University of Chicago reconnaissance expedition caravan of Fords traverses the desert near Falluja, bound for Abu Kemal, 1919–1920.

academic routine. With the Middle East no longer under the shackles of the Ottoman Turks following the end of World War I in 1918, however, he felt the time was right for scholarly research and archaeological exploration. In 1919 he decided to write to his friend, John D. Rockefeller, Jr., to propose the idea of an Oriental Institute at the University of Chicago.[20] In his letter he argued for the creation of "a laboratory for the study of the rise and development of civilization . . . [which began in] the ancient lands of Western Asia, . . . [one of] the unexplored areas of history. . . . In the entire history of knowledge, this is the greatest opportunity that has ever come for the study of man and his career."[21]

Breasted did not hear back from Rockefeller and assumed that the philanthropist had ignored his request. In the spring of 1919 he was sitting at his breakfast table going through his mail when he noticed a letter with the return address, The Homestead, Hot Springs, West Virginia. He almost threw it in the wastebasket, thinking it was a brochure for a vacation he could not afford, but instead decided to open it. It was a reply from Rockefeller apologizing for not getting back to him sooner and telling him that he was indeed interested in his proposal and would support it at a level of $10,000 per year for five years. Breasted was elated and immediately set about organizing a reconnaissance expedition to the Middle East looking for archaeological sites that could be excavated. This reconnaissance expedition (fig. 1.11), which he would direct, would visit Egypt, Palestine, Syria, and Mesopotamia in 1919 and 1920 and lay the groundwork for dozens of excavations led by the University of Chicago in the 1920s and 1930s.[22]

During the 1920s and 1930s, the Oriental Institute would sponsor a number of different excavations in the Middle East.[23] From 1928 to 1935, for example, Edward Chiera and others conducted excavations at the site of Khorsabad in northern Iraq, where they unearthed the capital

city of Sargon II and his palace, which included a colossal human-headed winged bull and the carved-stone reliefs that lined the walls of the king's palace. During the 1930s, Oriental Institute archaeologists excavated four sites on the lower Diyala River: Ischali, Khafaje, Agrab, and Asmar. Farther east, in Iran in 1932, Alexander Langsdorff and Donald McCown excavated the site of Tall-e Bakun in the fertile Marv Dasht plain of Fars, near the ancient city of Persepolis; McCown and Erich Schmidt would return to the site for a second season in 1937. In addition, Schmidt would lead expeditions to the Luristan region of Iran in 1935 and 1938.

In Palestine during the late 1920s and 1930s, Oriental Institute archaeologists excavated the Canaanite city of Megiddo (biblical Armageddon), which yielded an almost complete sequence of levels from the fifth millennium BCE to the fourth century BCE, as well as a spectacular array of objects documenting the rise and development of the city and its culture. From 1933 to 1938, Robert Braidwood from the Oriental Institute cataloged one hundred seventy-eight archaeological sites in the Amuq in Syria (a broad fertile valley in modern-day Turkey), which offered a fascinating history of life in northern Syria from earliest times to the Roman Period. Finally, from 1927 to 1932 in central Anatolia (modern-day Turkey), Hans Henning von der Osten, Erich Schmidt and others excavated the site of Alishar Hüyük that revealed the intriguing and often complex cultural development of this region.

It was clear by the late 1920s that the Haskell Oriental Museum was no longer large enough to adequately house the thousands of objects that were being shipped back to Chicago from Oriental Institute digs throughout the Middle East. With the support of John D. Rockefeller, Jr. and his various foundations, however, Breasted was able to raise the necessary funds to build a new building and provide endowments for faculty positions and research. When the new facility finally opened in 1931 (fig. 1.12), it became an immediate hit with Chicagoans and attracted over 50,000 visitors in its first six months. Breasted realized that the Oriental Institute, with its vast collections and special exhibitions, had an opportunity to reach a broad audience beyond its primary role of teaching and research.[24] Unfortunately, he never saw his dream fully realized; he died in New York in 1935 from a streptococcal infection following his return from Europe.

The Field Museum of Natural History and Kish

While the Oriental Institute was launching archaeological expeditions throughout the Middle East in the 1920s and 1930s, its Chicago neighbor, the Field Museum of Natural History, joined forces with Oxford University to launch its own excavation at this time.[25] In 1921 Stephen Langdon of Oxford wrote to Berthold Laufer, chief curator of the Anthropology Department at the Field, to propose a joint Mesopotamian expedition. After an archaeological reconnaissance in 1921 and 1922, they settled on the ancient city of Kish. Located fifty miles south of Bagdad, Kish had been an important city during the third millennium BCE. Indeed, the ancient Mesopotamians viewed Kish as the most important city in the northern alluvial plain and, according to the Sumerian King List, as the first city to which kingship descended from heaven after the great flood.

Figure 1.12. The Oriental Institute, University of Chicago, 1938.

From 1923 to 1933, American and British archaeologists explored many of Kish's forty mounds (fig. 1.13), uncovering evidence of the city's early history and urbanization and its dominant role as a political and religious center in Mesopotamia. During the first few years of excavations, for example, they unearthed a series of temple buildings that dated to the Old Babylonian and Neo-Babylonian periods and a ziggurat that dated to the mid-third millennium BCE. Subsequent work revealed a palace and an extensive cemetery with remarkably rich burials that included human skeletons, ceramic vessels, copper weapons and tools, and a variety of luxury items. In addition, during their decade of work at Kish, expedition archaeologists excavated a number of other sites in the region, including Jemdet Nasr, an important fourth millennium BCE site, located some eighteen miles northeast of Kish.

The University of Pennsylvania and the Royal Tombs of Ur

While the Oriental Institute of the University of Chicago and the Field Museum of Natural History were actively engaged in archaeological excavations at key locations throughout the Middle East, the University of Pennsylvania Museum of Archaeology and Anthropology was about to launch an expedition to a site in southern Mesopotamia which, when fully excavated, would turn the archaeological world upside down. The site was Ur "of the Chaldees," the legendary birthplace of the patriarch Abraham (Genesis 11:27–29) and a major city in southern Mesopotamia during the third millennium BCE.[26] The archaeologist who would excavate the site on behalf of the University of Pennsylvania Museum of Archaeology and Anthropology and the British Museum was the British archaeologist Leonard Woolley, one of the most dynamic, engaging, and eloquent archaeologists of the first half of the twentieth century.

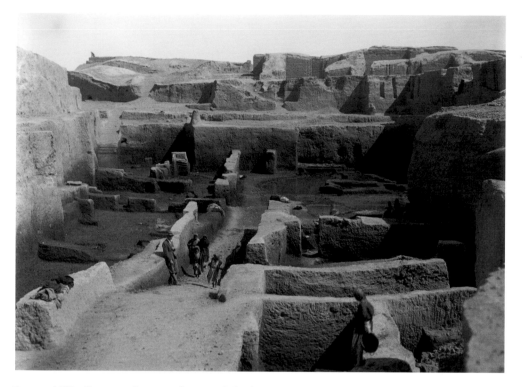

Figure 1.13. View of the excavations at Kish, with Field Director Charles Watlin and workmen in the foreground, 1928–1929.

Leonard Woolley was the son of an English clergyman. He was educated at Oxford in classics and was assistant keeper at the Ashmolean Museum at Oxford when, in 1905, he was asked to oversee the excavation of a Roman fort in Corbridge, Northumberland. He quickly absorbed archaeological field methods and in 1911 was asked to supervise a dig at the Hittite city of Carchemish in Syria. One of Woolley's students was T. E. Lawrence, who would go on to lead the Arab Revolt against the Ottoman Turks as "Lawrence of Arabia." Woolley and Lawrence worked together from 1911 to 1914. When England entered World War I, Woolley volunteered for service and was placed in charge of coastal patrols along the Eastern Mediterranean coast. When his boat hit a mine and sank, he was captured by the Ottoman Turks and made a prisoner of war until he was released in 1918 when the war ended.

Archaeological excavation in Mesopotamia by the Germans during the 1890s and early 1900s, as well as the ongoing translation of cuneiform texts by German, British, and American scholars, raised a number of intriguing questions about the origins of Mesopotamian civilization. With Iraq being governed by the British under a League of Nations mandate following the end of Ottoman rule in 1918, the time was right for renewed archaeological exploration. Breasted and the University of Chicago had already initiated a number of digs in the Middle East, and the Field Museum of Natural History and Oxford University were digging at Kish. The University of Pennsylvania and the British Museum agreed to excavate a number of mounds associated with the ancient cities of Ur and Eridu near the mouth of the Euphrates River and selected Woolley as their field director.

Woolley arrived at Basra in southern Iraq in late 1922 and after obtaining the necessary permits and recruiting laborers and other workmen he traveled to Ur to visit the site. He immediately dug two trial trenches near the ziggurat (fig. 1.14) and in the first trench discovered a lavish burial with human skeletons accompanied by jewelry and other precious materials. He knew

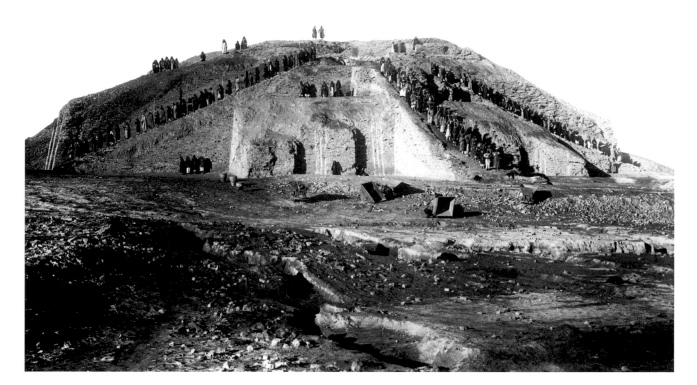

Figure 1.14. View of the ziggurat at Ur at the end of the second season, with workmen arrayed on the stairway, 1924.

that his workmen did not yet have the knowledge or skills to excavate a potentially important site, so he closed it up and switched to his second trench that had revealed a mud-brick wall. By the middle of 1923, he had established that this site was part of an enormous and potentially important temple complex.

By 1926 Woolley (fig. 1.15) decided to return to his first trial trench and quickly realized that he had uncovered an enormous cemetery. It eventually revealed more than 1,800 graves, many of which contained jewelry, exquisite objects of everyday life, and other lavish grave goods. Of particular significance was what Woolley coined the Royal Tombs of Ur (fig. 1.16), solidly built structures that revealed gold cups, jewelry, and exquisite musical instruments. As Woolley was working in one corner of the cemetery in 1928, however, he made a macabre discovery that would make international headlines and fascinate the entire world.

Digging in a different part of the cemetery, Woolley's workers found a single tomb with the skeletons of seventy-four people, which he dubbed "The Great Death Pit." In it each skeleton wore the remnants of fine clothing and jewelry and had a cuplike shell lying next to them. According to Woolley, there could be only one conclusion. These servants must have accompanied the deceased to their grave and committed mass suicide in order to accompany their master into the afterlife. Although the body of the principal occupant was missing, there were several signs that the deceased must have been a king. The tomb was filled with a number of

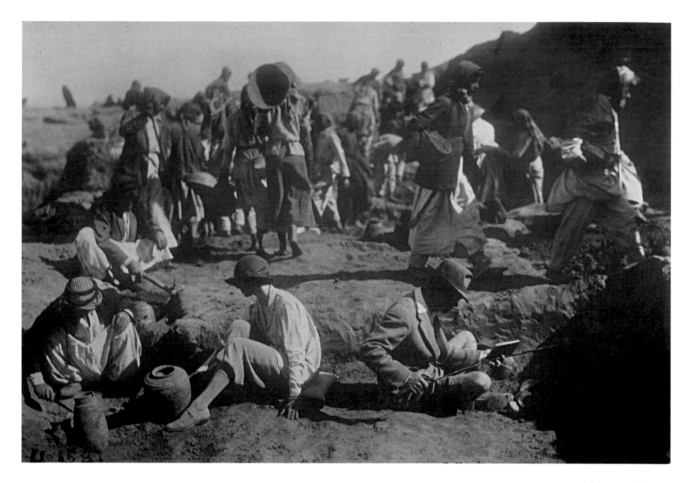

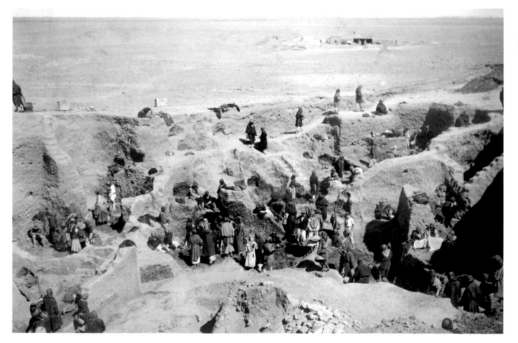

Figure 1.15. Katherine Woolley, left, and Leonard Woolley, right, at Ur "of the Chaldees," 1928.

Figure 1.16. The northeast corner of the cemetery at Ur during the last days of the fifth season, 1927.

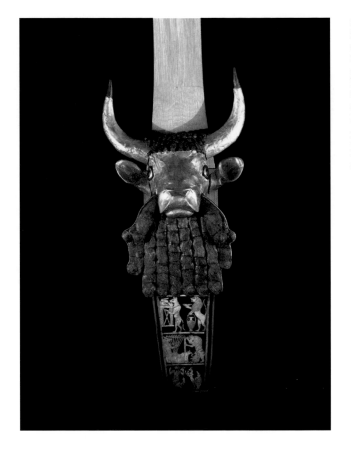

Figure 1.17. The Great Lyre from the "King's Grave"; Iraq, excavated from Ur, Late Early Dynastic Period, 2400–2300 BCE; gold, silver, lapis lazuli, shell, bitumen, and wood; head: H: 14 in. (35.6 cm), plaque: H: 13 in. (33 cm); University of Pennsylvania Museum of Archaeology and Anthropology, Joint British Museum/University Museum Expedition to Mesopotamia, 6th Season, 1927–1928, B17694.

spectacular objects, including a magnificent harp inlaid with gold and white shell (fig. 1.17) and a beautiful gold offering stand in the shape of a goat.

The excavations at Ur would continue uninterrupted until 1934 and would reveal a wealth of information about early Mesopotamian history, including evidence of a great flood (fig. 1.18). During the decade that Woolley excavated at Ur, he and his wife Katherine hosted many famous guests. The writer and explorer Gertrude Bell was a frequent visitor, and when the acclaimed British novelist Agatha Christie visited in 1930, she was assigned Woolley's young assistant, Max Mallowan, as her escort and guide. Christie and Mallowan would marry that year, and she would accompany him on his various archaeological digs for the rest of their married life. Christie's time at Ur undoubtedly inspired her to write *Murder in Mesopotamia* (1936), where the murder victim was clearly based on Katherine Woolley, the archaeologist's outspoken wife.[27]

Leonard Woolley's discovery of Ur "of the Chaldees," which made headlines around the world and was enhanced by the archaeologist's flair for publicity and his popular writing style, fueled American and European interest in the art and cultures of the Middle East. In fact, it could be argued that just as Howard Carter's discovery of the tomb of Tutankamun in the Valley of the Kings in 1922 rekindled an interest in Egyptian art and culture in the 1920s, Leonard Woolley's excavation of the Royal Tombs of Ur in 1926 and his subsequent discovery of "The Great Death Pit" in 1928 and evidence of a great historical flood in 1929 created an interest in Sumerian art and culture in the late 1920s and 1930s. Indeed, the American and European discovery of the art and architecture of the ancient Near East would have a strong influence on American

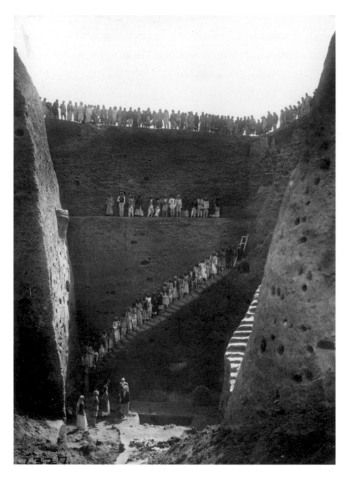

Figure 1.18. The Great Flood Pit at Ur, 1933–1934.

art and culture in the 1930s and early 1940s, including the development of the Art Deco style in art, design, architecture, fashion, and film.[28]

The University of Pennsylvania's Other Expeditions

Like the Oriental Institute of the University of Chicago, the University of Pennsylvania Museum of Archaeology and Anthropology was involved in a number of other archaeological excavations in the Middle East in the 1920s and 1930s.[29] From 1921 to 1933, for example, they excavated the ancient site of Beth Shean in Palestine. Clarence S. Fisher, who worked with Reisner at Samaria in 1909 and 1910 and at Giza, Memphis, Thebes, and Dendera in Egypt for the University of Pennsylvania Museum of Archaeology and Anthropology from 1915 to 1923, served as field director for the first two seasons. Over a ten-year period Fisher, Alan Rowe, Gerald M. Fitzgerald, and others distinguished eighteen different occupation levels at the site and unearthed a number of Egyptian temples that the Philistines had adapted to their own worship practices. The site was made famous in the Old Testament when the Philistines affixed the bodies of Saul and his sons to the city walls after Saul's defeat at the battle of Mount Gilboa (2 Samuel 21:12–14).

In addition to its excavations at Ur in southern Mesopotamia, the University of Pennsylvania Museum of Archaeology and Anthropology excavated two sites in northern Mesopotamia in the 1930s: Tepe Gawra, fifteen miles northeast of Mosul, and Tell Billa, nine miles farther

northeast of Tepe Gawra. Directed at various times by Ephraim A. Speiser and Charles Bache from 1930 to 1938, the sites revealed a wealth of information about life in northern Mesopotamia. At Tepe Gawra, for example, Speiser and Bache discovered the earliest known temple decorated with pilasters and recesses, while at Tell Billa, they unearthed material from the Middle Assyrian and Neo-Assyrian periods. In 1936 and 1937, Speiser took over the Oriental Institute's excavation at Khafaje, a Sumerian site known for its temples, private homes, and limestone and alabaster votive statues. Finally, from 1931 to 1933, Erich Schmidt, working on behalf of the University of Pennsylvania Museum of Archaeology and Anthropology at this time, would be the first American to excavate in Persia (modern-day Iran), at Tepe Hissar, which was found to be an important trading center between the Middle East and Central Asia.

Cylinder Seals and Tablets

While the Oriental Institute of the University of Chicago and the University of Pennsylvania Museum of Archaeology and Anthropology were actively engaged in major archaeological expeditions to the Middle East in the 1920s and 1930s, shipping back thousands and thousands of objects that filled their galleries and storerooms (not surprisingly, there are still some crates of Khorsabad material from the 1920s and 1930s in Chicago that have been opened but not yet unpacked), a number of collections of ancient Near Eastern art were being formed elsewhere at this time. In 1909, for example, the New York financier, collector, and philanthropist J. P. Morgan founded the Yale University Babylonian Collection in New Haven, Connecticut, which currently houses 45,000 objects that date from 3000 BCE to the beginning of the Common Era, including cylinder seals, cuneiform tablets, and related objects.[30] The collection is particularly rich in ancient Mesopotamian writing, including Sumerian, Akkadian, and Hittite inscriptions, treatises, letters, business documents, and literature in poetry and prose.

J. P. Morgan died in 1913, and the bulk of his vast art collection was gifted to the Metropolitan Museum of Art. In 1924 Morgan's son, J. P. Morgan, Jr., known as Jack, established the Morgan mansion on Madison Avenue at 36th Street in New York as a public institution,[31] transferring ownership of the home and its collections to a Board of Trustees along with a $1.5 million endowment. In addition to its extraordinary library, Morgan's collection included nearly three thousand cuneiform tablets, the bulk of which are currently housed in the Yale University Babylonian Collection, and more than 1,100 cylinder seals, assembled by the American clergyman, editor, and Orientalist William Hayes Ward on J. P. Morgan's behalf. The collection of Robert F. Kelley, given by his sister Caroline M. Burns, and the collection of Jonathan P. Rosen, have further enhanced the Morgan's collection of Near Eastern seals and tablets in recent years.

Ancient Israel in New York

Originally housed in the library of the Jewish Theological Seminary of America, the Jewish Museum began in 1904 with a gift of twenty-six ceremonial objects donated by Judge Meyer Sulzberger.[32] The first collection of archaeological material was donated by Hadji Ephraim Benguiat and his brothers in 1925; it consisted mostly of Byzantine clay oil lamps with Jewish symbols. The library continued to house the Jewish Museum and its collections (fig. 1.19) until

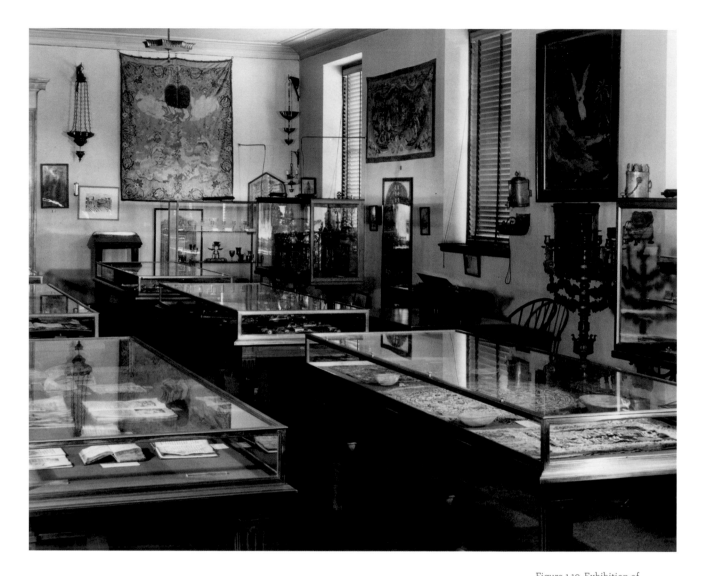

Figure 1.19. Exhibition of the collection of The Jewish Museum in The Library of The Jewish Theological Seminary of America, ca. 1930s (P1334).

1944, when Frieda Schiff Warburg, wife of the financier Felix Warburg and daughter of Jacob Schiff (who had supported George A. Reisner's excavations at Samaria in 1909 and 1910), donated her ornate mansion on the corner of 92nd Street and Fifth Avenue in New York to the Jewish Theological Seminary of America to expand the Jewish Museum.

From the reopening of the Jewish Museum in the former Warburg mansion in 1947, a number of significant archaeological collections have been acquired through donation, purchase, and bequest.[33] In 1948, for example, Samuel Friedenberg and his son Daniel donated their comprehensive collection of ancient coins, and in 1973 the former Jewish Museum director Joy Ungerleider-Mayerson negotiated the acquisition of nearly 600 objects from ancient Israel from the classics department at New York University. These objects were originally part of the collection of H. Dunscombe Colt, who excavated the site of Tell ed-Duweir (biblical Lachish) and several Nabataean settlements in the Negev desert in Palestine in the 1930s. In 1981, the Jewish Museum received a major gift from Max and Betty Ratner of Cleveland, Ohio, further enhancing their antiquities collection.

Metropolitan Museum of Art

The Metropolitan Museum of Art, one of the foremost museums in the world, was founded in 1870 in New York.[34] The earliest examples of ancient Near Eastern art to enter its collection were a group of cuneiform tablets, acquired when the Board of Trustees purchased the antiquities collection of Louis P. Cesnola, an Italian-American soldier, diplomat, and collector, who would serve as the first director of the Met from 1879 until his death in 1904. These objects were supplemented by a group of cylinder seals and tablets donated by William Hayes Ward, editor of the New York *Independent*, twice president of the American Oriental Society, and an accomplished ancient Near Eastern scholar who had assisted J. P. Morgan in the development of his collection of cylinder seals that ultimately went to the Morgan Library. In 1884 the first Assyrian relief entered the Met's collection, to be followed in 1917 and 1932 by other key examples (fig. 1.20) of monumental Assyrian sculpture.

Throughout the 1930s, the Met participated in several archaeological digs in the Middle East. From 1931 to 1932, for example, they worked with the German State Museums in the excavation of Ctesiphon, an important Parthian and Sasanian site on the east bank of the Tigris River twenty miles south of Bagdad, where they unearthed superb examples of Parthian and Sasanian art. When a new antiquities law passed in Iran in 1930 that ended the French monopoly on archaeological exploration in that country, they sent an expedition to southern Iran in 1932 to excavate the site of Qasr-i-Abu Nasr near modern Shiraz. In 1935, the expedition shifted its focus to Nishapur in northeastern Iran and was able to enhance the Met's collection with a large number of Sasanian and early Islamic objects. Back home in New York, the collection

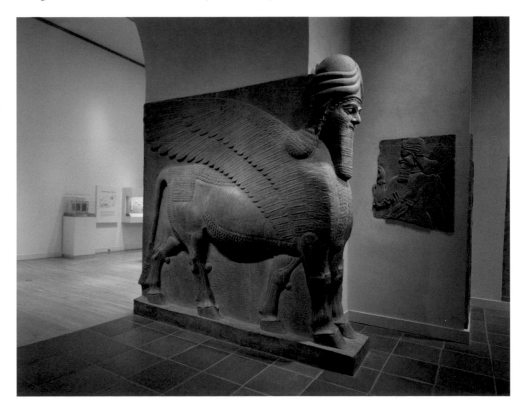

Figure 1.20. Bearded, winged, human-headed bull figure; Iraq, from the Northwest Palace of Ashurnasirpal II at Nimrud, Neo-Assyrian Period, reign of Ashurnasirpal II, ca. 883–859 BCE; gypseous alabaster; H: 123 ½ in. (313.7 cm); Metropolitan Museum of Art, gift of John D. Rockefeller, Jr., 1932, 32.143.1.

Figure 1.21. View of one of the ancient Near Eastern art galleries at the Metropolitan Museum of Art, New York.

was further enriched by the donation of ceramics and other objects from Tell ed-Duweir (biblical Lachish) in Palestine from Harris D. Colt and his son H. Dumscombe Colt in 1934, and a splendid collection of Syrian ivories from George D. Pratt and his wife in 1936.

In the 1950s and 1960s, the Met continued to participate in a variety of archaeological digs. They supported Max Mallowan's (Agatha Christie's husband) excavations at Nimrud beginning in 1951 that unearthed a striking array of ivories, stone vessels, sculptures, and architectural fragments from the reigns of Ashurnasirpal II, Sennacherib, and Ashurbanipal. In the mid-1950s, they partnered with the Oriental Institute of the University of Chicago to continue excavations at the holy city of Nippur, where the first American excavation in the Middle East had begun in 1889, and significantly enriched their collection of Mesopotamian material from the third millennium BCE to the end of the Assyrian Period. By 1956, when the Department of Ancient Near Eastern Art was finally established (a Department of Near Eastern Art had existed since 1932 but included Islamic art as well), the Metropolitan Museum of Art (fig. 1.21) could rightfully take its place among the great ancient Near Eastern art collections in the United States.[35]

Museum of Fine Arts, Boston

The Museum of Fine Arts, founded in Boston in the same year as the Metropolitan Museum of Art in New York,[36] began collecting ancient Near Eastern art at the end of the nineteenth

century, although it never garnered the same kind of curatorial attention that Egyptian or classical art received. George A. Reisner, who served as curator of the Egyptian Department from 1910 until his death in 1942, was primarily interested in building a collection of Egyptian art through his ongoing excavations in Egypt and Nubia, even though he spent two seasons at Samaria in Palestine in 1909 and 1910. Still, over the course of a number of years, the Museum of Fine Arts was able to acquire a number of significant ancient Near Eastern objects, such as a diorite portrait of Gudea and an Achaemenid silver bowl from near the Black Sea, among others.[37] In 1958 the Egyptian Department was enlarged to include responsibility for the art of the ancient Near East, which up to that time had been a part of the Department of Asian Art.

(Near) East Meets (Mid) West

Beyond the Oriental Institute and the Field Museum of Natural History in Chicago, a number of other museums in the Midwest began acquiring examples of ancient Near Eastern art in the 1930s. The Detroit Institute of Arts, founded in 1885, acquired its first major example of ancient Near Eastern art in 1930.[38] William Valentiner, director of the Detroit Institute of Arts from 1924 to 1945, was a brilliant German art historian who had worked at the Kaiser Friedrich Museum in Berlin before immigrating to the United States. The excavations of the Deutschen Orient-Gesellschaft at Babylon had made it possible to reconstruct the Ishtar Gate in Berlin, but several of the animal reliefs had been left over and Valentiner, because of his previous associations, was offered one of the fragments. The purchase was accomplished and the "Dragon of Marduk" (fig. 1.22) came to Detroit. From the 1950s through the early 1980s, other key examples were added to the collection, including cylinder seals, a range of Assyrian and Persian reliefs, pottery from ancient Palestine, and Luristan bronzes from ancient Iran.[39]

Figure 1.22. The "Dragon of Marduk"; Iraq, from the Ishtar Gate at Babylon, Neo-Babylonian Period, reign of Nebuchadnezzar II, 604–562 BCE; terracotta glazed and molded bricks; H: 45 ½ in. (115.6 cm), W: 65 ¾ in. (167 cm); Detroit Institute of Arts, Founders Society Purchase, General Membership Fund, 31.25.

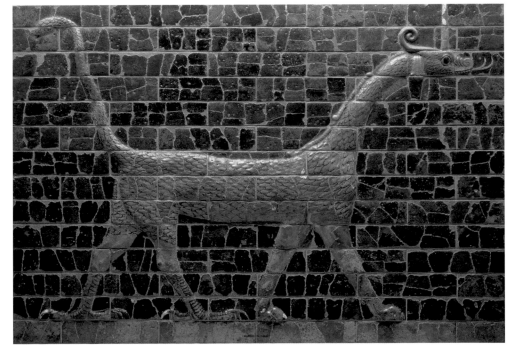

The Cincinnati Art Museum, founded in 1881, acquired a large collection of Nabataean objects in 1939 when Nelson Glueck, an archaeologist and professor at Hebrew Union College in Cincinnati, led an expedition to the ancient city of Petra in modern-day Jordan. Glueck, working at a time when archaeological finds were divided between the host country and the dig sponsors, enlisted fifty Cincinnatians to organize a subscription to bring the objects to Cincinnati.[40] This collection was supplemented in the 1950s and 1960s by the addition of examples of Sumerian, Assyrian, and Persian art, acquired by director Phillip Adams because at the time this was a field where they could make their limited funds go further.[41] Similarly, the Cleveland Museum of Art, founded in 1916, was able to enhance its already strong collection of Egyptian art in the 1960s and 1970s when John Cooney, an Egyptologist and curator of ancient art with an impeccable eye for quality, acquired a number of superb examples of ancient Near Eastern art.[42]

The St. Louis Art Museum, founded in 1881, acquired its first example of Assyrian monumental sculpture in 1925 when they purchased a relief of a winged genius that had been excavated by Austen Henry Layard from the Palace of Ashurnasirpal II at Nimrud.[43] In the 1950s and 1960s, they added a superb Sumerian bearded bull's head, a warrior god from Jezzine in modern-day Lebanon, a Persian relief of a tribute bearer, and a number of Luristan bronzes through various purchase funds.[44] Farther west, in Kansas City, the Nelson-Atkins Museum of Art was building a strong ancient Near Eastern collection as well.[45] Founded in 1933, the Nelson-Atkins supported a number of archaeological digs in the Middle East in the 1930s, including the University of Pennsylvania's excavations at Ur in southern Mesopotamia and at Tureng Tepe in Iran, as well as the Louvre's excavation at Telloh (the ancient Sumerian city of Girsu), in the hopes of building a diverse collection of ancient art. While their financial support of these various digs yielded poor results and was eventually dropped, they were nevertheless able to acquire some significant examples of ancient Near Eastern art on the art market, including a Persepolis relief in 1933, an Assyrian relief from the collection of the St. Louis Mercantile Library in 1940, a Persepolis bull in 1950, and a head of a Sumerian woman from Khafaje in 1955, among others.

Dealers, Collectors, and Curators

During the 1930s and 1940s, a number of antiquities dealers worked with museums and collectors across the United States to build their ancient Near Eastern art collections. Based in New York, they created a wide network of connections across America, enhancing collections from Baltimore to Seattle. Among them was Joseph Brummer, a Hungarian-born art dealer and collector, who opened his first gallery in Paris in 1906 with his brothers Ernest and Imre. At the beginning of World War I, he moved to New York and reopened his gallery in 1921. From 1921 until his death in 1947, Brummer worked with a number of major institutions, most notably the Metropolitan Museum of Art and the Walters Art Gallery in Baltimore, to enhance their collections of ancient Near Eastern art.

Dikran Kelekian, an Armenian-born dealer and collector who specialized in Persian and Islamic art and maintained galleries in New York, London, Paris, and Cairo, worked closely with Charles Freer, who would eventually found the Freer Gallery of Art in Washington, DC, and Henry Walters, who amassed an encyclopedic collection of art that he would eventually donate

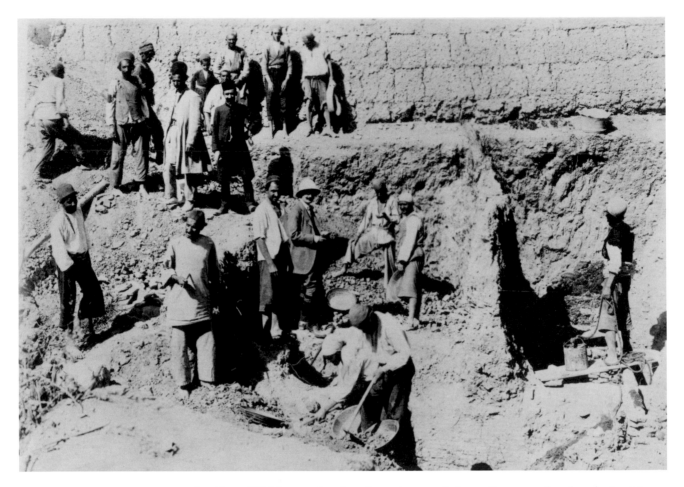

Figure 1.23. Hagop Kevorkian (in pith helmet), described in a *New York Times* article (April 12, 1914) as "an excavator of old temples, buried cities of the ancient Persian dynasties," at Rayy, Iran, ca. 1904.

to the City of Baltimore. Another Armenian art dealer, collector, and archaeologist, Hagop Kevorkian (fig. 1.23), who had settled in New York in the late nineteenth century, would help America acquire a taste for Western Asiatic art. During his lifetime, Kevorkian would play a significant role in the development of the ancient Near Eastern art collections at the Seattle Art Museum and the Brooklyn Museum, among others.

Charles Lang Freer was a railroad executive and collector. Born in Kingston, New York, he moved to Detroit in 1876, and in 1885, with business partner Frank Hecker, formed the Peninsular Car Co. to build railroad cars. They eventually merged with American Car and Foundry in 1899, becoming one of the largest railroad car manufacturers in America. By this time, however, Freer had been diagnosed with neurasthenia (a term used at the time to describe a range of psychological states characterized by fatigue and a lack of motivation) and was encouraged by his doctors to reduce his stress levels. He decided to begin to collect art as a hobby, and over the course of the next two decades made several trips to China, Korea, and Japan and amassed a collection of approximately 30,000 objects, which he decided to donate to the United States.[46] Initially he approached the Smithsonian, who turned down his request; however Freer persevered and eventually, through his friendship with President Theodore Roosevelt and his wife Edith, Roosevelt directed the Smithsonian to accept Freer's gift. Construction of the Freer Gallery of Art began in 1916 but was interrupted because of World War I; the gallery was not completed until 1923.

Figure 1.24. Henry Walters, ca. 1930.

The collection of ancient Near Eastern art donated by Freer to the Smithsonian in 1923 included a few examples of Egyptian art, a collection of Parthian vessels, and a stone relief from Palmyra, among others. Over the years, however, the collection has grown exponentially.[47] In 1929, for example, the New York art collector John Gellatly gave his extensive collection of European and American art to the Smithsonian, as well as sending key examples of ancient Near Eastern, Islamic, and Asian art to the Freer. In 1966 Joseph Hirshhorn donated his extensive collection of ancient Iranian ceramics and metalwork, and in 1987 Arthur M. Sackler donated a thousand pieces of Asian art to the Smithsonian, including a major collection of Western Asiatic art. Moreover, since the early 1990s the ancient Near Eastern art collection has grown through gifts from diplomats and other collectors, along with other major gifts of ancient Iranian ceramics and ancient Sumerian, Assyrian, and Elamite cylinder seals.

Like Freer, Henry Walters (fig. 1.24) was a railroad executive and collector. Born in Baltimore in 1848, he was raised in the city and educated at Georgetown University.[48] His father William was an avid collector who had a gallery built adjacent to his home that he would open every spring for Baltimoreans to visit. When William passed away in 1894, he bequeathed his art collection to his son who, during the next four decades, would expand it with a number of astonishing purchases. Within the field of ancient Near Eastern art, Walters had already bought a collection of Near Eastern cylinder seals from Dikran Kelekian as early as 1893, and over time the Armenian dealer and raconteur would become Walters's primary source for ancient Near Eastern, Egyptian, Greek, Roman, and Islamic art.

When Henry Walters passed away in 1931, he bequeathed his encyclopedic art collection, his Baltimore residence (he had lived in New York since 1894 but traveled frequently to Baltimore to oversee some of his business operations), and the gallery his father had built, to the City of Baltimore. The city council and the mayor accepted the donation, and in 1934 the Walters Art Gallery (renamed the Walters Art Museum in 2000) officially opened with a collection of more

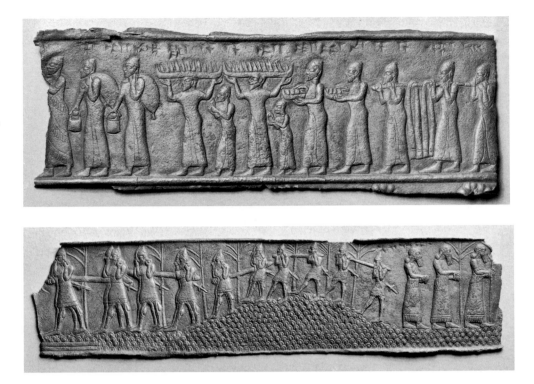

Figure 1.25. Fragments of gate bands; Iraq, from Balawat, Neo-Assyrian Period, reign of Shalmanesar III, 859–824 BCE; bronze; fragment a: H: 3 15/16 in. (10 cm), W: 11 in. (28 cm), fragment b: H: 3 9/16 in. (9 cm), W: 14 ½ in. (36.8 cm); The Walters Art Museum, Baltimore, Maryland, 54.2335.

than 22,000 objects. In time, the collection would evolve into one of the finest collections of ancient art in America, with superb examples of Sumerian sculpture, fragments from the Balawat Gate (fig. 1.25), Syro-Palestinian objects in bronze and silver, a range of ancient Iranian ceramics and bronzes, and one of the finest collections of ancient Anatolian art in the United States.[49]

Richard Fuller (fig. 1.26) was a geologist who, with his mother Margaret MacTavish Fuller, founded the Seattle Art Museum in 1933.[50] Born in New York in 1897, Fuller served as an ambulance driver during World War I. After an extensive trip to Asia in 1919, at which time he developed his lifelong love of Asian art, he returned to the United States and earned his BA degree from Yale University. In 1923 he followed his brother and sister to Seattle, and in 1924 he earned a second BA degree from the University of Washington, followed by MA and PhD degrees from the university in geology in 1926 and 1930, respectively. In 1930 Fuller's father passed away, leaving a substantial estate to his mother.

In 1928, Fuller joined the Seattle Fine Arts Society, and in 1930 he was elected president. At this time he hired Lawrence Coleman, Director of the American Association of Museums, to study the need for a permanent home for the Seattle Fine Arts Society's art collection. Coleman came to the conclusion that a permanent home was indeed needed, and in 1933 Fuller and his mother presented the newly completed Seattle Art Museum building, designed by Seattle architect Carl F. Gould and funded in total by the Fullers, as a gift to the City of Seattle. The building would house the Seattle Fine Arts Society's art collection, along with the Fullers's extensive collection of Asian art, and Fuller would be retained as a nonpaid director for the next forty years.

From the beginning of his directorship in 1933 until his retirement in 1973, Fuller wanted to "gradually acquire examples that emphasize the creative art of the various cultures of the world."[51] Working with the New York dealer and collector Hagop Kevorkian in the 1940s, he

Figure 1.26. Richard E. Fuller, no date.

added a number of important pieces of Egyptian and ancient Near Eastern art to his collection to "illustrate one of the main roots from which, since Biblical days, the culture of the Occident . . . descended."[52] These objects, which included a Sumerian votive sculpture, a Babylonian boundary marker, cylinder seals, and an Assyrian relief of soldiers, would be supplemented in the 1950s and 1960s with other gifts and purchases.[53]

The Brooklyn Museum, founded in 1890 and home to what is arguably one of the finest collections of Egyptian art in the world, had a surprisingly small collection of ancient Near Eastern art until the 1950s.[54] In 1957, however, twelve Assyrian reliefs (fig. 1.27) were given to Brooklyn by Hagop Kevorkian. Excavated by Austen Henry Layard from the Palace of Ashurnasirpal II at Nimrud, they had originally been purchased by American expatriate Henry Stevens and shipped to Boston. When Stevens was unable to find a buyer in Boston, he sold them to the New York Historical Society. In 1937, the society lent them to the Brooklyn Museum, and in 1957 Kevorkian agreed to purchase and donate them.[55] From the time of their acquisition, Brooklyn has added Sumerian sculpture, a Persian relief, and fragments of gold and silver jewelry to their small but choice collection.

Like the Nelson-Atkins Museum of Art, the Walters Art Gallery, and the Seattle Art Museum, the Virginia Museum of Fine Arts was founded at the height of the Great Depression, in 1936. The ancient art collection began to take form in the 1950s and 1960s with endowment support from the Adolph D. and Wilkins C. Williams Fund and the A. G. Glasgow Fund.[56] A number of curators and scholars advised the VMFA on acquisitions, including John Cooney of the Brooklyn Museum and Cleveland Museum of Art, and William Stevenson Smith of the Museum of Fine Arts in Boston. Among the VMFA's significant ancient Near Eastern art objects are a foundation peg of Shulgi of Ur, as well as a fragmentary Assyrian relief of a winged genius that was acquired in 1920 by the New York dealer and collector Paul Mallon, who had

Figure 1.27. View of the Hagop Kevorkian Gallery of Ancient Near Eastern Art at the Brooklyn Museum.

owned an art gallery on the Champs-Elysées in Paris in the 1920s and 1930s; Mallon sold the relief to the Virginia Museum of Fine Arts in 1956.

To Educate, Inspire, and Delight

In addition to the Assyrian reliefs that were purchased by Williams, Amherst, Yale, Dartmouth, Bowdoin, and other colleges and seminaries in New England in the 1850s, and the great collections of ancient Near Eastern art that were being acquired through excavation by the universities of Pennsylvania and Chicago from 1889 onward, other American colleges and universities began acquiring examples of ancient Near Eastern art during the nineteenth and twentieth centuries. The first university art museum was founded at Yale University in 1832, followed by Vassar College in 1864, Princeton University in 1882, Bowdoin College in 1894, and Harvard University in 1896, to mention only a few. From their very beginnings, these institutions were established to support the liberal arts curriculum of their respective universities, to provide a vehicle for introducing their students to the history of art and culture, and, in the words of Edward W. Forbes of Harvard University, to build collections that "tell the story of the artistic and imaginative possibilities of man" and to create a place wherein the student is fired "by the inspiration that comes from contact with [original] works of art."[57]

The Princeton University Art Museum (fig. 1.28) was founded in 1882 by President James McCosh, Professor William C. Prime, and General George McClellan of Civil War fame to support the liberal arts curriculum of the university.[58] From its inception the focus of Princeton's ancient art collection has been on Greek and Roman art, and because Egyptian and ancient Near Eastern art have never been regularly taught at the university, there are very few objects from these cultures in their collection. In fact, the academic study of Egyptian and ancient Near Eastern art has not been a regular part of art history curriculums in the United States until recent years. Nevertheless, Princeton has acquired a small but choice collection of ancient Near Eastern art over the years, including an Assyrian ivory from Nimrud, a range of bronzes from ancient Iran, an Assyrian relief that was donated by Princeton alumnus Robert Garrett in 1900 (Garrett, coincidentally, set a world record in the discus in the 1896 Olympic Games in Athens), and a Persian relief of a tribute bearer from Persepolis.[59]

During the first half of the twentieth century, the United States witnessed a rapid growth in university art museums. Major academic museums, for example, were founded at the University of Washington in 1927, the University of Oregon in 1932, and the University of Michigan in 1946. The University of Missouri Museum of Art and Archaeology was founded in 1957 to house the university's growing collection of ancient art, which is especially strong in Greek, Roman, and ancient Near Eastern art, including Palestinian ceramics and coins, Anatolian art, and Iranian ceramics and bronzes.[60] The following year, at the University of North Carolina at Chapel Hill, the Ackland Art Museum was founded through a bequest of William Hayes

Figure 1.28. The Museum of Historic Art and McCormick Hall, Princeton University, ca. 1920s.

Ackland, a Nashville lawyer who died in 1940.[61] Over time, the Ackland has built a small but choice study collection of Egyptian, ancient Near Eastern, Greek, and Roman art, including a nice collection of Mesopotamian cylinder seals.

A New Wave of Collectors

During the 1950s and 1960s a new wave of individual and institutional collectors of ancient art began to emerge. Among them were Leon and Harriet Pomerance, who began to collect ancient art in 1954 and, during their lifetimes, amassed a substantial collection of ancient art.[62] Their collection was particularly rich in Egyptian and ancient Near Eastern art. Norbert Schimmel, a manufacturer of engraving machinery who immigrated to the United States in 1938 and who passed away in 1990, assembled over a thirty-five-year period what many scholars considered to be one of the finest private collections of antiquities in the world.[63] Similarly, the late Alastair Martin and his wife, Edith, began to collect Egyptian and ancient Near Eastern art (as well as Medieval, Asian, and American folk art, to name just a few fields in which they collected) in the late 1940s and 1950s, amassing a substantial collection that included among its many treasures a small Proto-Elamite sculpture of a lioness (see fig. 2.27) that is considered by many scholars to be one of the masterpieces of ancient Iranian art.[64]

In addition to the emergence of individual collectors in the early 1950s and 1960s, the era saw the birth of several new museums that would eventually develop significant collections of ancient Near Eastern art. In 1961, for example, the Los Angeles County Museum of Art was founded, although it had its roots in the Los Angeles Museum of History, Science, and Art that had been established in 1910 in Exposition Park, where James Henry Breasted, Jr., the second son of the legendary Egyptologist, was an early director. During the 1960s and early 1970s, LACMA built a small but choice collection of ancient Near Eastern art with generous support from the Ahmanson Foundation and several Los Angeles collectors, and in 1976 purchased a spectacular collection of ancient Iranian bronzes and silver from the Indian-born art dealer Nasli M. Heeramaneck.[65] The Kimbell Art Museum in Fort Worth, Texas, was founded in 1966 but didn't officially open its doors until 1972.[66] Yet from its inception the Kimbell has focused on objects of the highest artistic quality and historical significance, and its ancient Near Eastern art collection, while small in size, is of extremely high quality.

Arthur M. Sackler and His Legacy

Arthur M. Sackler (fig. 1.29) was one of the most remarkable collectors and philanthropists of the twentieth century.[67] Born and raised in New York, he attended the New York University School of Medicine in the midst of the Great Depression. After an internship and residency at Lincoln Hospital in New York, he became a resident in psychiatry at nearby Creedmoor State Hospital. There, during the 1940s and 1950s, he conducted research that resulted in the publication of more than a hundred fifty articles and papers on psychiatry and experimental medicine; in fact, he considered his research into the metabolic basis of schizophrenia to be his most significant scientific contribution. In 1958 he established the Laboratories for Therapeutic

Figure 1.29. Arthur M. Sackler, no date.

Research, and in 1960, he founded the *Medical Tribune*, a weekly newspaper devoted to medicine. While Sackler considered himself to be first and foremost a scientist, he was a passionate, erudite, and knowledgeable art collector as well.

Sackler began to acquire art in medical school, and during the late 1930s and 1940s he collected historic and modern American and European art. In 1950, however, he saw a small table made during the Ming Dynasty (1368–1644) that resonated with him, and from that time until his death in 1987 he became a passionate collector of Chinese art, building one of the finest collections outside of China. During the 1960s and 1970s Sackler developed a keen interest in ancient Iranian ceramics and metalwork and enlisted the help and advice of Dr. Edith Porada, an internationally recognized authority on ancient Iranian art who taught Near Eastern art and archaeology at Columbia University. During this time, he acquired a number of Western Asiatic objects from the Anavian Gallery and Rabenou Gallery in New York, and in 1966 and 1967 he donated a large collection of ancient Iranian art to Columbia, where he served on the Visiting Committee for the Department of Art History and Archaeology for many years.

In addition to his role as a scientist and collector, Sackler was a major philanthropist who helped support hospitals, medical schools, universities, and museums. In the 1960s and 1970s, for example, he endowed several galleries at the Metropolitan Museum of Art, including the Sackler Wing (with his brother Mortimer), which houses the Temple of Dendur—a gift of the Egyptian government to the United States, it is the only extant Egyptian temple in the Western Hemisphere—as well as the Arthur M. Sackler Gallery at the Princeton University Art Museum. In 1977 he provided a major gift to build the Arthur M. Sacker Museum at Harvard University to house their splendid collections of ancient, Islamic, and Asian art, including a small study collection of ancient Near Eastern art; the building was completed and dedicated in 1985. Finally, in 1987, the Arthur M. Sackler Gallery at the Smithsonian Institution in

Washington, DC, officially opened as an adjunct to the Freer Gallery of Art with financial support from Sackler and a gift of a thousand objects from the Sackler collection. Since his death in 1987, the Arthur M. Sackler Foundation in New York has carried on Dr. Sackler's legacy through long-term loans and special exhibitions.

The Philologists

In addition to the American archaeologists, adventurers, collectors, and curators who, over the past one hundred and fifty years, have helped reconstruct and reinterpret the civilizations and material culture of the ancient Near East, there have been a handful of American scholars who, through their knowledge of ancient languages and literature, have provided new insights into life in ancient times. At the University of Pennsylvania, for example, the great Sumerian scholar Samuel Noah Kramer devoted a lifetime to translating some of the 30,000 cuneiform tablets unearthed at Nippur at the end of the nineteenth century.[68] His popular writings, such as *History Begins at Sumer* (1956) and *The Sumerians* (1963), introduced lay audiences around the world to the accomplishments and contributions of the ancient Sumerians. In 1974 Kramer's colleagues Erle Leichty and Åke Sjöberg (fig. 1.30) initiated The Pennsylvania Sumerian Dictionary Project, the first comprehensive dictionary of the Sumerian language, under the auspices of the University of Pennsylvania Museum of Archaeology and Anthropology.

Similarly, at the Oriental Institute of the University of Chicago, scholars and philologists are in the process of compiling dictionaries for both the Assyrian and Hittite languages.[69] The Chicago Assyrian Dictionary Project, for example, is a nine-decade initiative dedicated to compiling a dictionary of ancient Assyrian and its various dialects. Modeled after the *Oxford English Dictionary*, it was started in 1921 by James Henry Breasted, the founder of the Oriental Institute, who had worked on the *Wörterbuch der ägyptischen Sprache* (a dictionary of ancient

Figure 1.30. Erle Leichty (left) and Åke Sjöberg, curators of the University of Pennsylvania Museum of Archaeology and Anthropology's Tablet Collection, examine some of the 30,000 tablets from which they are compiling The Pennsylvania Sumerian Dictionary Project, no date.

Egyptian) over the years with his teacher, mentor, and friend Adolph Erman. The Chicago Hittite Dictionary Project, founded in 1975 by Hans Gustav Gutterbock and Harry Hoffner and funded with a major grant from the National Endowment for the Humanities, seeks to develop a comprehensive dictionary of ancient Hittite, an early Indo-European language that was written on clay tablets in central Anatolia during the second millennium BCE; the majority of these tablets were excavated by German archaeologists during the first half of the twentieth century.

The Continuing Discovery of the Ancient Near East

World War II slowed down the archaeological exploration of the Middle East, but by the late 1940s and 1950s a number of new expeditions were launched at old as well as new sites.[70] As might be expected, both the University of Pennsylvania and University of Chicago were at the forefront of archaeological exploration. From 1956 to 1962 James B. Pritchard, a professor of religion and curator at the University of Pennsylvania Museum of Archaeology and Anthropology, excavated the site of Tell Jib (biblical Gibeon), eight miles north of Jerusalem (fig. 1.31). It was at Gibeon, according to the Bible, that the sun stood still for Joshua (Joshua 10: 13). In the 1960s and early 1970s Pritchard would go on to excavate at Tell-es-Sa'ideyeh, in Jordan, and at Sarafand, Lebanon, a Phoenician port known in the Bible as Zarepath. From 1956 to 1977, Pritchard's colleague Robert Dyson, Jr. would spend two decades excavating the site of Hasanslu in northwestern Iran (fig. 1.32), a once prosperous city that was destroyed by Urartian invaders in the first millennium BCE. In recent years, Richard L. Zettler, associate curator-in-charge of the Near East section at the University of Pennsylvania Museum of Archaeology and Anthropology, has worked at Tell-el-Sweyhat, in northern Syria, a city on the Euphrates River that dates to 3000 BCE, while his colleague Holly Pittman has excavated two sites near Jiroft in south-central Iran that have revealed a hitherto unknown civilization that had connections to Mesopotamia, the Indus Valley, and Central Asia.

Like the University of Pennsylvania Museum of Archaeology and Anthropology, the Oriental Institute of the University of Chicago resumed excavations in the Middle East in the late 1940s. Beginning in 1947, anthropologist Robert J. Braidwood and his wife Linda excavated a number of prehistoric sites in Iraq, Iran, and Turkey over the next two decades. In 1948 Braidwood's colleague Richard C. Haines began digging at Nippur, where he focused his excavations on the religious quarter to which the city owed its historical significance. In recent years, however, Oriental Institute archaeologists have shifted their focus to the administrative and residential quarters to give a more balanced view of this once thriving city. From 1961 to 1978, Pierre Delougaz and Helene Kantor from the Oriental Institute excavated the site of Chogha Mish in Iran and unearthed a wealth of new information on the development of this region, and since 1999 McGuire Gibson has excavated Tell Hamoukar, an important site in northeastern Syria during the fourth and third millennia BCE. While the universities of Pennsylvania and Chicago remain the principle research institutions and museums to continue to excavate in the Middle East, a host of other American universities and colleges have mounted important expeditions to Israel, Jordan, Syria, Lebanon, Turkey, and Iran, all of which have shed new light on the art and cultures of the ancient Near East.[71]

Figure 1.31. The pool of Gibeon at El Jib (Gibeon), Jordan, 1958.

Figure 1.32. An aerial view of the main mound at Hasanlu, Iran, 1962.

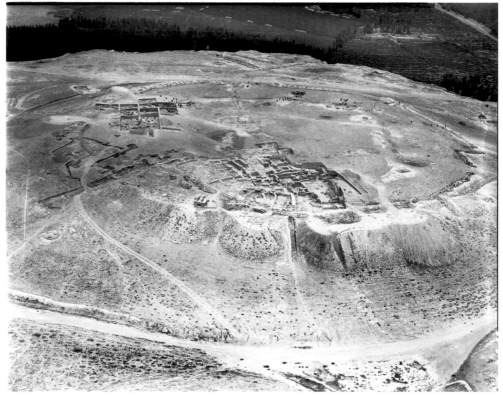

Conclusion

Over the past two centuries, Americans have played an important role in the discovery of the ancient Near East. While American missionaries initially traveled to the Middle East to bring Christianity to a region that, in their opinion, "was destitute of the gospel, immersed in gross ignorance, and led away by the delusions of Mahomet,"[72] they were soon replaced by archaeologists and scholars who sought to scientifically unravel the origins and history of the ancient Near East. Over the past one hundred fifty years, American archaeologists have unearthed the ancient civilizations of Sumer and Akkad and have brought to light the people and places of the Old Testament. American philologists have studied the wedge-shaped marks on cuneiform tablets and seals unearthed at these archaeological sites and, through painstaking research and scholarship, have brought to light the lives, hopes, dreams, and aspirations of these ancient peoples. Over the years, American collectors have acquired stunning examples of ancient Near Eastern art and have helped preserve them for future generations, while American curators and others have helped make these once remote and obscure civilizations accessible to a general audience through permanent collections, special exhibitions, and popular writings. Indeed, the American impact on the study and interpretation of the ancient Near East has been both significant and profound.

The Middle East has dominated global headlines for the past sixty years. The creation of the State of Israel in 1948, the ongoing clash between Palestinians and Israelis, the global reliance on Middle Eastern oil, the Tehran hostage crisis in the late 1970s, the ten-year war between Iraq and Iran in the 1980s, Saddam Hussein, the first and second Iraqi Wars in the 1990s and 2000s, 9/11 and the hunt for Osama bin Laden, and the political uprisings in North Africa and the Middle East known as Arab Spring, have dominated both regional and international politics and economics over the past half century and have seeped into our collective consciousness. Amid the turmoil and unrest of these years, however, it is sometimes easy to forget the important contribution that the Middle East has made to the development of Western civilization. While we often look to Greece and Rome as the birthplace of our Western culture, it is the even older cultures of the ancient Near East—the cradle of civilization—to whom we owe an equally important cultural debt.

1 "A-Sitting on a Tell" is a poem written by Agatha Christie that serves as a preamble to her memoir *Come, Tell Me How You Live* (1946) about her travels in Syria in the 1930s with her archaeologist husband Max Mallowan. Christie's poem mimics "Haddocks' Eyes," a poem recited by the White Knight to Alice in Lewis Carroll's *Through the Looking-Glass*.

2 The term "Fertile Crescent" was first used by University of Chicago Egyptologist James Henry Breasted in his book *Ancient Records of Egypt* (1906) to describe the Middle East. The region, comprised of Egypt, the Levant, Iraq, and western Iran, was so named because of its rich soil and geographical crescent shape.

3 Two classic books on the history of Mesopotamian archaeology are Brian M. Fagan, *Return to Babylon: Travelers, Archaeologists, and Monuments in Mesopotamia* (Boston: Little, Brown, 1979) and Seton Lloyd, *Foundations in the Dust: The Story of Mesopotamian Exploration* (London: Oxford University Press, 1947. Reprinted London: Thames & Hudson, 1980). There are a number of good books on the history of Biblical archaeology, including Moshe Pearlman, *Digging up the Bible* (New York: William Morrow, 1980) and Neil Asher Silberman, *Digging for God and Country: Exploration, Archaeology, and the Secret Struggle for the Holy Land, 1799–1917* (New York: Alfred A. Knopf, 1982).

4 For the American discovery of the ancient Near East, see Phillip J. King, *American Archaeology in the Mideast: A History of the American Schools of Oriental Research* (Philadelphia: American Schools of Oriental Research, 1983) and G. Ernest Wright, "The Phenomenon of American Archaeology in the Near East," in *Near Eastern Archaeology in the Twentieth Century: Essays in Honor of Nelson Glueck*, edited by James A. Sanders (Garden City, NY: Doubleday and Co. 1970): 3–40.

5 Secondary quote cited in Mehmet Ali Doğan, "From New England into New Lands: The Beginning of a Long Story," in *American Missionaries in the Middle East: Foundational Encounters*, edited by Mehmet Ali Doğan and Heather J. Sharkey (Salt Lake City: University of Utah Press, 2011): 7.

6 The history of the American missionary movement in the Middle East is discussed in David A. Finnie, *Pioneers East: The Early American Experience in the Middle East* (Cambridge, MA: Harvard University Press, 1967), and especially Doğan, "From New England into New Lands: The Beginning of a Long Story," *American Missionaries in the Middle East*, 1–32.

7 For a history of the early exploration of northern Mesopotamia, see Julian Reade, "The Early Exploration of Assyria," in *Assyrian Reliefs from the Palace of Ashurnasirpal II: A Cultural Biography*, edited by Ada Cohen and Steven Kangas (Hanover, NH: Hood Museum of Art, 2010): 86–106. For a popular and highly readable account of the life of Austen Henry Layard, see Arnold C. Brackman, *The Luck of Nineveh: Archaeology's Great Adventure* (New York: McGraw-Hill, 1978). Other books that include a wealth of information on Layard are Fagan, 97–137, and Lloyd, 87–129.

8 For further information, see Austen Henry Layard, *Nineveh and Its Remains* (London: John Murray, 1849) and Austen Henry Layard, *Discoveries in the Ruins of Nineveh and Babylon* (London: John Murray, 1853).

9 For a history of Assyrian reliefs in American collections, see Ada Cohen and Steven Kangas, "Our Nineveh Enterprise," in *Assyrian Reliefs from the Palace of Ashurnasirpal II: A Cultural Biography*, 1–45, and John B. Stearns, *Reliefs from the Palace of Ashurnasirpal II* (Graz: Weidner, Archiv für Orientforschung, vol. 15, 1961).

10 Several excellent books and articles discuss the history of Assyrian reliefs in New England academic collections, including Elyse Gonzales, *The Stones of Assyria: Ancient Spirits from the Palace of Ashurnasirpal II* (Williamstown, MA: Williams College Museum of Art, 2001); Susan B. Mattheson, *Art for Yale: A History of the Yale University Art Gallery* (New Haven, CT: Yale University Art Gallery, 2006): 27–29; Barbara Porter, *Assyrian Bas Reliefs at the Bowdoin College Museum of Art* (New Brunswick, ME: Bowdoin College Museum of Art, 1989); and John B. Stearns and Donald P. Hansen, *Assyrian Reliefs at Dartmouth* (Hanover, NH: Dartmouth College, 1953).

11 Secondary quote cited in Cohen and Kangas, 13.

12 For a magisterial history of the University of Pennsylvania Museum of Archaeology and Anthropology, see Dilys Pegler Winegrad, *Through Time, Across Continents: A Hundred Years of Archaeology and Anthropology at the University Museum* (Philadelphia: University of Pennsylvania Museum of Archaeology and Anthropology, 1993).

13 There are several short accounts of America's first archaeological expedition to Nippur in southern Mesopotamia, including Fagan, 200–210, Winegrad, 6–8, and Wright, 10–12.

14 Secondary quote cited in Winegrad, 6.

15 Two wonderful biographies of James Henry Breasted are Charles Breasted, *Pioneer to the Past: The Story of James Henry Breasted, Archaeologist* (New York: Charles Scribner's Sons, 1943. Reprinted Chicago: University of Chicago Press, 1977), and Jeffrey Abt, *American Egyptologist: The Life of James Henry Breasted and the Creation of His Oriental Institute* (Chicago: University of Chicago Press, 2012).

16 Secondary quote cited in Breasted, 94.

17 For further information, see Karen L. Wilson, Jacob Lauinger, et al., *Bismaya: Recovering the Lost City of Adab* (Chicago: Oriental Institute of the University of Chicago, 2012). Oriental Institute Publication 138.

18 Succinct accounts of George A. Reisner's excavation at Samaria are included in King, 39–41; Pearlman, 137–140; Silberman, 171–179; and Wright, 14–16.

19 For further information, see George A. Reisner, Clarence S. Fisher, and David G. Lyon, *Harvard Excavations at Samaria, 1908–1910* (Cambridge, MA: Harvard University Press, 1924).

20 For an introduction to the birth of the Oriental Institute, see Breasted, 238–241, and John A. Wilson, "James Henry Breasted: The Idea of an Oriental Institute," in *Near Eastern Archaeology in the Twentieth Century: Essays in Honor of Nelson Glueck*, 41–56.

21 Secondary quote cited in Breasted, 238.

22 For an introduction to Breasted's reconnaissance expedition to the Middle East, see Geoff Emberling, *Pioneers to the Past: American*

Archaeologists in the Middle East, 1919–1920 (Chicago: Oriental Institute of the University of Chicago, 2010).

23 For a synopsis of the Oriental Institute's excavations in the Middle East, including a complete list of excavation reports beginning in 1924, see the Oriental Institute of the University of Chicago's website.

24 Two excellent introductions to the Oriental Institute Museum are Leon Marfoe, *Guide to the Oriental Institute Museum* (Chicago: University of Chicago Press, 1982) and especially Geoff Emberling, "Views of a Museum: The Extraordinary Collection of the Oriental Institute, University of Chicago," *The Canadian Society for Mesopotamian Studies* 4 (2009): 29–35.

25 Unfortunately, the Field Museum of Natural History's excavations at Kish have not been published yet, but an excellent introduction may be found on their website.

26 For further information on the University of Pennsylvania Museum of Archaeology and Anthropology's excavations at Ur, see Leonard Woolley, *Ur of the Chaldees, a Revised and Updated Edition of Sir Leonard Woolley's* Excavations at Ur, P. R. S. Moorey, ed. (Ithaca, NY: Cornell University Press, 1982), and Richard L. Zettler, Lee Horn, Donald P. Hansen, and Holly Pittman, *Treasures from the Royal Tombs of Ur* (Philadelphia: University of Pennsylvania Museum of Archaeology and Anthropology, 1998).

27 In fact, Agatha Christie wrote four Hercule Poirot mysteries with strong archaeological and travel themes: *Murder on the Orient Express* (1934), *Murder in Mesopotamia* (1936), *Death on the Nile* (1937), and *Appointment with Death* (1938). In addition, she wrote two other books set in the Middle East: *Come, Tell Me How You Live* (1946), a delightful memoir based on her travels in Syria in the 1930s with her archaeologist husband Max Mallowan, and *They Came to Bagdad* (1951), a spy thriller inspired by her many trips to Baghdad.

28 During the 1920s and 1930s in the United States, there was a growing fascination with archaeology because of Howard Carter's discovery of the tomb of Tutankamun in the Valley of the Kings in 1922 and Leonard Woolley's excavation of Ur "of the Chaldees" in southern Mesopotamia from 1922 to 1934. As a result, American artists, designers, and architects would often integrate Egyptian and ancient Near Eastern motifs into their designs and buildings. A good example of the Assyrian style in architecture is the Sampson Tire and Rubber Co. building in Los Angeles, California; built in 1930, it was designed to look like an Assyrian palace.

29 An outstanding summary of the University of Pennsylvania Museum of Archaeology and Anthropology's many excavations in the Middle East (with great photographs!) is Alessandro Pezzati, *Adventures in Photography: Expeditions of the University of Pennsylvania Museum of Archaeology and Anthropology* (Philadelphia: University of Pennsylvania Museum of Archaeology and Anthropology, 2002).

30 For further information, see the Yale University Babylonian Collection website.

31 For further information, see the Morgan Library and Museum website.

32 For a history of the Jewish Museum, see Julie Miller and Richard Cohen, "A Collision of Cultures: The Jewish Museum and JTS, 1904–1971," in *Tradition Renewed: A History of the Jewish Theological Seminary*, edited by Jack Wertheimer (New York: Jewish Theological Seminary, 1997): 311–361, and Joan Rosenbaum, "The Jewish Museum and Its History," in *Masterworks of the Jewish Museum*, by Maurice Berger and Joan Rosenbaum (New Haven, CT: Yale University Press, 2004): 10–17.

33 A brief introduction to the history of the antiquities collection at the Jewish Museum is summarized in Andrew S. Ackerman and Susan L. Braunstein, *Israel in Antiquity: From David to Herod* (New York: The Jewish Museum, 1982): 12.

34 A marvelous and highly readable history of the Metropolitan Museum of Art (even after forty years!) is still Calvin Tompkins, *Merchants and Masterpieces: The Story of the Metropolitan Museum of Art* (New York: E. P. Dutton, 1970).

35 For a history of the ancient Near Eastern art collection at the Metropolitan Museum of Art at different times and from different perspectives, Charles K. Wilkinson, "The Art of the Ancient Near East," *Metropolitan Museum of Art Bulletin* 7(7) (1949): 186–198; Prudence O. Harper, "Department of Ancient Near Eastern Art, Metropolitan Museum of Art," in *Vorderasiatische Museen: Gestern, Heute, Morgen: Berlin, Paris, London, New York: Eine Standortbestimmung: Kolloquium aus Anlass des einhundertjährigen Bestehens des Vorderasiatischen Museums Berlin am 7. Mai 1999*, edited by Beate Salje (Mainz: Verlag Philipp von Zabern, 2001): 53–62; and Joan Aruz, "Archaeology and the Department of Ancient Near Eastern Art," *Metropolitan Museum of Art Bulletin* 68(1) (2010): 6–11.

36 For a superb history of the Museum of Fine Arts, Boston, see Walter Muir Whitehill, *Museum of Fine Arts, Boston: A Centennial History* (Cambridge, MA: Harvard University Press, 1970).

37 The ancient Near Eastern art collection is discussed in Whitehill, 283–286, and Edward L. B. Terrace, *The Art of the Ancient Near East in Museum of Fine Arts, Boston* (Boston: Museum of Fine Arts, 1962).

38 An outstanding history of the Detroit Institute of Arts is William H. Peck, *The Detroit Institute of Arts: A Brief History* (Detroit, MI: Detroit Institute of Arts, 1991).

39 For further information on the ancient Near Eastern art collection in Detroit, see William H. Peck, "The Arts of the Ancient Near East in Detroit," *Connoisseur* 183(737) (1973): 28–32.

40 For a history of the Cincinnati Art Museum, see Aaron Bestky, *Cincinnati Art Museum: Collection Highlights* (London: D. Giles, 2008). For a brief discussion of Nelson Glueck and Cincinnati's Nabataean collection, see Bestky, 230.

41 For further information, see Bestky, 274–275.

42 For a history of the Cleveland Museum of Art, see *Object Lessons: Cleveland Creates an Art Museum*, edited by Evan Turner (Cleveland, OH: Cleveland Museum of Art, 1991).

43 For an overview of the St. Louis Art Museum, see Brent Benjamin, "A Brief History of the Collection," in *Saint Louis Art Museum: Handbook of the Collection* (St. Louis, MO: Saint Louis Art Museum, 2004): 8–16.

44 For further information on the Egyptian and ancient Near Eastern art collections in St. Louis, see Sidney M. Goldstein, "Egyptian and Ancient Near Eastern Art," *The Saint Louis Art Museum Bulletin* 4 (Summer 1990).

45 Information on the ancient Near Eastern art collection at the Nelson-Atkins Museum of Art was provided by ancient art curator Robert Cohon. For a lively overview of some of the forgeries in their ancient art collection, including a fifth or sixth century CE Sasanian gilded silver disk, see Robert Cohon, *Discovery and Deceit: Archaeology and the Forger's Craft* (Kansas City: Nelson-Atkins Museum of Art, 1996).

46 For a fascinating study of Charles Lang Freer as an art collector, see Thomas Lawton and Linda Merrill, *Freer: A Legacy of Art* (Washington, DC: Smithsonian Institution, 1993).

47 Information on the ancient Near Eastern art collection at the Freer Gallery of Art was provided by ancient Near Eastern art curator Alex Nagel.

48 For a marvelous history of William and Henry Walters as collectors and the beginnings of the Walters Art Museum, see William R. Johnston, "From Private Collection to Public Museum," in *The Walters Art Gallery: Guide to the Collections* (London: Scala Books, 1997): 9–18, and especially William R. Johnston, *William and Henry Walters: The Reticent Collectors* (Baltimore, MD: The Johns Hopkins Press, 1999).

49 For further information on the ancient Near Eastern art collection at the Walters Art Museum, see Jeanny Vorys Canby, *The Ancient Near East in the Walters Art Gallery* (Baltimore, MD: Walters Art Gallery, 1974).

50 For further information on Dr. Richard Fuller and the history of the Seattle Art Museum, see Patterson Sims, "Introduction," in *Seattle Art Museum: Selected Works* (Seattle: Seattle Art Museum, 1991): 9–20.

51 Richard Fuller, "Director's Report," *Annual Report of the Seattle Art Museum* (1941): 7.

52 Fuller, 7.

53 For further information on the ancient Near Eastern art collection at the Seattle Art Museum, see John W. Clear, "The Ancient Near East," in *Near Eastern Civilizations Through Art*, by Jere L. Bacharach, John W. Clear, and Cynthia May Sheikholeslami (Seattle: Seattle Art Museum, 1977): 1–9.

54 An introduction to the history of the Brooklyn Museum is found in Linda S. Ferber, "A Brief History," in *Brooklyn Museum of Art* (London: Scala Books, 1997): 9–16.

55 For further information on Hagop Kevorkian's gift, see Robert H. Dyson, Jr., "A Gift of Nimrud Sculptures," *The Brooklyn Museum Bulletin* 17(3) (1957).

56 For further information on the ancient art collection at the Virginia Museum of Fine Arts, see Margaret Ellen Mayo, *Ancient Art in the Virginia Museum of Fine Arts* (Richmond: Virginia Museum of Fine Arts, 1982).

57 Edward W. Forbes, "The Relationship of the Art Museum to a University," *Proceedings of the American Association of Museums*, 5 (1911): 55.

58 For an introduction to the history of the Princeton University Art Museum, see "A Short History of the Princeton University Art Museum," in *Princeton University Art Museum: Handbook of the Collections* (Princeton, NJ: Princeton University Art Museum): x–xx.

59 The history of the ancient art collection, especially its early years, is discussed in J. Michael Padgett, "The Collections of Ancient Art: The Early Years," *Record of the Art Museum, Princeton University* 55(1–2) (1996): 107–124.

60 Information on the history of the University of Missouri Museum of Art and Archaeology and its ancient art collection was provided by director Alex Barker.

61 Information on the history of the Ackland Art Museum at the University of North Carolina at Chapel Hill and its ancient art collection was provided by collection curator Timothy Riggs.

62 For further information on the Pomerance collection, see *The Pomerance Collection of Ancient Art* (Brooklyn: The Brooklyn Museum, 1966).

63 For further information on the Schimmel collection, see *Ancient Art: The Norbert Schimmel Collection*, edited by Oscar White Muscarella (Mainz: Verlag Philipp Von Zabern, 1974).

64 Alastair and Edith Martin named their collection the Guennol Collection. Guennol means "martin" (a type of swallow) in Welsh, and Wales had a special meaning for the couple who spent their honeymoon there. For an overview of the Guennol Collection, see Diana Fane and Amy G. Poster, *The Guennol Collection: A Cabinet of Wonders* (Brooklyn: Brooklyn Museum of Art, 2000).

65 For further information on the ancient Near Eastern art collection at the Los Angeles County Museum of Art, see Ali Mousavi, *Ancient Near Eastern Art at the Los Angeles County Museum of Art* (Los Angeles: Los Angeles County Museum of Art, 2012).

66 A brief history of the Kimbell Art Museum is discussed in Timothy Potts, "Introduction," in *Kimbell Art Museum: Handbook of the Collection*, edited by Timothy Potts (Fort Worth, TX: Kimbell Art Museum, 2003): vii–xv

67 Information on Dr. Arthur M. Sackler was provided by Trudy S. Kawami, Director of Research at the Arthur M. Sackler Foundation in New York, and the foundation's website.

68 For a wonderful autobiography of Samuel Noah Kramer, see Samuel Noah Kramer, *In the World of Sumer: An Autobiography* (Detroit, MI: Wayne State University Press, 1988).

69 For further information, see the Chicago Assyrian Dictionary and Chicago Hittite Dictionary sections of the Oriental Institute of the University of Chicago's website.

70 For further information on recent excavations of the University of Pennsylvania Museum of Archaeology and Anthropology and the Oriental Institute of the University of Chicago, see Pezzati, 2–4, and the Oriental Institute of the University of Chicago's website.

71 For an overview of some other American excavations in the Middle East, especially in Israel and Jordan after World War II, see King, 111–274.

72 Secondary quote cited in Doğan, 12.

Part Two:
Breath of Heaven, Breath of Earth:
Ancient Near Eastern Art from
American Collections

The Divine Realm

(from top)
Figure 2.1. Irrigation canal with gardens, southern Iraq.

Figure 2.2. View from Hattuša (modern Boğazköy), the Hittite capital, central Turkey.

Figure 2.3. View of Alalakh (tree-covered mound) in the Orontes plain, Turkish-Syrian border.

Breath of Heaven, Breath of Earth: Ancient Near Eastern Art from American Collections

By Trudy S. Kawami

> "Enlil uttered 'Breath of Heaven,' 'Breath of Earth,'
> . . . vegetation, coming out of the earth, rises up"
>
> — The re-creation of the world after the flood,
> Sumerian Deluge Epic, ca. 2150 BCE, lines 251ff

Introduction: The Land

The land of the ancient Near East encompasses a rich and varied landscape, presenting a panorama with few neat boundaries. Its geographical features like rivers and mountain ranges do not necessarily conform to modern national borders, and often run through them (see map, pages 188–189). In this section of the book we will use old geographical terms for the various regions since they carry a lighter political burden than the nation-state labels of the twenty-first century, which can be a distraction. The central area of our concern is Mesopotamia, the land between the Tigris and Euphrates Rivers. It is a relatively flat, easily irrigated plain that rolls from Syria in the north to the subtropical marshes at the head of the Persian Gulf (fig. 2.1).

The area we refer to today as Mesopotamia roughly corresponds to modern Iraq. This once-fertile land is rich in clay, which was an important medium of early artistic expression. The Tigris and Euphrates Rivers themselves rise far to the north in the mountainous uplands of Anatolia, modern Turkey (fig. 2.2). In antiquity Anatolia produced many kinds of metallic ores that yielded gold, silver, electrum, copper, tin, and iron. It was also a source of lumber and wool.

To the south of Anatolia, the rocky rim of the eastern Mediterranean forms the western edge of Syria and the Levant, modern Lebanon, Israel, Gaza, the West Bank, and Jordan. This habitable environment includes mountains with cedar forests as well as pleasant valleys and fertile river plains (fig. 2.3). Parts of the region could easily be connected via coastal sailing, even reaching more distant cultures like Cyprus to the west and especially Egypt to the south. The

Figure 2.4. View to the east in Kurdistan, northeast Iraq.

Mediterranean Sea defines the western edge of the area we call the Levant, but its eastern edge is less precise. The open, rolling, and sometimes arid eastern portions of Syria and Jordan merge into the northern plains of Mesopotamia with no clear demarcation. In antiquity the important cities in this transitional region reflected a mixture of the cultures of Mesopotamia, Anatolia, and Egypt.

To the east of Mesopotamia a series of rocky ridges rise up like a wall, culminating in the Zagros Mountains, which form a distinct boundary between Mesopotamia and the Iranian plateau (fig. 2.4). These mountains, and their broad, verdant valleys (fig. 2.5), run somewhat to the southeast, so that the lowlands of southwestern Iran merge with no clear boundary into the plains and marshes of southern Mesopotamia. The land of the ancient Near East was as varied as the art that sprang from it and the people who produced that art.

The People

Many peoples populated the Near East in antiquity, but without records of their writing we cannot tell what languages the inhabitants spoke nor what they believed. It is only in the third millennium BCE, with the spread of cuneiform, a writing system using wedge-shaped marks on clay or stone, that we can begin to see the varied ethnic and linguistic groups across the

Figure 2.5. View from Bisotun, near Kermanshah, Iran.

region. Sumerians, whose distinctive language was related to no other, lived in southern Mesopotamia, but *toponyms*, the names of cities and places, suggest an older non-Sumerian population. People speaking and writing various Semitic languages like Akkadian, Eblaite, and Amorite, were scattered across Syria and the Levant and into northern Mesopotamia. Elamite, another language neither Semitic nor Indo-European, may have prevailed in the adjacent regions of southwestern Iran, but our understanding of their early writing system and the language it represented is still poor. The linguistic mix was such that Shulgi, a Sumerian king who ruled a good portion of Mesopotamia and southwestern Iran from about 2094 to 2047 BCE, claimed that he could speak five languages.[1]

By the second millennium BCE, when writing was commonly used in Anatolia, we can identify Indo-European–speaking newcomers like the Hittites, who spoke and wrote Luvian and related languages, as well as what seems to be a small group speaking and writing Hattic. Hurrians, who spoke a language possibly related to those of the Caucasus, are known in northern Mesopotamia. The Kassites, whose little-documented language is known only from personal names, stand alone as an isolated group that ruled for a time in the south. While the later language variants of Akkadian, Assyrian, and Babylonian became widespread across large areas, many scribes, along with merchants and officials, were bi- or trilingual. By the earlier years of the first millennium BCE, the Assyrian empire was using at least two Semitic languages, Standard Assyrian and Aramaic, which originated in Northern Syria, in its well-developed bureaucracy. The Assyrians could also communicate with those Luwian speakers living in Syria, the Urartians of eastern Anatolia with whom they fought, and speakers of various West Semitic dialects in

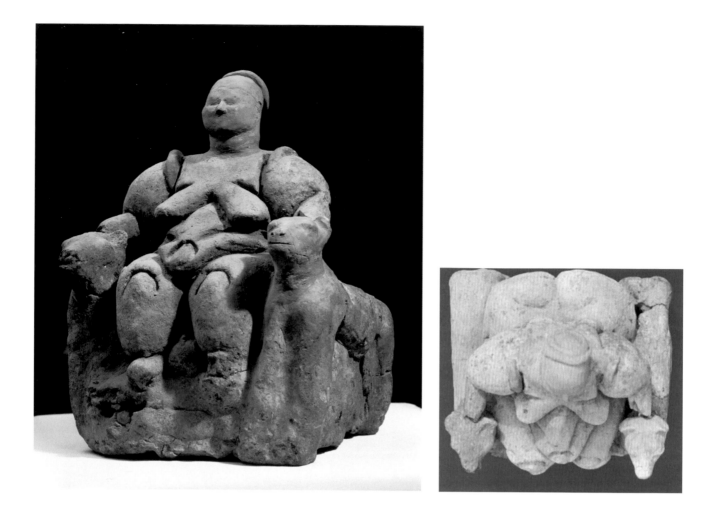

the Levant like Hebrew, Aramaic, Phoenician, and early Arabic. The Indo-European speaking Achaemenid Persians, military and political successors to the Assyrians, used Semitic Aramaic, Old Persian, and local Elamite in their official records. In addition to these ethnic and linguistic complexities, the basic lifeways of urban traders, rural farmers, and transient herders ranged across all ethnic and linguistic groups. The ancient Near East at any period was a rich blend of many varied peoples.

The Prologue: Neolithic Art

Art bloomed in the Neolithic Period (the New Stone Age, from the eighth through the sixth millennia BCE), although scattered earlier examples are known. Even before the ceramic arts were fully developed, societies formed in the Levant, Syria, and Anatolia that supported crafts-people who made clay, stone, and ivory sculptures displaying remarkable skill and beauty. Painting and even architecture existed as specialized skills. Small sculptures of clay like Plate 1, for instance, were produced in a wide variety of locations. But a few areas, even in this early period, seem to have had a more complex and sophisticated visual tradition. Çatal Hüyük in Anatolia² yielded a carefully formed clay sculpture of a woman (fig. 2.6a) apparently giving birth (note the tiny head emerging from between her legs), enthroned on a pair of large felines whose sinuous tails curve up her back and over the top of her shoulders like a support. The malleable plasticity of the clay reiterates the figure's abundant flesh, producing an evocative and

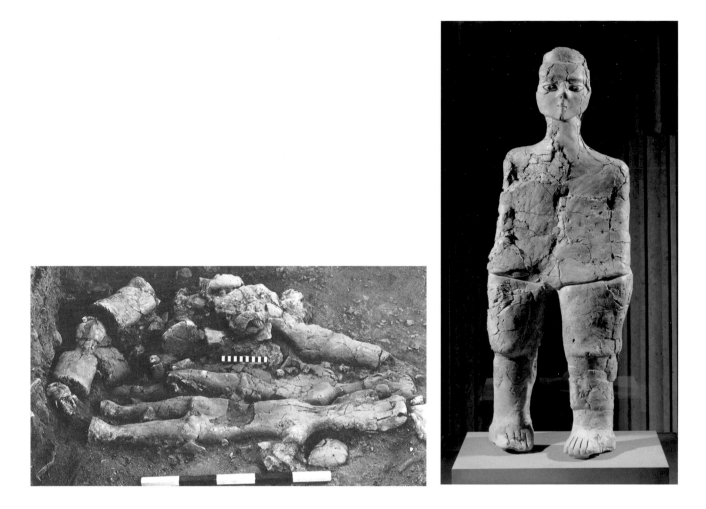

Figure 2.7a. Clay and gypsum figure over reed armature from 'Ain Ghazal, Jordan.

Figure 2.7b. Human figure; Jordan, from 'Ain Ghazal, Pre-Pottery Neolithic B Period, 7600–6000 BCE; clay and gypsum over reed armature; H: 41 5/16 in. (105 cm); Musée du Louvre, Paris, on loan from the Jordan Archaeological Museum, Amman.

tactile response. The symmetrical arrangement of the rounded shoulders, pendulous breasts, and plump thighs frames the belly, the source of life, while the formal elements are manipulated to keep the viewer's eye returning to the center of the figure, the focus of its meaning. The flat base and the vertical sides formed by the standing felines give the work a solid visual foundation, a formal throne for the fecund figure on it. When one views the piece from above (fig. 2.6b), the care the artist took to fully render the figure in three dimensions, and to arrange the component forms from large (the square base) to small (the figure's head) is evident. (The head was missing in the original but has been restored in the illustrations.) From this small but monumental sculpture will grow an iconographic tradition that will flower in the ancient Near East (see fig. 2.25) and eventually culminate in medieval Europe with depictions of the Madonna seated on a lion throne holding the Christ Child on her lap.

Sculptures were also made on a larger scale, formed of clay and gypsum plaster over armatures of bound reeds (figs. 2.7a, 2.7b). The most arresting examples, some almost life-size, were found in a deposit in the Neolithic sanctuary at 'Ain Ghazal, near Amman in modern Jordan, where they were probably interred after their ritual life was over.[3] These startling figures, with their small or absent arms and thick, heavy legs and feet, probably looked quite different when they were new. Set upright and clothed in robes, cloaks, and veils, their inlaid eyes animated with the flicker of oil lamps, they would have been dramatic embodiments of supernatural entities.

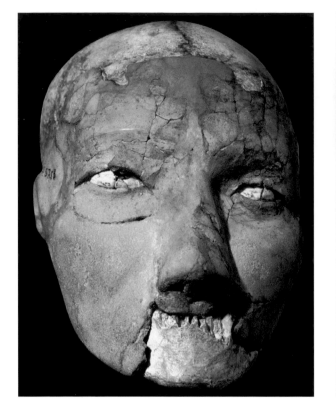
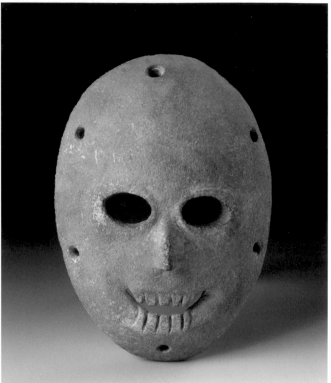

The desire to represent specific individuals, or to create what we now call portraiture, was also evident in the Neolithic Period, and sculptures that used a human skull as an armature are known from excavations throughout Neolithic Levant and Syria.[4] Enhanced well after death with clay, plaster, bitumen, and shell to recreate the face of the once-living person, each sculpture was sufficiently varied in its details to suggest that the artist wished to depict a specific person (fig. 2.8). Heads of this type have been excavated from residential settings, though not every household had one. We may suppose that the deceased so memorialized was an exceptional person, a figure of standing in the family, clan, or tribe.

In addition, stone was carved and sometimes painted to make masks of life-size human faces.[5] Once attached to figures of less permanent material, these have survived long after their perishable parts deteriorated (fig. 2.9). These clay, plaster, and stone works demonstrate the deep and continuous tradition of anthropomorphic representation in the Neolithic Period.

But human form was not the only subject matter in Neolithic art. Animal images were also produced in the region. Unlike the anthropomorphic forms that to us appear somewhat formal or abstracted, these animals demonstrate a distinct naturalism. Many of the animal sculptures are small and simple, but the best artisans were clearly capable of more ambitious work. The site of Tell Bouqras in Syria[6] has yielded marvelously naturalistic stone vessels, including one in the form of a hare (*Lepus capensis*, fig. 2.10) and even one in the shape of a hedgehog (*Paraechinus*)!

The arresting Neolithic site of Göbekli Tepe,[7] perched high on a ridge in southern Anatolia (see endpapers), stunned archaeologists with its large stone slabs, many ornamented with figural reliefs, set upright in circles. These large, enigmatic constructions (fig. 2.11) suggest that

Figure 2.8. Human skull with restored features; West Bank, from Jericho, Pre-Pottery Neolithic B Period, 7600–6000 BCE; bone, plaster, paint, and shell; life size; Jordan Archaeological Museum, Amman, J 5758.

Figure 2.9. Mask; Israel, from Hirbat Duma, Pre-Pottery Neolithic B Period, 7600–6000 BCE; stone; H: 8⅞ in. (22.5 cm); The Israel Museum, Jerusalem. 82.2.71.

Figure 2.10. Hare vessel; Syria, from Tell Bouqras, 6400–5900 BCE; alabaster; H: 3 ½ in. (9 cm), L: 6 ⅞ in. (17.5 cm); Dier-ez-Zor Museum, Syria, BJ100/2136.

Figure 2.11. Upright stone slab with animals in relief from Göbekli Tepe, Turkey.

Figure 2.12. Wall painting from Çatal Hüyük, Turkey.

this shrine or ritual site employed established groups of knowledgeable stoneworkers, and was somehow related to a society with the means to support them. As intriguing as these slabs are, we can only speculate as to their meaning. In the absence of writing we cannot be sure what the makers and patrons of such constructions thought about them. We can only marvel at what they created.

Paintings by their nature are more ephemeral than clay and stone. Nonetheless some Neolithic wall paintings have survived (fig. 2.12). The most extensive group of works comes from the site of Çatal Hüyük in Anatolia, where human as well as animal images were painted on the plastered walls of special houselike shrines (or shrinelike houses). The deer and bulls of Çatal Hüyük sometimes evoke Paleolithic (Old Stone Age) imagery much like that found in the caves of Europe. But what distinguishes them from cave art is that they were produced to decorate the built walls of clay and timber structures. Simply painted birds were discovered in two houses at Tell Bouqras[8] and human figures at Tel Halulu;[9] both are sites in Syria. Fragmentary wall paintings with angular elements from the somewhat later Teleilat Ghassul site in Israel[10] suggest that other more geometric painting traditions existed elsewhere.

The major art forms of architecture, painting, and sculpture in clay, plaster, ivory, and stone already had a long tradition in the Near East by the end of the Neolithic Period. In the subsequent millennia, the emergence of creativity, paralleling the growth of the population, shifted from the mountainous rims of Anatolia and the Levant to the flat plains of Mesopotamia. Here the development of large-scale irrigation gave rise to extensive agriculture, and, to judge from what has survived, the artistic impulses of this period focused on ceramics. Agriculture in turn supported extensive, complex, and hierarchical societies whose elite by the late fourth millennium BCE supported the production of art on a large scale.

The Divine Realm

Mesopotamia

While we can speculate that most anthropomorphic images of the Neolithic Period are divinities, by the early third millennium BCE in Mesopotamia we can be more certain of their identity. The development of writing and its use on long-lasting clay and stone has left an extensive body of information. We can observe that deities are usually shown as being larger in relation to other figures, and appear with specific attributes that distinguish them from mortal beings. Foremost among these attributes was the horned tiara or miter, featuring bovine horns. Early examples show the horns curving out sideways, but soon the artists began to wrap the horns around to the front of the head, the curving tips coming together at the forehead. This configuration became the identifying emblem of divinity for the next three thousand years. Higher ranking gods and goddesses had multiple tiers of horns, while lesser ones had only a single pair. Occasionally deities had wings, weapons, or sometimes rays of light springing from their shoulders, the latter being an artistic convention for *melammu*, the brilliant radiance that accompanies a deity.[11] It is common to find a specific attribute or weapon held in the deity's extended hand. Early divine images wore clothing that looks to us like the clothing worn by mortals. But human styles changed, while the clothing of the gods remained fairly stable. Long, full robes with horizontal rows of flounces or pleats that covered the entire body remained standard divine garb for over a thousand years.

Cult images were often made of precious materials and as such they were vulnerable to looting and "re-purposing." Metal, whether copper, bronze, silver, or gold, can be melted and reused, leaving no trace of its previous appearance. Thus most of the surviving divine images are small in scale or humble in material.

The peoples of the ancient Near East were well aware that the divine images they venerated were human creations dependent on the skill of the craftsman and the largess of the patron for their impact. At the same time they believed that it was divine inspiration that infused the art with its divine power. Essarhaddon, king of Assyria ca. 669 BCE, prayed to Marduk on the renewing of the divine statues of Babylon that had been damaged:

> The making of the images of gods and goddesses is your right, it is in your hands; so I beseech you create the gods, and in your exalted holy of holies may what you yourselves have in your heart be brought about in accordance with your unalterable word. Endow the skilled craftsmen who you ordered to complete this task with as high an understanding as Ea, their creator. Teach them skills by your exalted word; make all their handiwork succeed . . . [12]

The statues were then vivified through magical ceremonies like the *mīs pī*, "washing of the mouth."

Figure 2.13. Head of a woman, the so-called White Head; Iraq, from Uruk (modern Warka), Late Uruk Period, 3200–3000 BCE; marble; H: 8 ¼ in. (21 cm); Iraq Museum, Bagdad, IM 45434.

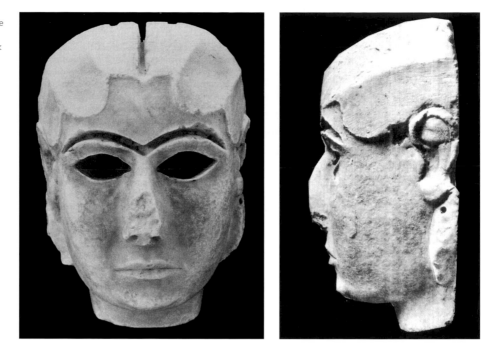

Goddesses are the most common divine images that have survived. The earliest goddess that we can identify is the one portrayed by the so-called White Head excavated at Uruk in southern Mesopotamia.[13] The life-size limestone head was found in the E-ana (House of Heaven) precinct, a walled complex that included large structures of presumably religious function or ownership. In its later phases, the complex was dedicated to the goddess Inana (Lady of Heaven), patron of love and fertility and daughter of the sky god Anu whose cult center was also at Uruk. Thus the White Head is assumed to be that of Inana.[14] The head originally had inlaid eyes and brows, perhaps earrings too, and quite likely a wig or other headgear fastened into the groove at the top of the head (fig. 2.13). The visual contrast between the formally symmetrical eyes and eyebrows and the sensitive modeling of the cheeks, lips, and chin engages the viewer with a combination of stern divinity and entrancingly human characteristics. The base of the neck is not broken but smoothly finished, and the back of the head is flat and has several diagonal holes used to fasten it onto another backing. The head was part of a life-size composite statue whose body, ultimately covered with clothing and jewelry, was probably of a perishable material like cedar wood.[15] The size, subtle modeling, and smooth finish of the stone clearly indicate that this was no novice work, but the product of a master sculptor working for a discerning patron. Unfortunately, while they must once have existed, no other examples of this caliber have been found.

Goddesses were not just lovers and nurturers, but also moderators, rulers, and protectors. They were numinous and powerful, and acted as guarantors of treaties and promises. Inana's identity metamorphosed over the centuries to fuse with the Semitic Ishtar, protector and patron of kings and the goddess of both love and war. Ishtar also encompassed aspects of both genders in her aspect of "warlike Ishtar," the only goddess with a weapon. She usually carried it in her hand but occasionally weapons would sprout from her shoulders as well. She wore a long tufted or pleated garment with a skirt whose central slit accommodated her forward-striding leg, usually placed on the back of a lion, her companion animal. In contrast to the stiff formality of most divine images, Ishtar is active and dynamic in posture.

Figure 2.14. Drawing of the wall painting on the south wall of Court 106, Palace of Zimrilim, Mari, Syria; the painting is currently in the collection of the Musée du Louvre, Paris.

Ishtar was a source of royal authority and as such was invoked by Zimrilim, king of Mari on the Euphrates in the eighteenth century BCE. The central panel of a large wall painting in his palace (fig. 2.14) shows Ishtar with one foot on her lion, a scimitar-like blade in her left hand, and maces rising from her shoulders. She extends the rod and ring of authority to Zimrilim with her right hand. King and deity are flanked by protective goddesses wearing flounced robes with alternating red and white stripes, their hands raised in gestures of praise or approval. The divinely authorized ruler is placed over a lower panel featuring water goddesses with flowing vases whose multistranded streams are enlivened with wriggling fish. The entire painting had additional framing elements, with green palm trees, protective griffons with striped wings, and even a blue bird.[16] With the fringed border at its lower edge, the whole scene appears as if it were a tapestry hanging on the wall. However, Zimrilim's claim to the throne was questionable at best,[17] and the illustration of divine approval may have been as much political as pious.

The mud plaster on which the scene was painted had slumped from the wall and was carefully pieced together by the excavators. The painting, now in the Louvre, is very difficult to reproduce because of its large size and damaged state. It serves to remind us of the many fragile paintings on plaster that once decorated temples and palaces that have been lost.

Divine statues could also be merely decorative. Zimrilim's palace at Mari featured a four-foot-high stone statue of a protective goddess holding a vase intended to release flowing water, not as an object of veneration but as a sculpture (fig. 2.15). The figure was pierced by a channel that allowed streams of water to flow from her vase, washing down the wavy tiers of her skirt, ornamented with subtly incised fish. The sculpture was a three-dimensional counterpart to the water goddesses in the lower portion of fig. 2.14. The body of the fountain sculpture was found in Room 64 of the palace, and her head was found in Court 106, so we are not certain where she was originally installed.[18] The Mari royal archives contain references to a famous courtyard (perhaps Court 106 with its painting), and explicitly to this sculpture. As Zimrilim wrote to an official named Mukannishum:

> About the protective spirit statue that was manufactured, this female statue
> turned out badly and its mountings are not secure. If ever this protective spirit is

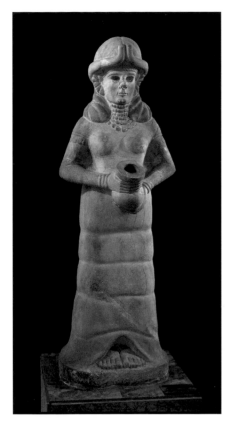

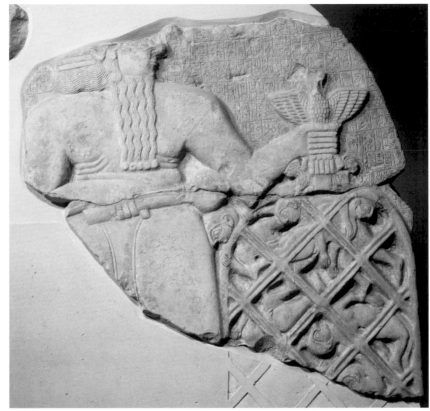

Figure 2.15. Fountain goddess; Syria, from the Palace of Zimrilim at Mari; 18th century BCE, alabaster; H: 55⅞ in. (141.9 cm); National Museum, Aleppo, 1659.

Figure 2.16. Victory stele of Eannatum, King of Lagash, called the "Vulture Stele" (obverse); Iraq, from Telloh, Late Early Dynastic Period, ca. 2450 BCE; limestone; Musée du Louvre, Paris, AO 50 and AO 2346.

put in place, the base of the mouth [of the pipe] will surely show up. I have seen it and became very upset. As soon as you hear this message of mine, your men should dismantle and reset the mounting of this statue as well as the tubing . . . [19]

Inexpensive divine images were made from clay. Larger ones, like Plate 7, were probably made for special installations, but the smaller ones like Plate 6 were mass-produced from molds and seem to have been readily available. The use of these clay images undoubtedly reflects levels of popular belief and practice now lost to us.

Male deities were sources of authority as well as of actual help in battle. The god Ningirsu on the so-called Vulture Stele (its name comes from a small fragment showing vultures picking at human heads) is identifiable because of the inscription that fills the background of the relief, which describes a battle between the city-states of Lagash and Umma in a boundary dispute ca. 2400–2350 BCE (fig. 2.16). Ningirsu wore a horned miter, shown on a now-missing part of the stele; the other surviving figures on this side of the relief wore them as well. Ningirsu's large size and corpulent physique confirm his divine status, though his naked torso is unusual. The inscription describes Ningirsu throwing his great battle net to capture the enemy of his devotee, Eannatum. Its visual counterpart shows him hoisting his net of prisoners with his left hand while with his right he bashes the protruding head of a writhing prisoner with his mace. Words and picture neatly complement each other.

By the early second millennium BCE, when the stele of king Hammurabi of Babylon was carved, gods were more sedate in their actions. The divinity to the right is the sun god

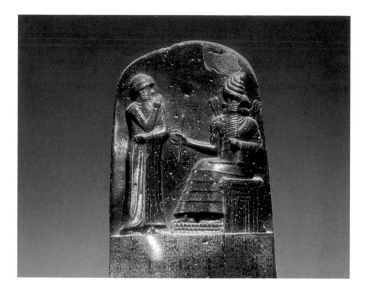

Figure 2.17. Stele of Hammurabi (detail); Iraq, from Susa, Iran, Old Babylonian Period, reign of Hammurabi, 1792–1750 BCE; basalt; Musée du Louvre, Paris, Sb 8.

Shamash, enthroned like a king atop a temple facade, while his footstool is covered with mountain patterns. Both Shamash and Hammurabi are similar in size; only the horned miter, the rays of light rising from the shoulders, and the flounced robe distinguish the god from the king (fig. 2.17). With only a few changes of attributes, the scene could show a petitioner approaching a ruler. Visually, the royal court and divine court appear interchangeable. The Hammurabi relief, however, is not just a statement of piety, but of divine support for the king. The lower three-quarters of the stele are covered with Hammurabi's famed "code of law," endorsed by Shamash, who as the sun god saw all that happened and hence was the god of justice. Like the painting in Zimrilim's palace, which was probably damaged in an attack by Hammurabi's troops, the relief is as much about the divinely ordained ruler as it is about his divine patron. At least five copies of the Hammurabi stele were erected in various cities of Mesopotamia during his reign.[20] The king was determined to see that his message of heaven-approved rule was spread as widely as possible, even to those who could not read the laws themselves.

While almost all male deities were anthropomorphic, that is to say totally human in appearance, a few exceptions have been found. The most unusual is the serpent-bodied god whose coiled tail formed his seat. This unusual god appeared rather abruptly during the period of Akkadian rule, about 2250 BCE. Popular on the cylinder seals used on clay documents (Plate 3) where he received worshippers like an enthroned ruler, the serpent-bodied god was depicted more frequently in Iran (see figs. 2.29 and 3.15). The Akkadians were a Semitic-speaking people who otherwise appear to have had no connection to Iran. The founder of the dynasty, Sargon of Akkad, served under a Sumerian ruler before overthrowing the old king and building his own empire. If we are to believe the stele of Naram-Sin, Sargon's grandson (see fig. 3.4), the Akkadians were hostile to the people of the Zagros. Akkadian acceptance of this unusual deity, whose name we do not know, suggests that currents of political control and religious belief could run in different channels.

Some supernatural figures were not deities in the formal sense, but were regarded as personifications of power or protection. The Assyrian human-headed winged bull, called a *lamassu*, functioned as a supernatural gate guardian and was a popular element in royal palace architecture

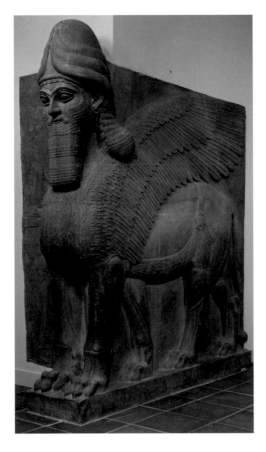

Figure 2.18. Bearded, winged, human-headed lion figure; Iraq, from the Northwest Palace of Ashurnasirpal II at Nimrud, Neo-Assyrian Period, reign of Ashurnasirpal II, ca. 883–859 BCE; gypseous alabaster; H: 123 ½ in. (313.7 cm); Metropolitan Museum of Art, gift of John D. Rockefeller, Jr., 1932, 32.143.2.

for two hundred years (see figs. 1.20 and 2.18). A hybrid descendant, at some remove, of the Egyptian sphinx, the *lamassu* was often given a face like the king's. It had five legs so that when viewed from the front, as one approached the gate, it stood firmly planted, and when viewed from the side as one walked past it appeared active, moving forward to ward off evil. Other protective spirits, or *shedu*, are identified by wings and occasionally by a raptor's head or legs. The cylinder seal in Plate 12 combines both the winged *shedu* and the *lamassu* to provide protection for the seal's owner. Other heroicized figures appear completely mortal, like the monster-hero Humbaba (Plate 11). We do not know why Humbaba, a negative figure in the literary tradition, was popular in the humbler arts. Perhaps these images may be echoes of popular beliefs and cults that did not find their way into the more formal records of the time.

Syria and the Levant

The naturalistic anthropomorphic tradition of divine representation so vigorously pursued in Mesopotamia was less strong in Syria and the Levant, where a preference for more aniconic representations—that were more abstract or geometric—asserted itself from time to time. At ancient Nagar (modern Tell Brak) in northern Syria more than three hundred so-called "eye-idols" (Plate 13) were excavated from the platform of a temple structure that was roughly contemporaneous with the E-ana precinct in Uruk.[21] The so-called Gray Eye Temple, given that name because of its gray bricks, also yielded beads, stamp and cylinder seals, and other small stone items. The huge deposit may have been the result of a rebuilding campaign in which all the old offerings were sealed in one votive deposit. Related "spectacle" idols, with open loops

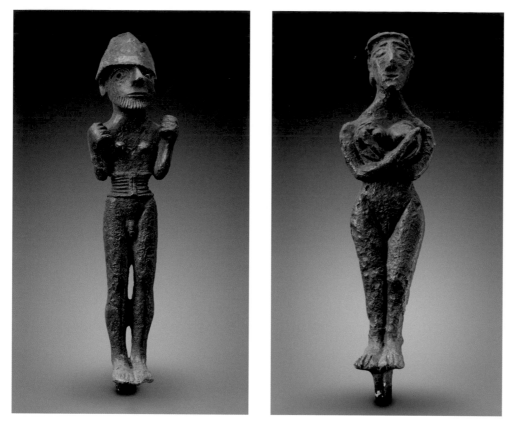

Figure 2.19a. Standing male figure; Syria, excavated from Tell Judeideh, 3200–2800 BCE; low-tin bronze with silver; H: 7 in. (17.8 cm); Museum of Fine Arts, Boston, gift of the Marriner Memorial Syrian Expedition, 49.118.

Figure 2.19b. Standing female figure, Syria, excavated from Tell Judeideh, 3200–2800 BCE, low-tin bronze with silver; H: 7 ½ in. (19.1 cm); Museum of Fine Arts, Boston, gift of the Marriner Memorial Syrian Expedition, 49.119.

where the eyes would be, are less numerous but are more widely distributed, with at least one example excavated at Susa in southwestern Iran.[22] The simplified forms of these small pieces recall the general appearance of the much earlier 'Ain Ghazal figures (figs. 2.7a, 2.7b) and suggest the continuity of some religious beliefs or practices.

Divine images in third millennium BCE Syria are anthropomorphic, but they rarely have the tactile corporeality of the Mesopotamian sculptures. Two caches of bronze figures, one from Tell Judeideh near the Turkish border[23] and the other from the mountainous region of Jezzine in south-central Lebanon (Plate 14), provide many examples of divine figures typically found in this region. In contrast to Mesopotamia, divine figures in Syria and the Levant are often nude, although it may be possible that they were dressed with real cloth garments. Both gods and goddesses stand rigidly with arms either crossed or upraised, presumably holding identifying attributes. Their forms retain a flat linearity when viewed from the side, and the heads are particularly angular, with thin lips, sharp chins, and prominent noses. Secondary details like hair are often rendered as abstract patterns (figs. 2.19a, 2.19b). Originally the figure in fig. 2.19a would have looked more imposing. During burial, the pressure of the earth pushed his silver helmet partly over his face. It then corroded in place and cannot be removed without further damage. There were six figures in the Tell Judeideh hoard, no two exactly alike. It is clear that they were produced individually and possibly even by different workshops. Similarly simplified nude deities, frequently but not always female, have been excavated from Mari in Syria,[24] Alaça Hüyük,[25] Horoztepe and Hasanoğlan in Anatolia,[26] and even Tell Agrab in Mesopotamia.[27] Recent research suggests that some of the Tell Judeideh figurines may date somewhat

Figure 2.20. Limestone cult basin from the entrance to Reshep Temple at Ebla, Syria, ca. 1850 BCE.

Figure 2.21. Stele of a weather god; Syria, from the acropolis at Ugarit (modern Ras Shamra), 14th–12th century BCE; limestone; H: 55 ⅞ in. (142 cm); Musée du Louvre, Paris, AO 15775.

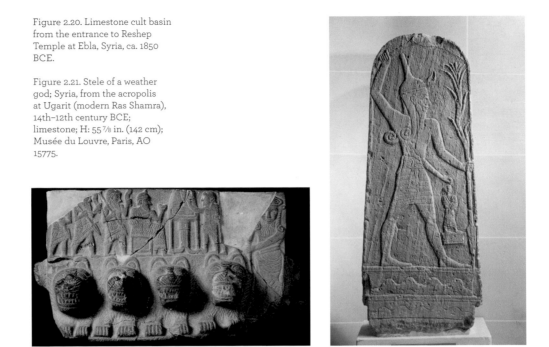

earlier than previously thought. From what is known, we can tell that cult practices in the third millennium BCE in the Levant did not center on large building complexes, and so we do not have an architectural context and its potential chronology to go with these small metal figures.

The preference for a less naturalistic style continued into the second millennium. Carved basalt cult basins from Ebla in northern Syria featured flat surfaces, angular forms, and linear patterns. The geometric formalism of the Ebla reliefs is in stark contrast to the soft naturalism of the Mari fountain goddess (fig. 2.15), although they are contemporaries. The basin found at the entrance to Temple B1, now identified as the Temple of Reshep, a deity of the Underworld, offers a prime example of this geometric style (fig. 2.20). The cubic lion heads, with their cartoon-like triangular ears and square paws, form a solid base for the cult scene above, a food offering ceremony rendered in geometricized low relief. The figures are patterned and repetitious with little volume or mass, and nothing indicates whether the scene shown is a specific one or a stylized reference.

By the middle of the second millennium BCE, the cultural influences of Egypt, whose prestige and power in the Levant were at their peak, could be seen in the divine images. The depiction of deities became more naturalistic, as they were rendered with supple and elegant lines. Proportions were also more realistic, posture more natural, and the musculature of the arms and legs was more skillfully shown. The stele of the storm or weather god from ancient Ugarit (modern Ras Shamra)[28] is a good example of this adaptation. The Egyptian image of the active pharaoh became in the Levant the model for a deity. The tall, pointed headgear of the god is based on the White Crown of the Egyptian pharaoh, and the deity's pose replicates the stereotypical image of the Pharaoh smiting his enemies. The raised right hand of the Ugarit god holds a thunderbolt instead of a mace, while the lowered left hand grasps a spear whose upper end sprouts leaves—an elegant reference to rain and the fertile earth (fig. 2.21). Like any weather god, Baal, the god from Ugarit, treads on mountains, symbolized by the wavy lines in the

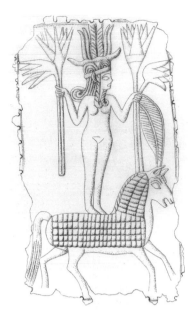

Figure 2.22. Drawing by Florica Vainer of a gold plaque of a naked goddess on horseback, from a 13th century BCE Canaanite temple at Lachish, Israel; the plaque is currently in the collection of the Israel Museum, Jerusalem.

register below his feet, which may be the mountains of the Mediterranean coast to judge from the fine, wavelike undulations in the register below the mountains. Some divine statuettes, like a small bronze from Ugarit, duplicated Egyptian pharaonic dress as well.[29] Another image of the smiting god appears in miniature on the cylinder seal in Plate 16, where the cuneiform inscription identifies him as Haddad, the weather god.

Egyptian influence is also seen in images of slender, youthful goddesses who often remain nude. The now badly wrinkled sheet-gold image from Lachish shows a slender nude frontal female figure with her head in profile (another Egyptian convention); she is wearing Egyptian-style plumed or feathered headgear. Standing with great aplomb on the back of a prancing horse she holds the stalks and blooms of lotus flowers in each hand, another characteristically Egyptian gesture (fig. 2.22). Despite her Egyptian style, however, she is Near Eastern in that she is borne by her animal attribute, the horse. Most likely she is Astarte, a Semitic goddess frequently associated with horses, as the horse arrived in Egypt relatively late and never entered into Egyptian religious imagery. Another portrayal of this goddess (Plate 17) shows her riding astride, something never shown for an Egyptian goddess or god.[30]

The preference for a simple standing female image may have been expressed in the pillar figures and related ceramic forms that were popular from the third millennium through the second millennium BCE (Plates 15 and 18). Probably reflecting popular practices and beliefs, these humble works may be simple versions of the earlier metal images. Through them we catch a glimpse of popular or vernacular religious art.

Anatolia

Early images of divinities in Anatolia are difficult to identify as written records begin only in the second millennium BCE. While the enthroned female familiar from Neolithic Çatal Hüyük (figs. 2.6a, 2.6b) may be assumed to be divine, we cannot be sure that every female figure should be similarly identified. In Anatolia, abstract stone forms, some with one arrowlike

Figure 2.23. Idol; Turkey, from the citadel at Kultepe, ca. 2200 BCE; stone; H: 6⅞ in. (17.5 cm); Museum of Anatolian Civilizations, Ankara, 24957.

Figure 2.24. Drawing of the "Divine Wedding," back wall from chamber A at Yazýlýkaya, Turkey, 13th century BCE.

head, others with two, were found in graves and have been considered to be images, or at least tokens, of the divine. A two-headed stone figure (fig. 2.23) from a grave at ancient Kanesh (modern Kultepe)[31] evokes the earlier "eye-idols" of Nagar and even the starkly realistic inlaid eyes of the Neolithic 'Ain Ghazal statues. One of the Ghazal sculptures also had two heads, and some of the Nagar eye-idols have one head carved atop another, or a second smaller figure carved in relief on the body. The Anatolian examples can thus be seen as a regional variation of the aniconic impulses seen in Syria and the Levant.

The Hittite empire, the paramount power in Anatolia in the mid-second millennium BCE, resulted in a pronounced turn to anthropomorphism in local representations of divinities, with gods and goddesses clearly identified as such. The "divine marriage" scene (fig. 2.24) carved into the back cliff of Chamber A at Yazýlýkaya, near Hattuša, the capital, in modern-day Turkey, depicts the culmination of a complex visual program in which a procession of male deities on the left and female deities on the right, carved on the sides of the canyon, meet to witness the union of the weather god and the sun goddess.

The deities are clearly identified by Luwian hieroglyphs held above their outstretched hands.[32] The weather god at the upper left wears a tall pointed hat and carries a mace, while standing on the backs of two bearded males whose scaly skirts and pointed hats identify them as personified mountains. The sun goddess stands on the back of a large cat, recalling the feline supports of the Çatal Hüyük goddess (figs. 2.6a, 2.6b). The goddess is followed by her son, armed with a sword and shouldering a battle axe, and who guides his cat with a leash. Behind him are twin goddesses supported by a single double-headed eagle. One wonders if these twins are a later naturalistic version of the double-headed "idol" from Kultepe (fig. 2.23) made hundreds of years earlier. However, this Yazýlýkaya relief is more that an expression of piety, because it also makes a veiled reference to the lofty status of the royal family that commissioned it. The entire series of works was carved during the reign of Tudhaliya IV (ruled ca. 1237–1209 BCE), whose mother Puduhepat was the chief priestess of the sun goddess and a political power in her own right. She corresponded with Nefertari, chief wife of Rameses II of Egypt, married off Tudhaliya's sister to the Egyptian court, and used the title "goddess-queen" after the death of

Figure 2.25. Seated goddess with a child; Turkey, Hittite, 14th–13th century BCE; gold; H: 1 11/16 in. (4.3 cm); Metropolitan Museum of Art, gift of Norbert Schimmel Trust, 1989, 1989.281.12.

Figure 2.26. Wall painting of the Urartian god Haldi from Erebuni, Armenia, 8th–7th century BCE.

her husband Hattushili III. One can read the relief as an apotheosis of the royal family, with the Queen Mother in place of the goddess and the ruling king as the divine son. Since the father, Hattushili, came to the throne via internal strife and bloodshed, the relief may have been an attempt to reinforce the family's legitimacy with religious imagery.

The importance of divine authority from the female is a persistent theme in the ancient Near East. The best-known examples from Anatolia, whether Neolithic (figs. 2.6a, 2.6b) or Hittite, show enthroned or seated females generating life or carrying children. One inscribed seal from Urkesh (modern Mozan) in Syria shows a child seated on the queen-mother's lap, and a related scene was carved on a seal from the Royal Cemetery at Ur in Mesopotamia.[33] Other examples show a ruler seated on a goddess's lap to emphasize that the ruler had been divinely selected and nurtured.[34] A Hittite gold pendant, now in the Metropolitan Museum of Art in New York, shows a plump woman on a throne with feline feet presenting a child who is sitting frontally on her lap (fig. 2.25). Another gold pendant from the Hittite capital of Hattuša shows a seated woman with a swaddled baby in her arms.[35] Because they have no inscriptions, we cannot tell whether these are divine children or perhaps divinely nurtured royal figures.

No divine mother and child images are known from the Urartians, successors to the Hittites in eastern Anatolia in the early first millennium BCE. The Urartians depicted their deities, usually carried by their animal attribute, as standing formally in profile (fig. 2.26). The major state deity Haldi, a war god, stands on a lion as if supplanting the Hittite sun goddess and Akkadian Ishtar, both of whom claimed lion companions. The stiff stance of the god and his angular gestures, as well as the measured pace of his lion, emphasize repetitive formality, a characteristic of Urartian art.

Iran

The earliest divine, or at least supernatural, images from Iran have animal, not human, shapes. Yet unlike Mesopotamian animals, the Iranian creatures have fully human postures, standing on

Figure 2.27. Standing lioness; Iran, Proto-Elamite Period, 3000–2800 BCE; limestone; H: 3½ in. (8.9 cm); formerly in the Guennol Collection (present location unknown).

Figure 2.28. Statue of the goddess Narunde; Iran, from Susa, late 3rd millennium BCE; limestone; H: 42 15/16 in. (109 cm); Musée du Louvre, Paris, Sb 54 (body), Sb 6617 (head).

two legs and using their forelegs like arms and hands. This mixing of human and animal forms is most pronounced around 3000 BCE, with both lions and bulls depicted in this manner. The most dramatic example of these images is the stone lioness once in the Guennol Collection.[36]

Its unusual blend of feline forms and human posture is so thoroughly submerged beneath a surface naturalism that the viewer does not question the basic illogic of the image (fig. 2.27). In contrast to most ancient art of the time, which offers clear fronts, sides, and backs, there is no single view. The dynamism of the twisting shapes and the sleek finish of the ivory-colored stone surface induce the viewer to look at the small sculpture from all sides. Seal impressions from Susa in southwestern Iran[37] provide additional examples of this dynamic entity striding through triangular mountains. The power of this numinous figure—whether for good or for ill one cannot say—is clear, but its actual identity remains unknown.

By the late third millennium BCE, southwestern Iran came under the political and military influence of Mesopotamia. The statue of the goddess Narunde from Susa (fig. 2.28) reveals the strong influence of Mesopotamia art, as the goddess is shown—like any Mesopotamian goddess—wearing horned headgear and a long flounced robe while seated on a throne-like stool, whose seat shows lions on the back and sides as well as beneath her feet on the front. Only her name, cut in linear Elamite on the right edge of the throne, reveals her Iranian identity. Her eyes were once inlaid, and the row of five holes along the edges of her ears suggest she wore multiple earrings, perhaps another Iranian characteristic.

Along with these Mesopotamian influences, the tradition of animal-shaped (theriomorphic) divine images continued in Iran. The rock relief at Kurangun, carved late in the third or early second millennium BCE (fig. 2.29), shows a pair of deities, male and female, wearing headgear whose horns extend out to the side. Seated on coiled serpents, each god holds the head of the snake as if it were a scepter. The worshippers on both sides pour what seem to be streams of water that arc over the enthroned gods, while the base of the relief has a carved band of water

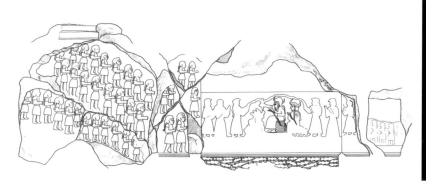

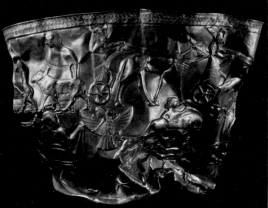

teeming with fish. These deities must have been widely venerated, for variations of this scene appear on seal impressions of the same date from Susa.[38]

A crushed gold bowl from Hasanlu, a besieged city in northwestern Iran that was conquered sometime after 800 BCE (see fig. 1.32), shows us a whole pantheon of gods, goddesses, and what may be mythic heroes in two rows worked in repoussé around the vessel (fig. 2.30). On the upper row, two deities with horned or winged headgear drive chariots pulled by mules following a winged deity with a whip in another chariot. A clothed goddess with a mirror rides sidesaddle on a lion, while a nude goddess stands in a frontal pose on a pair of rams, spreading her cloak wide to reveal her naked body.[39] Other figures like the warrior with his bow, arrow, and quiver, or the bearded figure with clenched fists emerging from a mountain on the back of a crouching lion, may refer to belief systems, myths, or epics now lost to us. Given the scarcity of written documents from this region, we know little about the beliefs of the people who made or used this bowl, or who in fact inhabited the region.

The Achaemenid Persians, who controlled western Iran, Mesopotamia, Anatolia, the Levant, and parts of northern Egypt by the late sixth century BCE, followed a very different belief system that did not require divine images. This distinction impressed the fifth-century BCE Greek historian Herodotus, who wrote, "It is not their custom to make and set up statues and temples and altars."[40]

For this reason, while we know the names of the major deities the Achaemenid Persians revered in their form of Zoroastrianism, or more accurately Mazda-worship, it is difficult to match deities to images. We have only a relatively few images of offering scenes, including a stylized motif of a sometimes winged crescent that encloses a male torso, and what appear to be fire altars on some cylinder seals.[41] Hence, we have few explicitly divine figures that can be dated with certainty to the Achaemenid Period (550–330 BCE). To conclude, we can say that although the basic tradition of the cultures of the ancient Near East was to show the divine in human form, a preference for non-iconic representation was clearly a continuing minor theme.

Figure 2.29. Drawing of rock relief with seated deities, from Kurangun gorge, Mamasani region, Fars province, Iran, late 3rd–early 2nd millennium BCE.

Figure 2.30. Crushed bowl; Iran, from Burned Building I-West at Hasanlu, 10th–9th century BCE; gold; H: 8 in. (20.3 cm); Iran Bastan Museum, Tehran, 15712.

NOTES

1 Shulgi B: lines 206–220, in the Electronic Text Corpus of Sumerian Literature [ETCSL], at http://etcsl.orinst.ox.ac.uk/edition2/general.php (accessed 5-24-13).

2 U. Bahadir Alkim, *Anatolia I: From the Beginnings to the End of the 2nd Millennium*, trans. James Hogarth (Cleveland, OH: World Publishing, 1968), plates 7–9, and 51–65; David Oates and Joan Oates, *The Rise of Civilization* (New York: Dutton, 1976), 5–25.

3 Peter M. M. G. Akkermans and Glenn M. Schwartz, *The Archaeology of Syria: From Complex Hunter-Gatherers to Early Urban Societies (c. 16,000–300 BC)* (Cambridge, UK: Cambridge University Press, 2003), 86.

4 Akkermans and Schwartz, *Archaeology of Syria*, 90–97.

5 Amnon Ben-Tor, ed., *The Archaeology of Ancient Israel*, trans R. Greenberg (New Haven, CT: Yale University Press, 1992), 30–31; Metropolitan Museum of Art, *Treasures of the Holy Land: Ancient Art from the Israel Museum* (New York: Metropolitan Museum of Art; Jerusalem: Muze'on Yiśa'el, 1986), 46–49.

6 Harvey Weiss, ed., *Ebla to Damascus: Art and Archaeology of Ancient Syria: An Exhibition from the Directorate-General of Antiquities and Museums, Syrian Arab Republic* (Washington, DC: Smithsonian Institution Exhibition Traveling Service, 1985), cat. nos. 8, 60–63, 69, and color plate 1; Akkermans and Schwartz, *Archaeology of Syria*, 114–115.

7 Akkermans and Schwartz, *Archaeology of Syria*, 87. See also www.gobeklitepe.info/ (accessed 5-21-13).

8 Weiss, *Ebla to Damascus*, 63.

9 Akkermans and Schwartz, *Archaeology of Syria*, 63–64.

10 Ben-Tor, *Archaeology of Ancient Israel*, 71–72.

11 A. Leo Oppenheim, "Akkadian pul(u)t(t)u and melammu," *Journal of the American Oriental Society* 63(1) (1943): 31–34.

12 Christopher Walker and Michael B. Dick, "The Induction of the Cult Image in Ancient Mesopotamia: The Mesopotamian *mīs pî* Ritual," in Michael B. Dick, ed., *Born in Heaven, Made on Earth: The Making of the Cult Image in the Ancient Near East* (Winona Lake, IN: Eisenbrauns, 1999), 64–65.

13 Matthew Bogdanos, in "The Casualties of War: The Truth About the Iraq Museum," *American Journal of Archaeology* 109, no.3 (July 2005), at page 478, gives one view of the looting of this head, which he calls "the Mask of Warka" (Warka is the modern name of Uruk). But he does not recount how it was returned to the Iraq Museum. For its return see William Harms, "Iraq's Treasured Lady of Warka Returns Home," *San Francisco Chronicle* (May 20, 2013) at www.sfgate.com/news/article/Iraq-s-treasured-Lady-of-Warka-returns-home-2555941.php (accessed 5-20-2013). As of May 2013, the Iraq Museum is not yet open to the general public.

14 Joan Aruz, with Ronald Wallenfels, eds., *The Art of the First Cities: The Third Millennium BC from the Mediterranean to the Indus* (New York: Metropolitan Museum of Art; New Haven, CT: Yale University Press, 2003), 25–26.

15 We have written evidence for composite cult statues from the later third millennium BCE. See Jean M. Evans, *The Lives of Sumerian Sculpture: An Archaeology of the Early Dynastic Temple* (Cambridge, UK: Cambridge University Press, 2012), 98.

16 For the mural and additional details, see www.louvre.fr/en/moteur-de-recherche-oeuvres?f_search_art=AO+19826 (accessed 5-28-13).

17 D. Charpin and J.-M. Durand, "La prise du pouvoir par Zimri-Lim," *Mari, Annales de Recherches Interdisciplinnaires* 4 (1985): 336–338.

18 Marie-Henriette Gates, "Artisans and Art in Old Babylonian Mari," in *Investigating Artistic Environments in the Ancient Near East* (Washington, DC: Arthur M. Sackler Gallery, Smithsonian Institution, 1990), 33; Yasin Al-Khalesi, *The Court of the Palms: A Functional Interpretation of the Mari Palace* (Malibu, CA: Udena Publications, 1978). Bibliotheca Mesopotamica 8.

19 See Gates, "Old Babylonian Mari," 33.

20 Piotr Michalowski, "Early Mesopotamian Communicative Systems: Art, Literature and Writing," in Ann C. Gunter, *Investigating Artistic Environments in the Ancient Near East* (Washington, DC: Arthur M. Sackler Gallery, Smithsonian Institution, 1990), 62.

21 Aruz and Wallenfels, *Art of the First Cities*, 19–20.

22 Jacques Connan and Odile Deschesne, *Le bitume à Suse: Collection du Musée du Louvre* (Paris: Reunion des musées nationaux, 1996): nos. 136, 137, at pages 204–205, and color figure 9.

23 Ora Negbi, *Canaanite Gods in Metal: An Archaeological Study of Ancient Syro-Palestinian Figurines* (Tel Aviv: Tel Aviv University, Institute of Archaeology, 1976), nos. 71–73, 1550–1552, pp. 15–16, and plates 10, 61. For a date much earlier in the third millennium, see Aslihan Yener, "Strategic Industries and Tin in the Ancient Near East" *Tüba-Ar* 12 (2009): 145. See also Elizabeth S. Friedman, et al., "Archaeology at the APS: Illuminating the Past," *Advanced Photon Source Research* 2(1) (1999): 12–16, for analysis of the metal at the Argonne National Laboratory in Lemont, IL.

24 Aruz and Wallenfels, *Art of the First Cities*, 142.

25 Aruz and Wallenfels, *Art of the First Cities*, 279.

26 Hans J. Nissen, Elisabeth Lutzeier, and Kenneth J. Northcott, *The Early History of the Ancient Near East: 9000–2000 B.C.* (Chicago: University of Chicago Press, 1988), 183, figure 69.

27 Evans, *Lives of Sumerian Sculpture*, 168, figure 58.

28 Marguerite Yon, *The City of Ugarit at Tell Ras Shamra* (Winona Lake, IN: Eisenbrauns, 2006), 134–135.

29 Yon, *City of Ugarit*, no. 15, 132–133.

30 Patrick F. Houlihan, *The Animal World of the Pharaohs* (London: Thames & Hudson, 1996), 33–37.

31 Alkim, *Anatolia I*, plate 70, 125–126; Aruz and Wallenfels, *Art of the First Cities*, 274–276.

32 For more on the rock sanctuary of Yazýlýkaya (rock with writing) see www.hattuscha.de/English/yazilikaya.htm (accessed 5-23-13).

33 Stephanie L. Budin, *Images of Woman and Child from the Bronze Age: Reconsidering Fertility, Maternity, and Gender in the Ancient World* (New York: Cambridge University Press, 2011), 185–187.

34 Budin, *Woman and Child*, 189–192.

35 Alkim, *Anatolia I*, plate 134.

36 Aruz and Wallenfels, *Art of the First Cities*, no. 14, 44–45.

37 Joan Aruz, "Power and Protection: A Little Proto-Elamite Silver Bull Pendant," in Donald P. Hansen and Erica Ehrenberg, *Leaving No Stones Unturned: Essays on the Ancient Near East and Egypt in Honor of Donald P. Hansen* (Winona Lake, IN: Eisenbrauns, 2002), 6–13.

38 Daniel T. Potts, *The Archaeology of Elam: Formation and Transformation of an Ancient Iranian State* (New York: Cambridge University Press, 1999), 183–186; Prudence O. Harper, Joan Aruz, and Françoise Tallon, *The Royal City of Susa: Ancient Near Eastern Treasures in the Louvre* (New York: Metropolitan Museum of Art, 1992), 111–112.

39 Stephan Kroll, "Urartu and Hasanlu" *Aramazd* 5, pt. 2 (2000): 21–35; Oscar Muscarella, "The Excavation of Hasanlu: An Archaeological Evaluation," *Bulletin of the American Schools of Oriental Research* 342 (2006): 69–94.

40 Alfred Denis Godley, trans., *Herodotus*, Book I (London: William Heinemann, 1948), line 131: 171.

41 John E. Curtis and Nigel Tallis, eds., *Forgotten Empire: The World of Ancient Persia* (Berkeley, CA: University of California Press, 2005), 150–160.

PLATE 1

Fertility figure

Iraq, Halaf Period, 6100–5400 BCE; clay with slip; H: 4 ⅛ in. (10.4 cm), W: 1 ⅞ in. (4.7 cm), D: 1 ⅝ in. (4.2 cm); Brooklyn Museum, Hagop Kevorkian Fund and Designated Purchase Fund, 1990.14.

Small, hand-formed clay figures of amply proportioned females make up one of the earliest and most widespread sculptural forms in the ancient Near East. Examples are known from Anatolia, Syria, Mesopotamia, and Iran over a span of several thousand years. Details of posture, proportion, and painted decor can vary from region to region, yet as a whole the figures are remarkably similar. Many of them came from debris layers or refuse pits, not from graves, and it is possible that their production—not their preservation for later—was the important part of a ritual. Figures like this have been associated with fertility themes, mother goddess worship, and the belief in rebirth after death, but these are all modern interpretations. The

intriguing little figures were produced before writing was developed, and so we do not know what people thought about them. We do not even know if the people who made the figures were the same people who used or venerated them. Nonetheless, these little sculptures are important for they mark the beginning of a long artistic tradition centered on the human form.

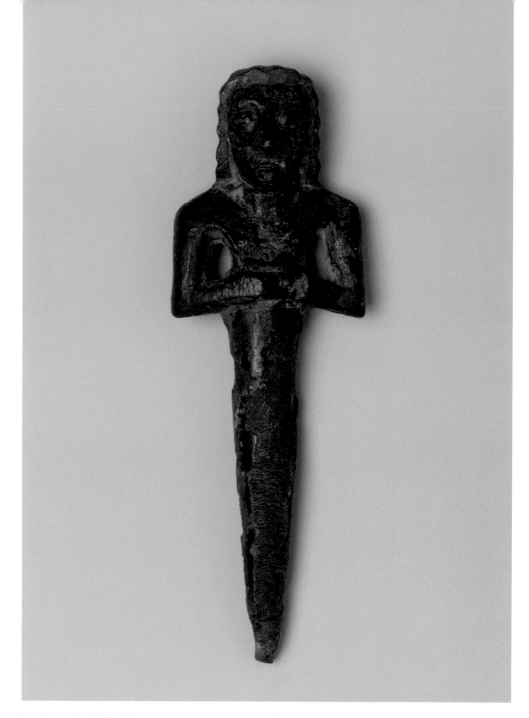

PLATE 2

Foundation figure
of a god

Iraq, Early Dynastic Period,
2800–2600 BCE; copper alloy;
H: 5 ¹¹⁄₁₆ in. (14.4 cm), W: 1 ¹⁵⁄₁₆
in. (4.9 cm), D: 1 in. (2.5 cm);
Brooklyn Museum, gift of the
Roebling Society, 81.7.

As early as the third millennium BCE, important
structures like temples and palaces had founda-
tion deposits, rather like our modern dedicatory
cornerstones, holding special figures whose peg-
like lower portion pinned the building, at least
symbolically, to the earth. Sometimes the peg
was driven through a hole in a tablet that could
record the names of the builder and the build-
ing (temples usually had their own names). This
simple foundation figure was cast via the lost-wax
process. For this, a wax sculpture was modeled and
then covered or invested with fine clay. It was then
fired, and in the process the wax either melted or
was burned off. Molten copper was then poured
into the empty clay mold. When the metal cooled

the clay mold was broken apart, revealing the cast
figure. In the case of the Brooklyn foundation
figure, the body was only summarily rendered and
the features of the face were simplified. The hair,
however, was given a more detailed depiction, with
rows of horizontal waves in front and back. Today
we see that these anthropomorphized foundation
pegs indicate a powerful drive to render abstract
concepts in human form.

PLATE 3

Cylinder seal with a
snake-bodied god

Iraq, excavated from Kish,
Akkadian Period, 2350–2150
BCE; basalt; H: 1 ⅜ in. (3.5 cm),
Diam.: ⅞ in. (2.2 cm); Field
Museum of Natural History,
Chicago, 156668.

This cylinder seal, once rolled across a tablet of
soft clay to impress the signature of its owner,
bears a simply cut scene. A worshipper, presum-
ably the seal owner, is led by two gods into the
presence of a bearded, snake-bodied deity who sits
on his own coiled tail. The first introductory god
raises his hand as if greeting the seated deity, and
the second god takes the worshipper by the wrist
as if affirming his connection to the suppliant.
The snake-bodied god is a most unusual deity for
Mesopotamia, where gods and goddesses are nearly
always shown in human form. He appeared more
frequently in Iran, and was popular in Mesopota-
mia only during the Akkadian Period, suggesting
that his worship was in some way connected with

the ruling dynasty. The carving of the seal is spare,
with few extraneous details. This is not because
the seal-cutter was unskilled, but because the stone
from which the seal was made is basalt, a hard,
igneous material that is very difficult to work.

This seal was excavated from Kish, near Baby-
lon and south of modern Baghdad, almost one
hundred years ago. Unfortunately the excavation
practices of the day were not as precise as in later
years, and no record of the exact spot where it was
found is known.

PLATE 4

Head of a goddess

Iraq, excavated from Ur,
Akkadian Period, 2350–2150
BCE; marble, shell, and lapis
lazuli; H: 3 ¾ in. (9.5 cm), W:
3 ⅛ in. (8 cm), D: 3 ⅜ in. (8.5
cm); University of Pennsylvania
Museum of Archaeology and
Anthropology, Joint British
Museum/University Museum
Expedition to Mesopotamia, 4th
Season, 1925–1926, B16228.

Thick, rounded headbands and long, flowing
hair are not secular styles, so this sculpture most
likely represents a goddess. This fragmentary
sculpture, which still retains both eyes strikingly
inlaid with shell and lapis lazuli, is a visual descen-
dant of the Uruk White Head (fig. 2.13). Indeed
the pronounced central part in the hair and the
rippling waves that frame the forehead can be
seen as a more naturalistic version of the austere
Uruk Head. Both sculptures also share the use of
colored-stone inlays for the eyes and the formal
rendering of the eyebrows as a joined double arc.
The petite, almost doll-like features imply a ten-
der and approachable goddess, not one associated
with authority and conflict like Ishtar. Yet with
no attributes or an inscription that may once have
been on the now-missing body, we cannot tell
which deity this figure is intended to invoke. The

elegance of its execution and the plasticity of its
form make the head memorable no matter what
deity it represents.

The head was found in a layer of loose soil with
other fragments of broken sculpture, none of
which matched each other. Clearly these fragments
were mutilated elsewhere and dumped where they
were later found.

See C. Leonard Woolley, *Ur Excavations*, Joint Expedi-
tion of the British Museum and the Museum of Univer-
sity of Pennsylvania, vol. 6, *The Early Periods* (London:
British Museum and University of Pennsylvania, 1954),
p. 52 and plate 43.

This foundation peg takes the form of a deity who holds the peg, rather than being part of it. The kneeling god has at least four rows of horns on his headgear, suggesting his high rank and thus the rank of the individual who commissioned it and the building in which it was interred. The elaborate beard, well-modeled body, and naturalistic arms and legs embracing the peg suggest that the artist was quite skilled, and that the figure probably was created for a building under royal patronage. We know from earlier inscribed figures that the deity depicted on a foundation peg was the personal god of the patron, now delegated to act as a stand-in to guarantee the stability of the structure. The support of this divine servant implied, by

extension, his support for the stability of the realm as well.

The purity of the copper and the small traces of arsenic and tin in it are both consistent with metalworking practices in the third millennium BCE in Mesopotamia. The arsenic and tin were probably in the original copper ore and not added later. At present we do not know where the source of the ore may have been, though Anatolia, the Zagros Mountains of Iran, and the Oman peninsula in the Persian Gulf are possibilities.

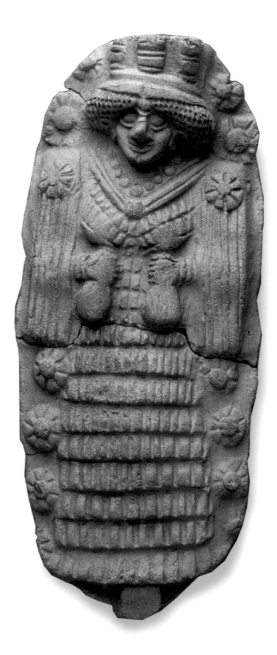

PLATE 6

Plaque with a standing goddess holding jars

Iraq, excavated from Tell Diqdiqqeh, near Ur, Old Babylonian Period, 2000–1600 BCE; clay; H: 6 7/8 in. (17.4 cm), W: 2 13/16 in. (7.1 cm); University of Pennsylvania Museum of Archaeology and Anthropology, Joint British Museum/ University Museum Expedition to Mesopotamia, 2nd Season, 1923–1924, B15634.

This agreeable goddess is anonymous to us, but she was probably easily identified to her devotees by the two jars or jugs she carries and by her elaborate outfit. The starlike rosettes at either side of her head, on her shoulders, and along the sides of her voluminous fringed robe may have been another identifying characteristic, along with the turret-like forms on top of her head. In the absence of an inscription, it is tempting for us to identify her with a Babylonian version of Siduri, the Sumerian goddess of beer-brewing and pleasant times who advises the hero Gilgamesh "Let your belly be full/ Make merry by day and by night/ Make a feast of rejoicing every day/ By day and by night dance and play." But that would be only one guess. It is

more likely that this goddess was a popular local divinity in the region around Ur, where the plaque was excavated. This figure's identity could well be among the many aspects of popular religious beliefs that remain unknown to us because they were not part of the formally organized temple culture that left written records.

See C. Leonard Woolley, M.E.L. Mallowan, and T. C. Mitchell, *Ur Excavations*, Joint Expedition of the British Museum and the Museum of the University of Pennsylvania, vol. 7, *Old Babylonian Period* (London: British Museum Publications, 1976), plate 78, no. 125.

PLATE 7

Relief fragment with
a water goddess

Iraq, excavated from Ur, Old
Babylonian Period, 2000–1600
BCE; clay; H: 28 ¾ in. (73 cm),
W: 12 in. (30.5 cm); University
of Pennsylvania Museum of
Archaeology and Anthropology,
Joint British Museum/
University Museum Expedition
to Mesopotamia, 9th Season,
1930–1931, 31-43-577.

With her tall horned miter, smiling face, and locks
of hair curling on her shoulders, this goddess was
a familiar and beneficent image in the early second
millennium BCE. She carries a small round vase
from whose mouth streams of water flow out over
her shoulders and down the sides of the plaque,
paralleling the watery rivulets that form her skirt.
Clearly she is a deity of flowing water. We do not
know the name of the goddess we see here (her
identity may have varied from place to place), but
we do know that the vase was called *hegallu*, or
"abundance" in the Akkadian language. Ancient
Mesopotamia was dependent on irrigation-based
agriculture and free-flowing sweet water was essen-
tial to life. At Mari (see fig. 2.15), a nearly life-size

stone version of her served as a fountain sculpture
in the palace of Zimrilim. This clay relief from
Ur is unusual for its size and thickness, making it
quite distinct from the otherwise numerous small,
mold-made plaques. It is possible that this large
panel was the focus of a small neighborhood cha-
pel or shrine, rather than a domestic votive image.

See C. Leonard Woolley, M.E.L. Mallowan, and T. C.
Mitchell, *Ur Excavations*, Joint Expedition of the British
Museum and the Museum of the University of Penn-
sylvania, vol. 7, *Old Babylonian Period* (London: British
Museum Publications, 1976), plate 64, no. 1.

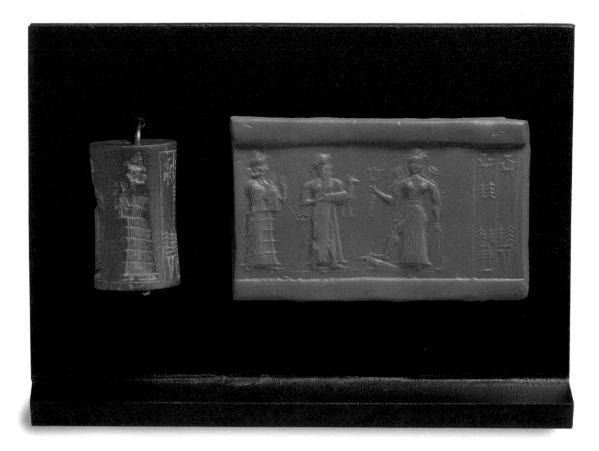

PLATE 8

Cylinder seal with
the goddess Ishtar

Iraq, Old Babylonian Period,
ca. 1800 BCE; hematite; H: 1 3/16
in. (3 cm), Diam.: ¾ in. (1.9 cm);
Ackland Art Museum, University
of North Carolina at Chapel Hill,
Ackland Fund, 72.53.3.

The seal impression shows the goddess Ishtar, modeled with great naturalism; she is facing the viewer, her breasts clearly indicated beneath her robe. Her long hair falls along her shoulders in a fine strand ending in a curl on either side. The goddess is fully armed with a scimitar-like sword in her lowered left hand and a multiheaded mace, a symbol of authority, in her extended right hand. She carries two quivers of arrows on her back, their bands forming a *V*-like neckline across her chest, and she stands with one bare leg braced against a tiny snarling lion. A well-dressed and perhaps royal figure, wearing a round-brimmed cap and a long fringed mantle, bears a small sacrificial goat. He is followed by a second goddess who stands with her hands raised in either prayer or approval. The elegant proportions of the figures and the delicate details of their garments, set against a spacious empty ground, give them a corporeality rarely found on such small seals. While the scene shows the meeting of a worshipper and the numinous divinity, the viewer is also a part of this tableau, as the goddess looks out directly at us. Worship scenes like this were very popular in the Old Babylonian Period, and some examples are known in which the scene was completely carved except for a blank panel that was left for whatever inscription the owner wished to add.

Inscription:
Line 1 ᵈNISABA
Line 2 ᵈEZINU(!)

Translation: "(deity) Nisaba, (deity) Ashnan"

Here, the superscripted "d" takes the place of the starlike first character of each line; it is a modern convention for indicating the Sumerian logogram DINGIR, indicating a divinity. It was not spoken. The exclamation point is another convention used to indicate a sign that was miswritten by the original scribe; this translation has been amended by a modern editor.

Nisaba is the Sumerian goddess of writing, accounting, and grain rationing/measuring. Ashnan is a goddess whose name means grain. It is not uncommon for the inscription on a seal to mention a deity that is not depicted on it.

PLATE 9

Plaque with the
goddess Ishtar

Iraq, Old Babylonian Period,
ca. 1800 BCE; clay; H: 5 in.
(12.9 cm), W: 3¼ in. (8.3 cm);
Yale University Babylonian
Collection, New Haven, YBC
10006.

The plaque shows "warlike Ishtar" armed with a scimitar in her lowered right hand and a bow and arrow in her extended left. Two quivers of arrows are slung across her back, their bands obscuring her upper torso. Standing in profile except for her shoulders, she places one extended foot on the neck of a recumbent lion while her supporting foot rests on the neck of a second lion facing in the opposite direction. The naturalistic modeling of the extended leg and the casual way the near lion's tail curves down over the ledge that forms the base of the plaque indicate how carefully the mold from which this image was pressed was prepared. Unfortunately, damage to the lightly fired clay has obscured details of her face and headgear. Nonetheless, the diagonals created by the advanced leg and the backward swinging scimitar give the figure a dynamism appropriate to such an active goddess.

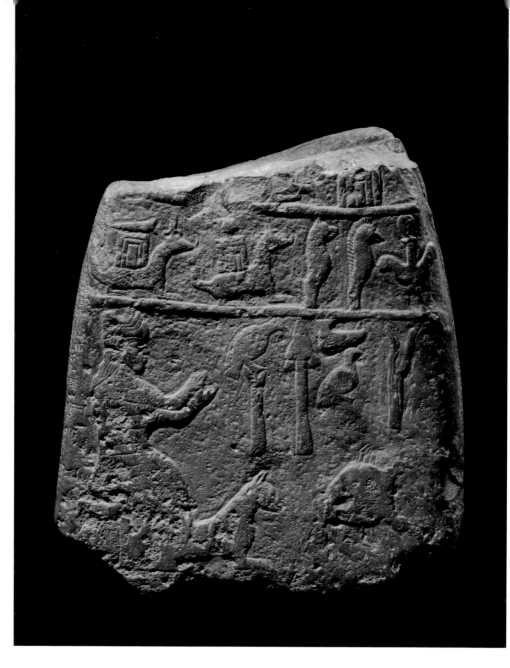

PLATE 10

Boundary marker with a seated goddess

Southern Iraq, Middle Babylonian Period, 1200–1000 BCE; stone; H: 14 ½ in. (37 cm), W: 13 in. (33 cm), D: 5 ½ in. (14 cm); Yale University Babylonian Collection, New Haven, YBC 9502.

This large piece of stone functioned as a boundary marker (*kudurru*), but was not meant to actually be placed out in an open field or along a road. Instead it would have been kept in a temple annex or similar place as a durable document marking a formal agreement—usually with the king—and duly approved by a number of deities. The images on the *kudurru* were symbolic rather than descriptive, providing a visual list of the gods presiding over the agreement. The major gods are represented as enthroned rulers with their companion animals as throne bases or footstools. The Yale stone bears an image of a seated goddess whose animal looks rather like a dog. If so, this is the goddess Gula. In front of her are various standards of Babylonian deities, of which the spearlike form of the spade of Marduk is the most easily

identifiable. In the upper registers the gods are represented by symbols, some resting on an altar supported by an animal. Directly above the seated goddess's head is the wedge-shaped stylus of Nabu, god of writing, learning, and destinies, set on a square altar supported by Nabu's horned dragon or *mushshushu*. Other symbols are worn or defaced, making it harder to match them with specific deities. The inscribed text of the agreement would be on the non-pictorial side of the stone. *Kudurru* were used only by Babylonians and have not been found in northern Mesopotamia (Assyria). The now partly worn away text of this agreement has not been fully read but does mention the Babylonian king Marduk-apla-iddina I.

PLATE 11

Plaque with the
demon Humbaba

Iraq, Old Babylonian Period,
1800–1600 BCE; clay; H: 4 in.
(10.1 cm), W: 3 ¾ in. (9.5 cm);
Yale University Babylonian
Collection, New Haven, YBC
2238.

Humbaba is a major figure in Tablet II of the
Gilgamesh epic. There he is described as the
monstrous guardian of the Cedar Forest (presum-
ably in Lebanon) where Gilgamesh and his best
friend Enkidu travel to secure timber. Humbaba
is killed by Enkidu (or Gilgamesh and Enkidu
together in another version) and the timber is
taken. But Humbaba was not an inherently evil
character, merely a strange and powerful one. He
was appointed forest guardian by Enlil, one of the
supreme Mesopotamian gods, and after Humbaba's
death Enlil distributed his terrible auras or radi-
ances to various natural elements like fields, rivers,
reed beds, and wild animals. Humbaba was always
depicted with a broad, frontal face, thick features,
and a wide, often grinning mouth with bared
teeth. Frequently his face was caricatured as a pile
of animal entrails, and because of this he was later
called Guardian of the Fortress of the Intestines.
Even when depicting a monster, the desire for a
human form asserted itself in the art of the ancient
Near East.

PLATE 12

Cylinder seal with winged genius and human-head bulls

Iraq, Neo-Assyrian Period, ca. 700 BCE; blue chalcedony; H: 1 9/16 in. (4 cm), Diam.: 7/8 in. (2.2 cm); Kimbell Art Museum, 2001.04.

This seal is engraved with a generalized image of protective power that quotes from the Assyrian royal reliefs and other art forms. Both the winged male figure and the human-headed lions are *shedu*, protective beings that were frequently included in the carved stone reliefs of the Assyrian royal palaces (see fig. 2.18). They combine on this seal to provide mystical shelter to the seal's owner, Nabu-appla-idin. The style of the carving displays a vibrant naturalism luxuriating in the musculature of the lions, the curled hair and beards of all three beings, and the elaborately fringed robe of the central figure. The beauty of the blue chalcedony and the elegance of the carving suggest that the owner was a person of some importance. Several

Babylonian kings bore this name, which means "Nabu has given me a son," but other non-royals took the name as well. Both the father and the son have Babylonian names, but the inscription and the engraved figures are Assyrian. This combination is a not uncommon occurrence as the ruling elite of both regions often intermarried.

Inscription: "Belonging to Nabu-appla-idin, son of Bel-shuma-ibni"

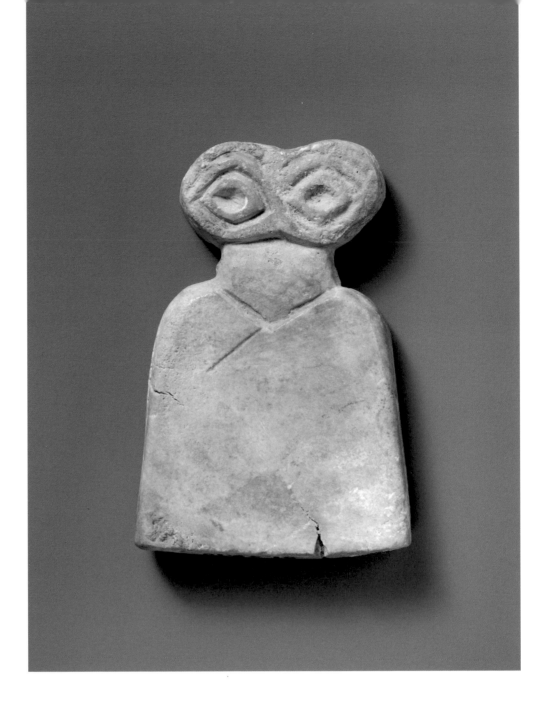

PLATE 13

Eye idol

Syria, excavated from Tell Brak,
Middle Uruk Period, 3700–3500
BCE; gypseous alabaster; H:
2 ⅛ in. (5.3 cm), W: 1 ⅜ in. (3.5
cm); Metropolitan Museum
of Art, gift of the Institute of
Archaeology, University College,
London, 1951, 51.59.10.

This simple stone form with a thick, stalk-like neck has two round "eyes" incised at the top. A shallow, *V*-shaped cut at the base of the neck and a second diagonal incision near it suggest the neck-line of a cloak wrapped around the body. Typically forms like this are called "eye idols," and this is one of more than a thousand similar figures—along with beads, stamp and cylinder seals, and small carved stones—embedded in the platform of the Gray Eye Temple, whose mud bricks were gray and easily distinguished from the red mud bricks of the temple beneath it and the white-plastered surfaces of the temple built above it.

These items were either buried as votive offerings at the time of construction or were deposited to make room for more offerings in the new temple. Since writing was not yet developed in this period we have no way of knowing exactly what these little stone forms meant. Nonetheless their human-like shape and prominent eyes evoke the inlaid eyes of later sculptures and suggest that the works were made with the intention of having human qualities.

See M. E. L. Mallowan, "Excavations at Brak and Chagar Bazar," *Iraq* 9 (1947): 1–259.

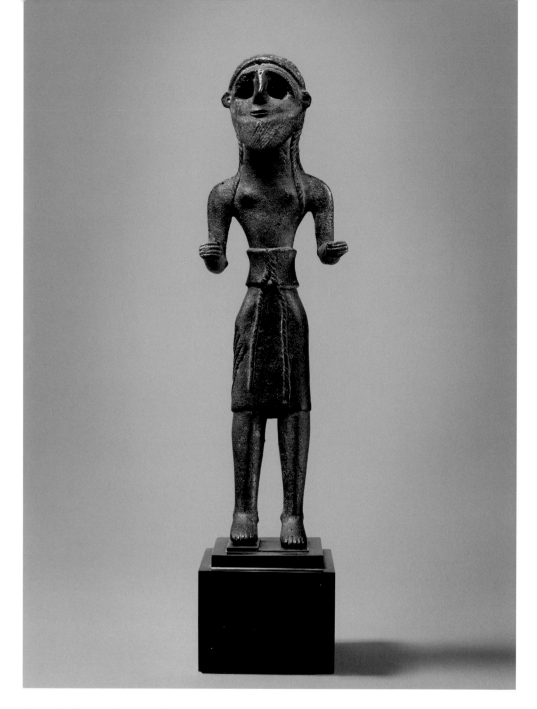

PLATE 14

Standing male figure

Lebanon, from Jezzine, late
3rd–early 2nd millennium BCE;
copper; H: 13 ½ in. (34.3 cm), W:
4 in. (10.2 cm), D: 2 in. (5.1 cm);
Private collection, New York.

This male figure is distinctive for its large size and
blend of abstract forms and naturalistic details.
The head is rather flat, and, when viewed from the
front, dominated by the large eyes that were once
inlaid with contrasting materials. Set beneath slop-
ing brows, the now-empty sockets distract from
the angular nose, the small, slit-like mouth, and
the tapered beard. In contrast, the hair on the head
is carefully rendered with long, narrow, twisted
coils. Two locks hang over the figure's shoulders
in front, and the rest falls down the back with a
single thick braid descending from the top of the
head nearly to the waist. No attributes remain
to identify the figure, but the resemblance to the
nude male figures from Tell Judeideh (see fig.
2.19)—who are probably deities—is strong. Yet
the lowered arms, the wide belt with its twisted tie,

and the long kilt with fringe on the right side sug-
gest that the figure may be a ruler, or perhaps the
divinized ancestor of one.

This Jezzine figure is not a solitary one, but was
among five excavated in 1948 at Jezzine in south-
central Lebanon. The hoard, including two torques
(neck rings), two pins, and a metal bead, appeared
to have been carried to where it was buried from
elsewhere. This transfer means we thus have no
archaeological evidence about the original installa-
tion of the statue.

See Henri Seyrig, "Statuettes trouvées dans les montagnes
du Liban," *Syria* 30(1-2), 1953: 24–50.

PLATE 15

Female figurine

Syria, 1900–1800 BCE; ceramic; H: 5 ⅞ in. (14.9 cm), W: 1 ¾ in. (4.4 cm), D: ⅞ in. (2.2 cm); The Jewish Museum, New York, gift of the Betty and Max Ratner Collection, 1981-207.

This simply formed figure has a distinctive silhouette, featuring abbreviated arms that echo the outline of the hips and protruding ears that echo the shape of the arms on a smaller scale. Decorative emphasis is supplied by small round pellets, each with a single punched hole. Two are applied to the head for eyes, and one to the top of the head as an ornament, while three more indicate breasts and a navel. Four additional holes have been punched through the ears and upper portion of the hair or head. A thick, crimped band around the neck suggests jewelry. The figure was meant to be seen only from the front as the back side is flat and plain, and the necklace does not encircle the back of the neck. The only details are two small holes

in the buttocks. These so-called fertility figures are ubiquitous, particularly in the western portion of Syria in the first half of the second millennium BCE, but their meaning is not well understood. Although some figures of this kind can stand on their own, most cannot—implying that they were carried in the hand or placed horizontally. Popular practices and beliefs were not always recorded in the records of the elite, and these little figures may have had more than one function.

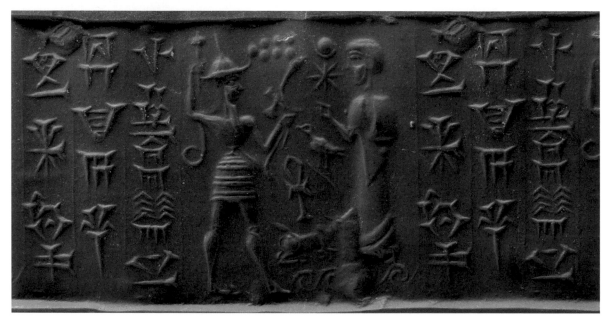

PLATE 16

Cylinder seal with a
helmeted god

Syria, 1650–1350 BCE; hematite;
H: ⅞ in. (2.3 cm), Diam.: ⁷⁄₁₆ in.
(1.1 cm); The Pierpont Morgan
Library, New York, Morgan
Seal 964.

This stone seal is carved with the standard scene of
a worshipper facing a deity. In this case the male
deity, identified by his horned hat with a central
spike, is Adad, the storm or weather god who is
directly invoked in the seal's inscription. The god,
with his short kilt and raised right arm bearing a
mace, echoes the posture of the Egyptian pharaoh
smiting his enemies, a pose that came to character-
ize gods rather than mortals in Syro-Levantine art.
The local aspects of the god are seen in the horns
of his spiked helmet, his straight, narrow beard,
the long curl of hair falling down his back, the
horizontal bands or stripes on his kilt, and most
of all in the cluster of irregular curving lines—
lightening?—and an axe grasped in his left hand.
Below this hand is an Egyptian *ankh*, the hiero-
glyph for life, a further reminder of the influence

of Egyptian culture along the coast of the Levant.
The worshipper, presumably Nurmu-ili, stands
somewhat higher, elevated on a simple guilloche or
spiral band, his right hand extended in address or
worship. In contrast to the clear open spaces of the
seal in Plate 8, the background space between the
figures on this seal is filled with astral symbols: the
group of seven drilled balls, a disk resting on a thin
crescent, a bird, and below the *ankh* a small recum-
bent bull. These "filler motifs" and the widely
spaced signs of the inscription, create a tapestry-
like surface that ties the figures into the décor of
the whole seal.

Inscription: "Nurmu-ili/ son of Iribu/
servant of Adad"

PLATE 17

Pendant frame of a
goddess on horseback

Levant, 15th–13th century BCE;
beaten sheet gold with traces
of glass paste; H: 1 ¾ in. (4.5
cm), W: 1 ⁷⁄₁₆ in. (3.7 cm); The
Walters Art Museum, Baltimore,
Maryland, 57.1593.

This beautiful gold pendant depicts Astarte, a
Syro-Levantine goddess who was associated with
horses and often had a martial aspect. Astarte
rides her mount seated well back over the croup,
a posture common on Egyptian representations
of horseback riders. She wears an Egyptian-style
crown, and brandishes a spear. While her dress
reflects Egyptian cultural influences, her basic
identity as a horse-riding deity is thoroughly
Near Eastern. Astarte is easily distinguished from
Ishtar, whose companion animal is the lion, not
the horse, and who carries a scimitar, not a spear.
Originally the gold frame was filled with colored
glass; only traces of light blue and white remain,
providing the details of both the decorated horse
and the divine rider. Two small horizontal tubes on
the back of the pendant facilitated its suspension
or attachment.

PLATE 18

Female figurine

Israel, from Tomb 106 at
Lachish, 800–700 BCE; ceramic;
H: 6 ⅛ in. (15.6 cm), W: 2 ¹⁵⁄₁₆
in. (7.5 cm), D: 1 ⅞ in. (4.8 cm);
The Jewish Museum, New York,
Archaeology Acquisition Fund,
JM 12-73.268a.

With its abbreviated form and rounded contours,
this simple female figure evokes the earliest known
clay figurines. However, unlike the older Neolithic
figures, the head and face are important and make
up a large proportion of the image. The bodies
and arms were hand-built, but the heads with
their rows of soft curls were made by pressing the
clay in a mold. The simplicity of these figures sug-
gests that they could have been produced by any
potter when the need for them arose. What these
so-called "pillar figures" do share with the earlier
female figurines is the fact that little is known
about their purpose. They are not mentioned in
the written sources of the period, yet have been
found in domestic as well as funerary situations.

This particular figure was excavated from a tomb,
so we know that it played some part in mortuary
practices, but that is all we can deduce.

See Olga Tufnell, with Margaret A. Murray and David
Diringer, *Lachish III (Tell Ed-Duweir): The Iron Age.* 2
vols. (London: Oxford University Press, 1953), plate
27:4.

PLATE 19

Spade-shaped idol

Turkey, 3rd millennium BCE;
marble; H: 4 ⅞ in. (12.4 cm), W:
2 ⅜ in. (6 cm); Museum of Art
and Archaeology, University of
Missouri-Columbia, 76.215.

This angular stone form recalls in a general way
the "eye-idols" of Nagar (modern Tell Brak), like
the one in Plate 13. However this piece displays
the more abstract tendencies of Anatolian art in
the third millennium, a characteristic seen also at
Kültepe (fig. 2.23). The smooth, sleek forms of the
many small stone sculptures like this one are very
appealing to modern taste, and their small scale
suggests that they were intimate objects, perhaps
held in the hand or otherwise kept close to the
body. While they may have had a function in daily
life, they are primarily known to us as grave gifts.
We do not know their precise significance because
we have no writing from this region.

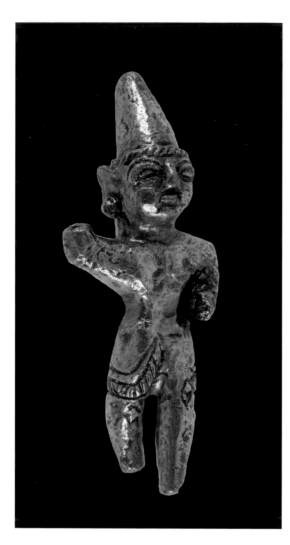
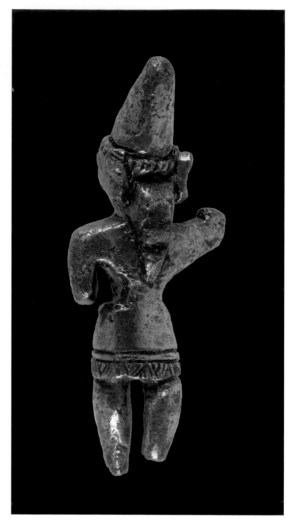

PLATE 20

Figurine of a god

Turkey, Hittite, 1500–1200 BCE;
silver; H: 1 ¾ in. (4.4 cm),
W: ¹¹⁄₁₆ in. (1.8 cm), D: ⁷⁄₁₆ in.
(1.1 cm); The Walters Art
Museum, Baltimore, Maryland,
57.2058.

This little silver figure is identifiable as Hittite by
his stocky proportions, his clean-shaven face, and
his large earrings. We know he is a deity because
he wears a tall conical cap and a short kilt that
leaves his legs bare, in contrast to kings, who wore
a close-fitting round cap and long, heavy robes.
The active pose with the left leg advanced and the
right arm raised is also characteristic of gods; kings
are almost always shown in a passive, static posture
(see figs. 3.12 and 4.7). This figure's raised right
hand would originally have held an attribute like
a mace or an axe, while his once-outstretched left
hand might have supported his name in Luwian
hieroglyphs like the storm god in the reliefs
of Chamber A at Kazýlýkaya (see fig. 2.24). A

number of small divine figurines of gold or silver,
signs of the pious practices of the Hittite elite,
have been excavated at Hattuša, the Hittite capital.
Some have loops on the back indicating that they
could have been worn as pendants, or hung over a
door or bed as an amulet.

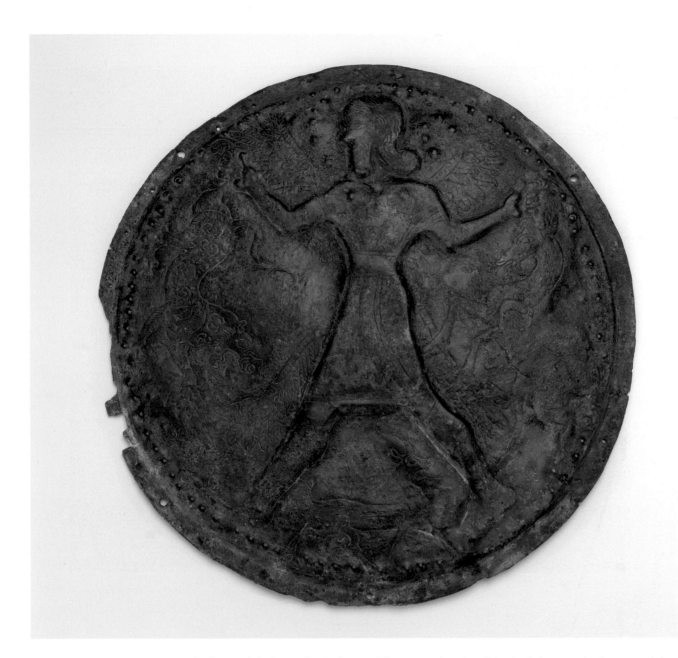

PLATE 21

Disk

Northwest Iran, 900–650 BCE; copper alloy; Diam.: 8 ¾ in. (22.3 cm); Arthur M. Sackler Gallery, Smithsonian Institution, Washington, DC, gift of Arthur M. Sackler, S1987.121.

This bronze disk shows a heroic figure striding toward the viewer's left; the image was raised from the back in a technique called repoussé. He wears a short, patterned garment, and a pair of fringe-like wings sprout from his shoulders. A second pair of wings, faintly chased like the upper pair, descend from near his waist along the edges of his legs. He holds a mountain goat by the horns with his left hand and the hind leg of a struggling feline with his right. Both animals are difficult to see as they are rendered with chased lines and not in relief. A small gazelle fills the space between his feet. The wings mark him as a supernatural figure and his posture suggests that he has dominion over wild animals. His pose, dress, and hair are based on Mesopotamian images like the one in Plate 12

but the wild animals he controls, the goat and the feline, mark the disk as Iranian. The few written records from this region deal with rulers and their conquests. We do not yet know the name of this figure nor what it represented. A less elegant, earlier version with the heroic figure hoisting bulls by the hind legs was excavated at Geoy Tepe, also in northwestern Iran. Both disks were once fastened to another backing and may have been part of decorative horse gear.

Thomas Lawton, et al., *Asian Art in the Arthur M. Sackler Gallery: The Inaugural Gift* (Washington, DC: Arthur M. Sackler Gallery, Smithsonian Institution, 1987), no. 2, p. 28.

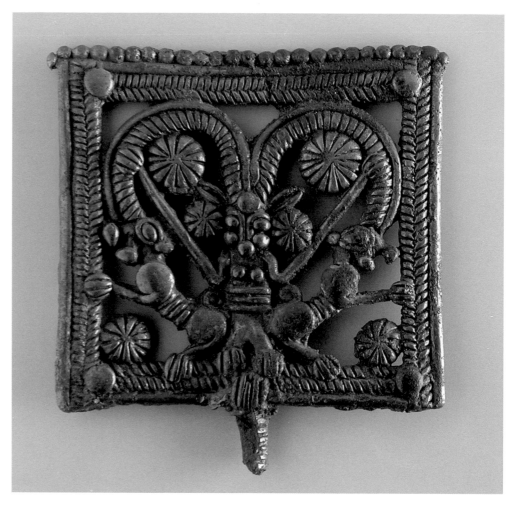

PLATE 22

Openwork dress-pin head

Iran, Luristan region, 800–650 BCE; bronze; H: 3 ¾ in. (9.8 cm), W: 3 ½ in. (8.8 cm); Los Angeles County Museum of Art, The Nasli M. Heeramaneck Collection of Ancient Near Eastern and Central Asian Art, gift of the Ahmanson Foundation, M.76.97.206.

This square openwork form was once the head of an elaborate dress pin. Only the stub of the pin itself, which would have been used to fasten a robe or heavy shawl, remains at the base. Framed by a thick, braidlike border, a semihuman frontal figure raises its thin arms to support the huge curving ibex horns that arch from its head. The face of this being is made of round, pellet-like shapes for eyes, cheeks, and nose, and elongated animal ears spring from the base of its horns. Two more pellets indicate breasts, and a thick triple band or belt marks the waist. A pair of rearing felines leap to the left and right, their heads touching the tips of the horns. Plump rosettes fill the arc of the horns, as well as the space between the arms and the ears and the lower corners of the square. This central figure replicates the symmetrical pose common to heroic figures in Mesopotamian art seen also in Plates 12 and 21. But in this example the central figure does not struggle with the felines. Instead it supports its own horns and appears to send the felines outward as if dispatching them into the

natural world. Whether deity or demonic spirit, the powerful creature dominates the composition.

Heavy cast-metal pin heads of this type are reputed to have come from graves in the Luristan region. The only similar ones as yet excavated, and which are not identical, were in votive deposits in the shrine at Surkh Dum-i Luri, excavated in the late 1930s by the Holmes Luristan expedition. It may be that these heavy dress pins were made for prestigious display rather than practicality, as their top-heavy weight and vertical orientation would make them difficult to wear. The most common garment fastener in this period was the safety-pin-like fibula rather than the straight-shanked dress pin.

See Erich Friedrich Schmidt, Maurits Nanning van Loon, and Hans H Curvers, *The Holmes Expeditions to Luristan* (Chicago: University of Chicago Press, 1989), plates 183–185. Oriental Institute Publication 108.

PLATE 23

Dress-pin head

Iran, Luristan region, 800–650
BCE; bronze; H: 5 5/8 in. (14.7
cm), W: 2 5/8 in. (7.1 cm); Los
Angeles County Museum of
Art, The Nasli M. Heeramaneck
Collection of Ancient Near
Eastern and Central Asian
Art, gift of the Ahmanson
Foundation, M.76.97.161.

This disk shows a figure in a long dotted robe
seated between two undulating snakes whose
necks he holds with each hand. One snake has
small dots on its body while the other snake's pat-
tern is obscured by corrosion. The human figure
appears to sit on the coils of one snake, recalling
the snake throne of earlier Elamite deities (see figs.
2.29 and 3.15). It is not clear whether the figure is
male or female. The apparent absence of a beard
would suggest a female figure, but the details are so
damaged by corrosion that it is not possible to be
certain. In any event, we know that both gods and
goddesses could sit on snake thrones. The large
disk head on this dress pin was made by hammer-
ing or beating the metal to the desired thinness

and then pressing the image into relief from the
reverse side. A fragmentary disk with a very simi-
lar scene was excavated from the shrine at Surkh
Dum-i Luri (field no. Sor 820, now in Tehran),
where it was part of a votive deposit.

See Erich Friedrich Schmidt, Maurits Nanning van Loon,
and Hans H. Curvers, *The Holmes Expeditions to Luristan*
(Chicago: University of Chicago Press, 1989), plate 210a.
Oriental Institute Publication 108.

Part Three:
Breath of Heaven, Breath of Earth:
Ancient Near Eastern Art from
American Collections

The Human Realm

The Human Realm

Mesopotamia

The surviving images of human figures—that is, of non-divine or mortal beings—in ancient Mesopotamia are primarily of rulers and those elite individuals with high status and sufficient resources to commission art. The resulting representations, of course, show the elite as they wished to be seen, not as they were in real life. This group may be divided into two general categories: the first were kings, princes, and other rulers; the second were their subsidiary or dependent cohorts, usually major officials and large landowners. From written evidence we know that there were powerful mercantile classes in many Near Eastern cultures, but little survives of their presence in the visual arts aside from seal impressions. It is not always easy to distinguish between the two main patronage groups, and sometimes the only clear confirmation is an inscription. Moreover, in antiquity as in modern times the power to rule did not always guarantee the services of the best artists or craftspeople.

Rulers, whether hereditary or selected, focused on maintaining their position, and art played a role in this. The two main sources of their power were divine protection and force of arms. For example, many early art works show male figures as guarantors of the well-being of their people through divine favor. Yet these two elements were closely related and totally intertwined, so that images emphasizing one aspect often imply the other.

The Uruk Vase, a tall stone vessel found, like the White Head, in the E-ana precinct (figs. 3.1a, 3.1b), shows in its damaged top register a ruler who presents gifts to a goddess standing in front of her shrine. As in the case of the White Head, it is generally accepted that the goddess is Inana. The second register contains a row of nude males, presumably priests in ritual purity, bringing additional offerings, while below them rams and ewes parade, and on the bottom band agriculture flourishes above a baseline of ever-flowing sweet water.[1] The vase is a visual description of Sumerian society, with the deity and ruler closely allied at the top, and the nourishing land at the base. The composition of the bands parallels that seen in the small carved cylinder seals like those in Plate 24, whose use also began in this period. There is clearly a top and bottom to the scene, but there are no borders to the left or right, merely the ever-revolving surface. At this early date, about 3000 BCE, we cannot easily distinguish between human and

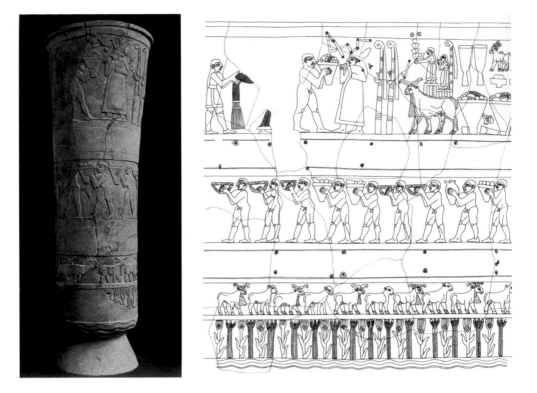

Figure 3.1a. Relief carved vessel, the so-called "Warka Vase"; Iraq, from Uruk (modern Warka), Late Uruk Period, ca. 3100 BCE; alabaster; H: 41⁵⁄₁₆ in. (105 cm); Iraq Museum, Bagdad, IM 19606.

Figure 3.1b. Drawing of the "Warka Vase."

divine figures. While it appears that the Uruk Vase shows a king or priest-king making an offering to a goddess with great pageantry, some have argued that it shows a priestess receiving the gifts in the guise of the goddess. Mortal and divine are visually interchangeable at this point, a worldview that may have been intended.

We often forget that ancient works of art had an existence that could extend far beyond the period in which they were made. Certainly the Uruk Vase enjoyed a long and valued service as a temple furnishing. The vase was broken at the rim and repaired in antiquity, though the carving of the repair was not equal to the skill of the original craftsman. Additional minor damage occurred when the piece was looted from the Iraq Museum in 2003.[2]

By the middle of the third millennium BCE, fully three-dimensional portrait statues of rulers were produced. The wonderfully sleek, polished diorite sculpture of Gudea, ruler of Lagash from ca. 2144 to 2124 BCE, depicts him seated with piously clasped hands, the plan of a temple lying on his lap (fig. 3.2). The extended inscription spread over his garments gives a detailed account of the divine charge to build this temple, which came to Gudea in a dream. The beginning of the inscription is particularly interesting as it states that the statue has its own name, a particular installation spot near the temple of Ningirsu, Gudea's personal god, and was to receive offerings in its own right. It functioned as a permanent portrait of the ruler, a "living statue," whose function was to embody the prince for eternity.[3] The now-missing head of the Louvre Gudea probably looked very much like the one in Plate 25, which belonged to another Gudea statue. The stone used in that work is the same hard, smooth diorite, but the scale of the head indicates that it originally belonged to a different, smaller sculpture.

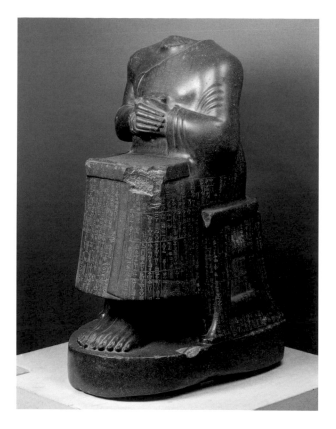

Figure 3.2. Headless statue of Gudea; Iraq, from Telloh, Second Dynasty of Lagash, reign of Gudea, 2144–2124 BCE; diorite; H: 36 5/8 in. (93 cm); Musée du Louvre, Paris, AO 2.

The Gudea sculpture is more than just a revered image to which prayer was offered. The powerfully modeled muscles of the arms and the corporeality of the body beneath the robes project a physical sense of latent power. We know from texts that survive from the late third millennium BCE that it was a period in which small regional states like Ur, Umma, and Lagash jockeyed for both economic and political power, much like the Italian city-states of the early Renaissance. Treaties were made and broken, alliances formed and fractured, and divine statues stolen and held hostage. After the fall of the Akkadian empire (in the early twenty-second century BCE), Gudea's father-in-law Ur-Ba'u (ruled ca. 2155–2142 BCE) was quick to fill the vacuum of leadership in southern Mesopotamia. Gudea then extended the political and economic power of Lagash to the north, acquiring cedar logs from the Lebanon range and hard stones from Syria to build the temple described in the inscription on his sculpture. His reach extended to southwestern Iran, where he carried off booty from Elam to fill his treasury, and even beyond, along the western shore of the Gulf. The smooth, dense, black stone of his statue was imported from Magan, now the region of modern Oman,[4] its exotic origin demonstrating the economic as well as the physical power held by the man whose image it portrayed.

The aesthetic aspects of royal sculpture are rarely noted in ancient records, but occasionally we can glimpse appreciation for the artwork itself. More than a thousand years after Gudea's reign the Assyrian king Shalmanesar III (ruled 859–824 BCE) dedicated a sculpture of himself intended to stand in a temple of the god Adad. At the end of its identifying inscription the king states: "So that my lord Adad may be pleased whenever he is moved to look at it, I have had made this statue of polished, shining, precious alabaster, whose artistic features are most beautiful to see."[5]

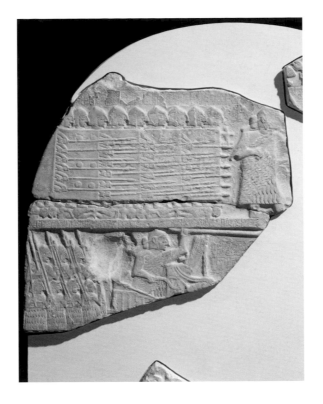

Figure 3.3. Victory stele of Eannatum, King of Lagash, called the "Vulture Stele" (reverse); Iraq, from Telloh, Late Early Dynastic Period, ca. 2450 BCE; limestone; Musée du Louvre, Paris, AO 50 and AO 2347.

The well-known stele of Hammurabi, the king of Babylon discussed earlier (see fig. 2.17), is plainly a later iteration of the image of the divinely ordained ruler. But unlike the Gudea sculpture, where the human image dominates the written text and the divine is not illustrated at all, the Hammurabi relief gives equal space to the deity Shamash. The entire relief, however, occupies only the top quarter of a stele whose purpose is to present the text of the ruler's laws.

The motif of the pious ruler could also be employed by those who wished to gain favor from the king. The small clay plaque in Plate 27, showing a ruler wearing the same garb as Hammurabi, could have been made to be dedicated in a temple by someone hoping to have a favorable decision from the king on a totally secular matter. Such dedications "for the life of the king," some of them even made of bronze, were a common way of gaining royal attention and favor. They were political compliments couched in religious terms.

Another way for a ruler to validate his position was to directly emphasize his personal abilities. Images of the ruler as literally a strong man appeared in the late fourth millennium BCE in Mesopotamia, with cylinder seals bearing images of conflict, both human against human, and human against animal. As a metaphor for war, the hunt played a role in princely activities and images as early as 3000 BCE.[6] By the middle of the third millennium rulers were representing themselves in specifically historical events. The reverse side of the main fragment of the so-called Vulture Stele of Eannatum depicts a battle between Eannatum (ruled ca. twenty-fifth century BCE) and his opponent, whose name is not recorded, arranged on two horizontal registers (fig. 3.3). Eannatum appears in both registers and is rendered on a slightly larger scale than the other figures. In the upper register he leads his massed troops, and in the lower dispatches his adversary with a spear from his war wagon. What is fascinating about this now-fragmentary relief is the manner in which as many figures as possible are crammed into the relief surface, how the troops wrap

around the narrow edge of the stone as if there were no border, and how they are organized to move from left to right. The solid, blocklike phalanx of soldiers literally backs Eannatum up, with the multiple horizontal lines of their lowered spears providing a sense of inexorable movement. The row of little human feet propels the block of men who trample over the small fallen bodies of the defeated enemy. In the lower register, the diagonal lances of the army provide a visual thicket against which Eannatum in his vehicle (only the edge of the wagon box remains) is prominently set in what would have been the center of the stele. Both scenes are carefully composed to make maximum use of the space to impress the viewer with the status of the ruler.

The Akkadian king Naram-Sin, who ruled between about 2254 to 2218 BCE, also commissioned a victory monument, but of a different style. The six-foot stone stele he erected at Sippar in central Mesopotamia memorializes his conquest of an Iranian mountain people, the Lullubi, in the rough country of northern Mesopotamia/northwestern Iran.[7] Its composition is totally different from that of the Vulture Stele. Rather than employing the rigid horizontal panels of Ennatum's stele, Naram-Sin's relief is vertically oriented, echoing in a general way the vertical shape of the stone upon which it is carved (fig. 3.4). The troops move on curving ground lines that ascend diagonally from left to right as if the soldiers were moving up a mountain. At the center of the upper portion of the stele stands Naram-Sin, treading on enemy bodies and silhouetted against the plain background. Like a victorious god, he wears a horned helmet. Naram-Sin is shown with naturalistic proportions and detailed musculature, wearing clothing that barely conceals the body beneath. The contrast with the cartoon-like Eannatum could not be more pronounced. Another remarkable aspect of the relief is the great triangular mountain opposite Naram-Sin, placed as if the landscape itself was his opponent. On the badly damaged top a series of radiant astral symbols suggest divine approval,[8] but visually they are secondary to the barely clad, muscular figure of Naram-Sin himself and offer little to engage the eye.

Relatively few large-scale portraits of rulers from Mesopotamia have survived to modern times, possibly because they could be carried off as "hostages" or trophies when one kingdom conquered another. Nevertheless historical depictions remained important long after the rulers they commemorated had passed from the scene. The Naram-Sin Stele, for instance, was prized for centuries after the fall of the Akkadians. It remained above ground and visible until the twelfth century BCE, when it was carried off to Iran by the Elamite king Shutruk-Nahhunte in a symbolic reversal of Naram-Sin's conquest in the twenty-third century. Installed in the temple complex of the god Inshushinak at Susa, the Naram-Sin Stele stood as a visible reminder of Elamite retribution.[9] Excavated in 1901 by the French archaeological mission to Iran, the stele was again carried off, this time to Paris where it was installed in the Louvre, itself the repurposed palace of the French kings. Both at Susa and in Paris, the stele was accompanied by a stone statue of Manishtusu, Naram-Sin's father, which Shutruk-Nahhunte had reinscribed with a statement of the centuries-later victory of his era. This example indicates that some Akkadian works remained visible for centuries, and could serve as exemplars for later artists and their royal patrons.

The most elaborate artworks created to display the ruler as a strong man are the wall-to-wall battle reliefs commissioned by the Assyrian kings of the earlier first millennium BCE for their palaces at Kalhu (modern Nimrud), Dur Sharrukin (modern Khorsabad), and Nineveh. Meant

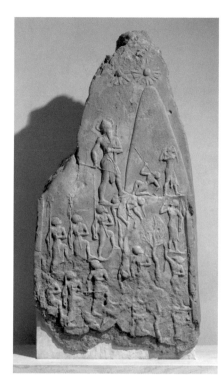

Figure 3.4. Victory Stele of Naram-Sin; Iraq, from Susa, Iran, Akkadian Period, reign of Naram-Sin, 2254–2218 BCE; limestone; H: 78 ¾ in. (200 cm); Musée du Louvre, Paris, Sb 4.

Figure 3.5a (left). Relief of a siege scene; Iraq, from the Northwest Palace of Ashurnasirpal II at Nimrud, Neo-Assyrian Period, reign of Ashurnasirpal II, 883–859 BCE; limestone or gypseous alabaster; H: 36 in. (91.4 cm), W: 85 in. (215.9 cm); Trustees of The British Museum, London, 124554.

Figure 3.5b (right). Relief of an attack scene; Iraq, from the Northwest Palace of Ashurnasirpal II at Nimrud, Neo-Assyrian Period, reign of Ashurnasirpal II, 883–859 BCE; limestone or gypseous alabaster; H: 37 ³⁄₁₆ in. (94.4 cm), W: 85 ³⁄₁₆ in. (216.4 cm); Trustees of the British Museum, London, 124556.

to impress visitors (and perhaps foreign emissaries), and once enhanced by red, black, green, yellow, and white paint, these reliefs give a vivid sense of the technical and logistical acumen of the Assyrians. Siege scenes like that of Ashurnasirpal II (ca. 856 BCE) are cinematic in their depiction of the attack, with soldiers knocking down the city walls, sappers tunneling under them, and using a mobile tower with a battering ram and tubes spouting fire (figs. 3.5a, 3.5b). The defenders fire arrows from the ramparts, use grappling hooks to dislodge the ram, and when pierced with arrows tumble off the walls while on the ramparts above women wail. The falling figures are of particular interest as they are one of the few depictions of gravity in ancient Near Eastern art. The hair of the victims is shown hanging in a disorderly manner, and one defender's clothes fall around him as he drops, exposing his naked lower torso and flailing legs. The Assyrian army meanwhile advances with a measured pace from the right, making an orderly contrast to the chaos of war. Viewing the entire wall, one sees that the besieged city is bracketed by the crown prince on the viewer's right and the king himself on the left side. This linking of order to the victorious and chaos to the conquered is a compositional effect commonly found in ancient art of both the Near East and Egypt. But the human eye finds chaos far more interesting than calm regularity; we keep looking at the siege itself, not the victorious Assyrians. The same effect appears again in the later hunting reliefs of Ashurbanipal (see fig. 4.3), where the animals are of greater visual interest than the hunters.

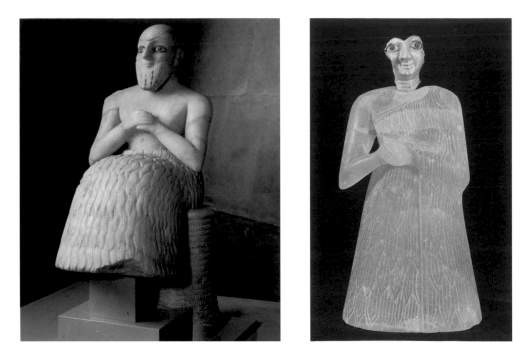

Figure 3.6. Statue of Ebih-il, Superintendent of Mari; Syria, from the Temple of Ishtar at Mari, ca. 2400 BCE; gypseous alabaster, lapis lazuli, and shell; H: 20 11/16 in. (52.5 cm); Musée du Louvre, Paris, AO 17551.

Figure 3.7. Standing female figure; Iraq, from Nippur, Mid-to-Late Early Dynastic Period, ca. 2600 BCE; aragonite and gold; H: 4 7/8 in. (12.4 cm); Iraq Museum, Bagdad, IM 96190.

The surviving human sculptures in stone are almost without exception those of kings, governors, and other paramount rulers, not lesser folk. Yet the middle of the third millennium BCE saw a remarkable exception to this practice, when a non-royal elite class, probably involved in the administration of both temple and royal estates and owning extensive property themselves, flourished.[10]

The development of this group coincided with a remarkable florescence in private votive or devotional portraits in stone. Some sculptures, like the alabaster portrait of Ebih-il (fig. 3.6), were inscribed with names and titles of the subject so that we know the identity of the individual portrayed. Excavated from the Ishtar temple at Mari, the head was found on the pavement of the outer court of the temple, the body a few meters away with the left arm and elbow broken, and the right elbow shattered. The inscription on the back of the right shoulder says "Ebih-Il, the superintendent, dedicated to warlike Ishtar." The smooth finish of the pale stone, the elegant and varied textures of the beard, fleece skirt, and the wicker stool on which he sits, set off the naturalistic modeling of the head and body, making this one of the more memorable portraits in the art of the ancient Near East.

Other sculptures without inscriptions, like the one shown in fig. 3.7 that was excavated at Nippur, may have had painted identification, or had been so well known that they needed none. Certainly the beautiful translucent green stone and gold face of the standing woman would have made the sculpture memorable to all who saw it. Set up in temples and shrines, the sculptures like Ebih-il, the green lady, and in Plates 29 and 30 functioned as surrogates for the patrons, rather like the donor portraits in European religious art of the later Middle Ages and the Renaissance. Archaeological evidence also shows that the sculptures could be revered and utilized after their owners were deceased.[11] Some sculptures, like the one in Plate 30, were broken and repaired, sometimes receiving new heads. However, after this brief period in the

middle of the millennium, the use of stone for sculpture seems to be limited to royal patrons only. The only other period in which we have independent depictions of non-royal citizens is in the early part of the second millennium in far southern Mesopotamia around the city of Larsa. The medium in this case was less costly clay, not stone, and the images varied greatly. Most, like Plates 6, 9, and 27, showed deities and rulers; others portrayed lesser folk, like the musician of Plate 31, and even animals like those in Plate 48. Clearly they did not serve exactly the same function as the earlier stone statues.

Syria and the Levant

Representations of the rulers of Syria and the Levant in the third millennium BCE were for the most part based on the artistic traditions of Mesopotamia. The ruler of Ebla in northern Syria decorated his palace with stone inlays of violent war scenes paralleling those on the so-called Standard of Ur from southern Mesopotamia.[12] In cities like Mari on the Upper Euphrates royal and private portraiture also followed the same conventions and styles as in Mesopotamia. Ishtup-ilum, *shakkanakku* (prince-governor) of Mari, in the twenty-second century BCE, chose a hard black stone for his sculpture, as Gudea had done (fig. 3.8). Like Gudea, the Mari ruler presented himself as a static figure with respectfully clasped hands. Ishtup-ilum's muscular arms and large, strong hands also recall those of Gudea. The Mari statue, however, displays a different style from Gudea's. The head is over-large, has a round, helmet-like hat, and is anchored to the chest by a flat rectangular beard. The face is also flat, with little modeling of the nose, lips, and moustache, and no indication of a chin or a neck beneath the patterned beard. Also unlike Gudea, the stiff, columnar forms of Ishtup-ilum's robe encase and obscure his body, providing little indication of the forms beneath. The almost brutal monumentality of the nearly five-foot-high figure is echoed in the brevity of its identifying inscription—merely his name and title—on the upper right arm. Ishtup-ilum was a twenty-second century contemporary of Gudea, but his statue remained visible at Mari until the eighteenth century BCE. It was excavated in 1934 from Room 65 in the palace, although to judge from the spot where it was found it may have been in Room 66 and hurled down the stairs into 65.[13] Whatever the case, it was a continuing artistic presence for almost four hundred years, serving as a template for later ruler portraits.

The stark portrait of Idrimi, ruler of Alalakh near modern Aleppo (see fig. 2.3 for a modern view of Alalakh), may well have been influenced by portraits like Ishtup-ilum's. Made of a less durable limestone and later badly broken, Idrimi's body is stiff and geometric, with few naturalistic features; his seated figure and throne are compressed into a cube. The large staring inlaid eyes, made more dramatic by their dark rims, the flat, narrow mouth, and the chinless jaw covered by the long, straight beard further simplify elements of Ishtup-ilum's statue (fig. 3.9). Most notably, the small, ill-rendered hands of this figure convey none of the power of the earlier Mari statue. Idrimi's statue, like that of Gudea, is covered with a large detailed inscription, yet the inscription here is not religious but blatantly political, recounting how he was ousted from his hereditary position as king of his city-state, spent seven years as an exile in neighboring lands, and then with the help of other exiles and new allies regained his throne and ruled successfully. Several important deities are invoked at the beginning and end of the account, but play no role in the story.

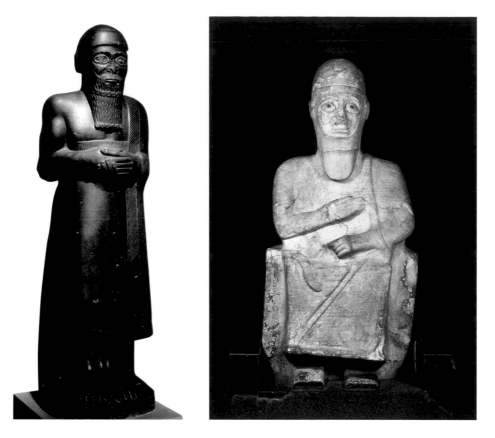

Figure 3.8. Statue of Ishtup-ilum, Governor of Mari; Syria, from the Palace of Zimrilim at Mari, ca. 2200 BCE; diorite; H: 59 ¹³⁄₁₆ in. (152 cm); National Museum, Aleppo, 7882.

Figure 3.9. Statue of King Idrimi of Alalakh; Syria, from Tell Atchana (near the Turkish-Syrian border), ca. 16th century BCE; magnesite and glass; H: 41 in. (104.1 cm); Trustees of The British Museum, London, 130738.

In some ways, the Idrimi sculpture is the antithesis of the Vulture Stele (see figs. 2.16 and 3.3), where the gods play a major role in the inscription and also get one full side of the stone.

The production of stark, almost brutally geometric royal figures continued in the monumental sculpture of Syria into the first millennium BCE, especially at Guzana (modern Tell Halaf), an important city-state in the ninth century BCE. The seated female found in a tomb chapel near the Palace of Kapara at Guzana (fig. 3.10) further regularized the cubic forms of the Idrimi statue. The massive lady, well over life-size, is reduced to the elemental geometric forms of her seated body and large uplifted head. The vertical, tubelike curls of her hair and the pronounced undercutting of the stone around her neck contrast starkly with the solid forms of her body. The punctuation of the footstool by her two small feet, the presence of the tall tapered cup on her knee, and her slim extended left hand enliven what could have been an extremely severe image. The delicacy of details like the finely incised waves of her hair, the chevron banding on the bodice and sleeves, the subtle fringe at the hem of her skirt, and even the woven bands on the sides of her seat interact with the monumental size of the stone block in a very sophisticated visual dialog. The sculpture speaks to the successful reimagining of the severe regional style by a confident sculptor working in that most-difficult of materials, basalt.

The current appearance of the statue differs from historical images taken at the time of its excavation and later installation in the Berlin museum. This work, and others from the same site, received a direct hit from a bomb in World War II and were reduced to fragments. Long believed to have been totally lost, the sculptures were reassembled from the small pieces in a painstaking project over the last decade.[14]

Figure 3.10. Seated female figure; Syria, from the funerary chapel at Tell Halaf, 9th century BCE; basalt; H: 75 in. (190.5 cm); Pergamon Museum, Staatliche Museen, Berlin, on loan from the Max Freiherr von Oppenheim Foundation.

Figure 3.11. Plaque with female sphinx holding cup; Israel, from the so-called "Treasury" at Megiddo, 13th century BCE; ivory; H: 3 15/16 in. (10 cm), W: 2 ¾ in. (7 cm); The Oriental Institute of the University of Chicago, A 22213.

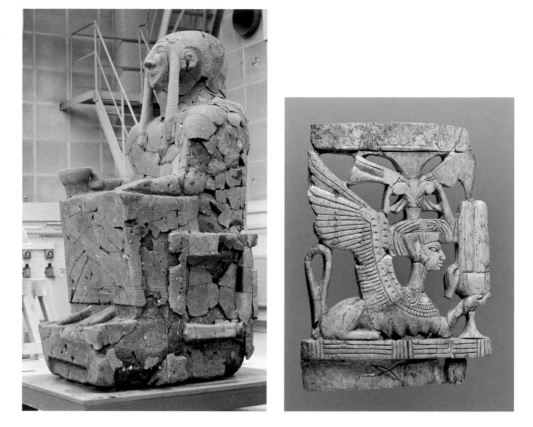

While ruler portraits followed a regional tradition in the Levant, the luxury goods produced in that region followed a totally different stylistic tradition. The Levant was a production and distribution center for luxury goods strongly influenced by Egyptian art. These works were desired by the elite throughout the Near East both for their innate beauty and their exotic associations. As early as the beginning of the second millennium BCE sophisticated rulers of city-states like Ebla (modern Tell Mardikh in northern Syria) collected Egyptian-style ivories.[15] The market for these small boxes, bowls, and combs, and for the plaques used as inlay on thrones, beds, and tables supported regional workshops of varying skill. Some ivories, like the small bowls whose slender handles take the forms of a nude swimming girl,[16] may have been made in Egypt, but most were made in the Levant. Extremely skillful local versions of Egyptian themes were excavated at Megiddo in what is now northern Israel. Found in a semi-subterranean room in the palace complex (Area A) called "the Treasury" by the excavators, they were part of a hoard of some three hundred eighty ivory objects assembled by the ruling dynasty over more than a century.[17]

The winged recumbent sphinx with an offering bowl drew on Egyptian motifs but was rendered in a more local style (fig. 3.11). Other ivories showed Myceneaen and even Hittite influence. The majority of the Megiddo ivories were produced in the Near East even though they featured Egyptian motifs. Similar collections of carved ivories with varied styles were also excavated at Lachish to the south and on or near the coast to the north at Byblos and Ugarit (modern Ras Shamra). Throughout the Levant in the second millennium BCE the demand for Egyptian luxury goods was substantial and it appears that local workshops continued to supply the demand, though bone was sometimes substituted for the more exotic elephant or hippopotamus ivory. It was customary for ivory plaques like the one in Plate 34, and inlays for luxury

furniture or decorative panels, like the one in Plate 33, to incorporate Egyptian elements when neither the patron, the craftsman, nor the material was necessarily Egyptian.

By the first millennium BCE Assyrian kings in Mesopotamia held huge collections of ivories in their palace storerooms at Kalhu (modern Nimrud), Til Barsip, and Nineveh. Nimrud alone held thousands of ivories in its storerooms, palaces, and temples.[18] Egyptianizing metal bowls of bronze, silver, and gold were another luxury product of the Levant. These goods, like the elegant silver dish from the Walters Art Museum (Plate 35), present Egyptian motifs on objects that were themselves not Egyptian, or add Egyptian-style details to images that were made locally.

Collecting exotic luxury goods was, like war and hunting, a royal prerogative. And war, or perhaps merely the threat of war, could also add to the royal storerooms. The decorative bronze plates from the Assyrian gate at Balawat (see fig. 1.25) show gifts brought to the Assyrian king from Sidon and Tyre on the coast of the Mediterranean. And the Black Obelisk of the Assyrian king Shalmaneser III (ruled 859–824 BC), which dates to about 841 BCE, records in words and images the tribute brought from the Levant: "The tribute of Jehu, son of Omri: I received from him silver, gold, a golden bowl, a golden vase with pointed bottom, golden tumblers, golden buckets, tin, a staff for a king [and] spears."[19] Ornate silver and bronze bowls and plates like the one in Plate 35 were exported as far west as Italy[20] and as far east as Iran.[21]

Anatolia

Images of human rulers in early Anatolia are difficult to identify; our knowledge of the third millennium is incomplete and the documentation is spotty. The art of that period featured elegant cast metalwork, and animal figures combining gold, silver, and electrum (see fig. 4.5), but human forms are relatively uncommon. Those that do exist, like the nude female figure from Alaça Hüyük,[22] seem to be deities. By the middle of the second millennium BCE the Hittites, an Indo-European speaking people, consolidated their rule over the other peoples of Anatolia and became a major player internationally. We know from written accounts of the time that the Hittites fielded powerful armies and challenged the Egyptians for control of the northern Levant. But Hittite art included no scenes of warfare. The standard portrayal of the king emphasized his piety (see fig. 4.7), showing him in various religious contexts. At the dynastic shrine of Yazýlýkaya, the ruler Tudhalyia IV is shown in a large relief in Chamber B literally under the arm of his patron god, Sharuma, whose own tall headgear enhances his size (fig. 3.12).

Tudhaliya is clean-shaven following the Hittite custom, and appears to have short hair, two characteristics that distinguish Hittite kings and princes from the other, uniformly bearded, rulers of the ancient Near East—even the Egyptian kings wore false beards in public. Tudhaliya wears a long, flowing robe or cloak that obscures most of his body. He holds a long staff with a curved lower end in his left hand while his right is clasped by the god. The merging of the king's form with that of the god makes a powerful visual statement that the two are one and that the king is divinely sheltered. Sharuma holds a hieroglyphic cluster forming his name in his right hand, while behind him, and above the king's head, is a large grouping of Luwian hieroglyphs giving the king's formal name and title. The Hittites invented their own

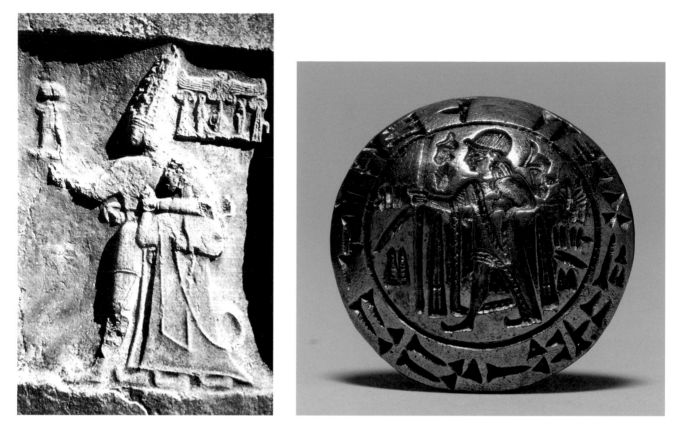

Figure 3.12. Rock relief of the Hittite god Sharuma and the Hittite king Tudhalyas IV from Chamber B at Yazýlýkaya, Turkey, 13th century BCE.

Figure 3.13. Seal of Tarkummuwa, King of Mera; Turkey, Hittite, ca. 1400 BCE; silver; H: ⅜ in. (1 cm), W: 1⅝ in. (4.2 cm); The Walters Art Museum, Baltimore, Maryland, 57.1512.

hieroglyphs, perhaps inspired by the prestige of their Egyptian opponents. Used on reliefs and other works directly associated with royalty, their meaning was restricted to a very small group, with that limitation serving to emphasize the elite status of the king.

The silver stamp seal of Prince Tarkamuwa features a similar royal figure with a long robe and pointed shoes (fig. 3.13). The prince's title in hieroglyphics fills the circle, but the rim of the seal bears a cuneiform inscription with his name. Cuneiform writing was used by the Hittites for all other functions from accounting and diplomatic letters to prayers and rituals.

The successors to the Hittites in eastern Anatolia in the early first millennium BCE, the Urartians, have left us no large-scale images of their kings or queens. In fact their surviving art has little in the way of human imagery save for the small mounted warriors that decorate their wide bronze belts (see Plate 36).[23] The focus on metalworking and martial images with men bearing weaponry may reflect the Urartians' balancing act as they tried to keep the Assyrians at bay and also expand their own influence in northwestern Iran.

Iran

Aside from simplified female figures from the Neolithic and slightly later periods[24] and occasional figures painted on vessels,[25] we have little figurative art in Iran until the late fourth millennium, at least to judge from a small cache of stone figures from Susa.[26] Few images of the ruling elite have survived even from the third millennium. Historically, we know that Mesopotamian rulers often controlled southwestern Iran, and that the life of the elite reflected

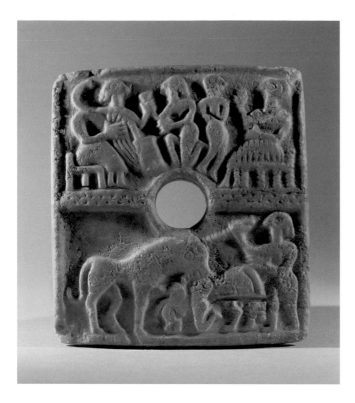

Figure 3.14. Perforated relief of banquet scene and two men fighting a wild animal; Iran, from the Ninḫursaǧa Temple on the acropolis at Susa, 2600–2400 BCE; limestone; H: 6 ¹¹⁄₁₆ in. (17 cm), W: 6 ⁵⁄₁₆ in. (16 cm); Musée du Louvre, Paris, Sb 41.

Mesopotamian styles and usage. The stone plaque in fig. 3.14 presents the Mesopotamian themes of feasting and hunting, but the style is odd and provincial, with rubbery figures and a cluttered hunting scene that is squashed in on the right. It was excavated in a deposit of old (or out of fashion) furnishings in the temple of Ninḫursaǧa at Susa, so we cannot be sure of its original placement or function. Similarly, with few identifiable images of Iranian rulers having survived, it is difficult to know if this plaque is typical or an anomaly.

The cultural influences of the Akkadian Period brought naturalism back to the art of Iran despite political and sometimes military disagreements. The intertwining of the ruling elites of both regions makes it hard to draw clear distinctions between the art they created. In the twentieth century BCE, the ostensibly Mesopotamian ruler Bilalama of Eshnunna (modern Tell Asmar in the Diyala region) married his daughter to Tan-Ruhuratir, king of Susa. Bilalama seems to have been ethnically Elamite, and it is not clear how he came to rule a Mesopotamian city-state.[27] Whatever the case may be, one can imagine that royal gifts flowed both ways on such a state occasion. Our best documentation comes from cylinder seals or their impressions, as no large-scale sculpture has come down to us. By the early second millennium BCE Elamite rulers and nobles showed themselves in the Mesopotamian mode, as pious worshippers before their gods, despite whatever military action they may have pursued to reach that state.

One of the few extant large sculptures is the stele of king Untash-Napirisha who ruled from Susa in the fourteenth century BCE. Once smashed into fragments, the surviving pieces of this relief are sufficient to show its basic composition, which once included a series of at least four rectangular panels (fig. 3.15). The ruler himself takes up relatively little space on the monument compared to the many divine and supernatural beings that support the upper register, where

Figure 3.15. Reconstruction drawing of the stele of King Untash-napirisha from Susa, Iran, ca. 14th century BCE; the stele is currently in the collection of the Musée du Louvre, Paris.

Figure 3.16. Statue of Queen Napirasu, wife of King Untash-napirisha; Iran, from Susa, ca. 14th century BCE; copper and bronze; H: 50 13/16 in. (129 cm); Musée du Louvre, Paris, Sb 2731.

Untash-Napirisha worships or addresses a god. The shape of the stele and the top register echo the Hammurabi stele, but the god being worshipped is larger than the king, and is a version of the snake deities of the Kurangun relief (see fig. 2.29). Here the deity sits on a snake throne and holds the hissing head of the snake rather like a scepter. Below this panel is a second one with Untash-Napirisha and his wife Napirasu, identified by inscriptions on their arms, standing before a priestess named U-tik who may have been the king's mother.[28] Below this panel a pair of plump goddesses hold flowing vases whose streams connect to rivers coming from the hems of their mountain skirts. Below the goddesses are hybrid ibex-men with snakelike tails who stand to the left and right of a central treelike form. Undulating serpent bodies frame the entire stele, culminating with the snakes' heads meeting over the worship scene at the top.

A heavy bronze and copper life-size statue of Untash-Napirisha's queen, Napirasu, indicates the monumentality and power royal portraits could have. Cast of nearly pure copper over a solid core of high-tin bronze, it was once covered with a fine layer of gold that was crimped into the narrow vertical slots on each side.[29] Napirasu stands, her hands folded at her waist, dressed in an elaborate robe patterned all over with small dotted circles (fig. 3.16). A long undulating fringe at the hem of her skirt calls to mind the streams of the water goddesses on her husband's stele. What seems to be a shawl with broad appliquéd or embroidered bands and a fringed pointed end is pinned to her right shoulder and upper arm. An inscription at the end of the point begins "I, Napir-Asu, wife of Untash-Napirisha . . . " and goes on to curse anyone who defaces her name or statue. The inscription ends, "This is Napir-Asu's offering." Although the

statue has lost its head and left shoulder, it remains intact otherwise primarily owing to its solid construction and weight of more than 3,700 pounds. The wonderful naturalism of the sculpture, particularly the relaxed, capable hands, contrasts with the stereotypical rendering of the queen on her husband's stele. At present it is hard to characterize the art of this period since even when commissioned by the same patrons its artists produced two monuments of such differing styles.

Our understanding of Elamite art is further complicated by the military success of the twelfth century BCE king Shutruk-Nahhunte, who conquered parts of southern Mesopotamia and carried off—among other works—the Naram-Sin Stele (fig. 3.4). Not only did he install Naram-Sin's stele in Susa, but he also placed his own triumphant inscription on it. Yet this was not the only Mesopotamian sculpture in Susa. The Hammurabi Stele (see fig. 2.17) was found there as well. Since the Hammurabi Stele was not reinscribed, we don't know who was responsible for the move. But its seizure by the Elamites does show that it was above ground and visible in Mesopotamia for hundreds of years, and that it was then visible to Elamite artists for a substantial period after that.

Surviving royal Elamite sculptures of the first millennium BCE were based on the formulaic seated figure/standing figure composition, and were, in effect, repetitions of the Hammurabi Stele. In contrast, the art of the rulers of northern and western Iran had a different vocabulary. The rich tombs excavated at Marlik near the Caspian Sea were full of long swords, daggers, and spears as well as decorated vessels of gold, silver, and bronze. Some works were made locally and others may have been gifts of vassal peoples from Mesopotamia, held as heirlooms before they were deposited in the elite graves. But of the few human representations found, both the styles (and probably dates) vary widely.[30] In the absence of writing, we cannot know the identity of these people. In contrast, the regional rulers of the Zagros Mountains were linguistically Elamite but seem to have been independent princelings. They alternated between being vassals of the Assyrian kings of Mesopotamia, clients of the Elamite rulers of Susa, or independent polities who even dealt with the Urartians. In their art they exploited the Mesopotamian vocabulary of military might and prowess in the hunt to signal their status without direct references to kingly hierarchies.

The citadel of Hasanlu in northwestern Iran (see fig. 1.32), which was sacked sometime after 800 BCE, illustrates the nature of the arts favored in this region, a mixture of old and new, local and imported luxury goods (see fig. 2.30). Warfare, hunting, and feasting were typical themes on metalwork objects (fig. 3.17) as well as on carved ivories. A silver beaker with a nontarnishing electrum overlay combines both themes in its décor. The upper register features elements that could have been copied from an Assyrian relief: a bearded man drives a chariot bearing an archer while a third party falls from the back of the chariot box. Behind the chariot group comes a man with open arms who is led (or chased?) by an armed man leading a horse followed by an archer on foot. The lower register features the hunt: a bull and a lion, each followed by an archer, confront each other while a ewe-like animal fills the remaining space.[31] The execution of the palmette ornament at the top and bottom of the beaker is simplistic, as are the figures, but the overall result is a lively drinking cup with no reference to royal authority.

Figure 3.17. Drawing by G.
F. Muscarella of a silver and
electrum beaker from Burned
Building I-West, room 1, at
Hasanlu, Iran; the beaker is
currently in the collection of the
Iran Bastan Museum, Tehran.

Figure 3.18. Headless statue
of King Darius; Iran, from
the Palace of Darius at Susa,
reign of Darius, 522–486 BCE;
greywacke; H: 76 ¾ in. (195 cm);
Iran Bastan Museum, Tehran,
4112/1968.

The presence on the Hasanlu beaker of horses that are both driven and led is another distinctive Iranian characteristic. The heroic ruler/hunter on horseback appears on ivories, seals (Plate 40), and painted pots in the early first millennium BCE, with the dynamically leaping horse enlivening the by-now stereotypical scenes.

The Achaemenid Persians, who succeeded the Babylonians and Assyrians as rulers of western Asia, merged aspects of all the cultures they ruled, including Egypt, into their art. Darius (ruled 522–486 BCE) followed the customary depiction of rulers in showing himself as an impassive, static figure. In at least one sculpture, however, he added a distinctive aspect to the image. His over life-size statue, carved in Egypt, shows the Achaemenid king dressed in Persian robes with a Persian *akinakes* sword in his belt standing in a stereotypical Egyptian royal pose, the left foot advanced and the left hand, with its clenched fist, folded across the chest (fig. 3.18). On the sides of the rectangular base Egyptian depictions of conquered people—complete with hieroglyphs in cartouches—record the king's victories, while the front of the base shows the symbols of Upper and Lower Egypt, the lily and the papyrus, tied together, another stock motif in Egyptian royal representation. After being quarried and carved, this huge piece of stone, measuring more than six feet high without the head and shoulders, was shipped from Egypt to Susa in southwestern Iran, where it was installed in a gateway of the Achaemenid palace. The combined stylistic elements of the sculpture intentionally paralleled the various peoples and cultures united in the Achaemenid empire. The image of the king was literally a summation of his realm.

1 See Joan Aruz, with Ronald Wallenfels, eds., *The Art of the First Cities: The Third Millennium BC from the Mediterranean to the Indus* (New York: Metropolitan Museum of Art; New Haven, CT: Yale University Press, 2003), 24–25.

2 For the political role that this vase played in the aftermath of the Iraq invasion in 2003, see Matthew Bogdanos, "The Casualties of War: The Truth About the Iraq Museum," *American Journal of Archaeology* 109(3), 2005): 478–480, and 497–498, who dubs it "the Sacred Vase of Warka" (its usual title is simply the Uruk or Warka Vase). See also http://oi.uchicago.edu/OI/IRAQ/dbfiles/objects/14_2.htm (accessed 5-24-2013), where the original plaster restorations can be clearly seen as pinkish areas.

3 For the Gudea inscription, see the Cuneiform Digital Library Initiative [CDLI], at www.cdli.ucla.edu/cdlisearch/search/index.php?SearchMode=Text&ResultCount=1000&txtCont ent=gudea+statue+B&requestFrm=Search&txtPrimaryPublic ation=&order=primary_publication&txtAuthor=&txtDate_ publication=&txtOther_Publication=&txtCollection=&txtAcces sion_Number=&txtMuseum_no=&txtProvenience=&txtExcavati on_Number=&txtPeriod=&txtDates_Referenced=&txtID_Txt=& txtATFSource=&txtCatalogueSource=&txtTranslationSource=&tx tObjectType=&txtObjectRemarks=&txtMaterial=&txtSealID=&t xtLanguage=&txtGenre=&txtSubGenre= (accessed 5-22-2013).

Lines 21 to 53 of the 365 lines of this inscription read: "For Ningirsu, strong hero of Enlil, Gudea, he of lasting fame, ruler of Lagash, the shepherd chosen by the heart of Ningirsu, regarded favorably by Nanše, given might by Nindara, a person subject to the word of Baba, child born by Gatumdug, given authority and a great scepter by Igalima, richly provided with encouragement by Šulšaga, rightful head of the assembly come forth in splendor of Ningešzida his (personal) god, when Ningirsu had directed his righteous gaze towards his city, and Gudea he had chosen as the rightful shepherd in the nation, and out of 36,000 people had taken him by the hand, he (Gudea) sanctified the city and refined it with fire. He set up the brick mold, and chose the (first) brick by kid-omen . . . "

4 Aruz and Wallenfels, *Art of the First Cities*, 307.

5 Marie-Henriette Gates, "Artisans and Art in Old Babylonian Mari," in *Investigating Artistic Environments in the Ancient Near East* (Washington, DC: Arthur M. Sackler Gallery, Smithsonian Institution, 1990), 29–30.

6 Aruz and Wallenfels, *Art of the First Cities*, 22–24, figs. 5–8.

7 Irene J. Winter, "Tree(s) on the Mountain: Landscape and Territory on the Victory Stele of Naram-Sîn of Agade." In L. Milano, et al., eds., *Landscapes: Territories, Frontiers and Horizons in the Ancient Near East, Part I. Invited lectures* [History of the Ancient Near East, Monograph III/1], 63–72 (Padova, Italy: Sargon, 1999).

8 Irene J. Winter, "How Tall was Naram-Sîn's Victory Stele? Speculation on the Broken Bottom," in Donald P. Hansen and Erica Ehrenberg, *Leaving No Stones Unturned: Essays on the Ancient Near East and Egypt in Honor of Donald P. Hansen*, 301–311 (Winona Lake, IN: Eisenbrauns, 2002).

9 Prudence O. Harper, Joan Aruz, and Françoise Tallon, *The Royal City of Susa: Ancient Near Eastern Treasures in the Louvre* (New York: Metropolitan Museum of Art, 1992), 159–162.

10 Jean M. Evans, *The Lives of Sumerian Sculpture: An Archaeology of the Early Dynastic Temple* (Cambridge, UK: Cambridge University Press, 2012); pages 100, fig. 36, and 104, fig. 39, show stone plaques dedicated by a merchant and a master craftsman, respectively.

11 Evans, *Lives of Sumerian Sculpture*, 105–106, 131–139, 195, 206–208.

12 Aruz and Wallenfels, *Art of the First Cities*, 175–177.

13 Gates, "Old Babylonian Mari," 33.

14 For more on the Tell Halaf Project, see www.tell-halaf-projekt.de/en/index_eng.html (accessed on 5-15-2013).

15 For more on the palaces of Old Syrian Ebla, see www.ebla.it/escavi__i_palazzi.html (accessed on 5-10-2013).

16 Gordon Loud, *The Megiddo Ivories* (Chicago: University of Chicago Press, 1939), plates 40–42, Oriental Institute Publication 52; and Richard D. Barnett, *Ancient Ivories in the Middle East and Adjacent Countries* (Jerusalem: Institute of Archaeology, 1982. QEDEM 14, Monographs of the Institute of Archaeology, The Hebrew University of Jerusalem), plates 11b and 16 e–f.

17 Amnon Ben-Tor, ed., *The Archaeology of Ancient Israel*, trans R. Greenberg (New Haven, CT: Yale University Press, 1992), 254.

18 Barnett, *Ancient Ivories*, 50–53.

19 For more details on the Black Obelisk of Shalmaneser III, see www.britishmuseum.org/explore/highlights/highlight_objects/me/t/black_obelisk_of_shalmaneser.aspx (accessed on 5-15-2013).

20 Glenn Markoe, *Phoenician Bronze and Silver Bowls from Cyprus and the Mediterranean* (Berkeley: University of California Publications, 1985). Classical Studies 6.

21 Javier Álvarez-Mon, *The Arjan Tomb: At the Crossroads of the Elamite and the Persian Empires* (Belgium: Peeters, 2010), 141. Acta Iranica 49.

22 Aruz and Wallenfels, *Art of the First Cities*, no. 181, 279.

23 Elsie Holmes Peck, "A Decorated Bronze Belt in the Detroit Institute of Arts," in Donald P. Hansen and Erica Ehrenberg, *Leaving No Stones Unturned: Essays on the Ancient Near East and Egypt in Honor of Donald P. Hansen*, 183–202 (Winona Lake, IN: Eisenbrauns, 2002).

24 Edith Porada, with R. H. Dyson and C. K. Wilkinson, *Ancient Iran: Pre-Islamic Cultures* (New York: Crown Publishers, 1965), plate 1.

25 Prudence O. Harper, Joan Aruz, and Françoise Tallon, *The Royal City of Susa: Ancient Near Eastern Treasures in the Louvre* (New York: Metropolitan Museum of Art, 1992), no. 2, 33–34.

26 Harper, Aruz, and Tallon, *Royal City of Susa*, 58–67.

27 Clemens Reichel, "A Modern Crime and an Ancient Mystery: The Seal of Bilalama," in Gebhard Selz, ed., *Festschrift Bürkhart Kienast*, 355–389 (Münster, DGR: Ugarit, 2003). Alter Orient und Altest Testament 274.

28 Harper, Aruz, and Tallon, *Royal City of Susa*, 128–130.

29 Peter Meyers, "The Casting Process of the Statue of Queen Napir-Asu in the Louvre," *Journal of Roman Archaeology, Supplementary Series* 39, 2000: 11–18.

30 Ezat O. Negahban, *Marlik: The Complete Excavation Report.* 2 vols. (Philadelphia: The University Museum, University of Pennsylvania, 1996), figs. 4, 5, 7, 11, and 12; color plates XIB, XXA, and XXII; plates 23, 32–35, and 96.

31 Maude de Schaunsee, *Peoples and Crafts in Period IVB at Hasanlu, Iran* (Philadelphia: University of Pennsylvania Museum of Archaeology and Anthropology, 2011), 67, 69–71. Hasanlu Special Studies IV. Museum Monograph 132.

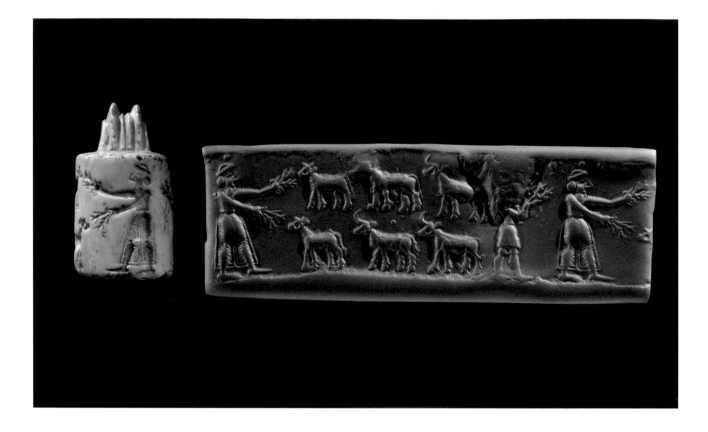

PLATE 24

Cylinder seal with
king feeding rows
of cattle

Iraq, late Uruk-Jemdat Nasr
Period, 3300–2900 BCE; marble;
H: 2 ½ in. (6.3 cm), Diam.: 1 ½
in. (3.8 cm); Yale University
Babylonian Collection, New
Haven, NBC 2579.

This seal, carved with its own suspension loop,
bears a scene showing a male figure extending
branches of vegetation to two rows of cattle, a calf
followed by two cows in each row. The man, who
wears a patterned, netlike skirt, has been identi-
fied as a ruler or priest-ruler. He is attended by a
second figure, now partly damaged by a chip in
the stone, who carries additional leafy branches.
Cattle were prestige livestock in that they needed
far more care in the Mesopotamian climate than
sheep or goats. This image of the ruler feeding his
cattle was not merely a picture of good animal
husbandry but carried the message that he was
a ruler who cared for his people as he cared for
his herds, much like a good shepherd. We know

that in other representation of abundant herds
the animals' fruitfulness is credited to the goddess
Inana. Thus, although this scene may appear to be
a secular one, it may also imply Inana's support of
the beneficent ruler.

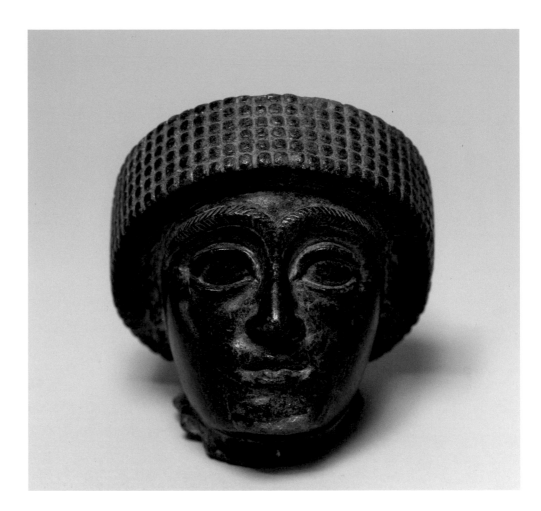

PLATE 25

Head of Gudea

Iraq, possibly from Telloh,
Second Dynasty of Lagash,
reign of Gudea, 2144–2124 BCE;
diorite; H: 3¾ in. (9.5 cm), W:
3½ in. (9 cm), D: 3½ in. (9 cm);
University of Pennsylvania
Museum of Archaeology and
Anthropology, purchased from
Hagop Kevorkian, 1927, B16664.

This beautifully carved head of diorite, a hard
and fine-grained stone, depicts the ruler Gudea of
Lagash, who ruled southern Mesopotamia from
about 2144 to 2124 BCE. It could have belonged
to a seated statue like the one in fig. 3.2 or to a
standing figure of a slightly smaller size. The tightly
ordered curls of the headgear and the finely incised
chevrons of the joined brows contrast with the
soft carving of the eyes, nose, mouth, and rounded
chin. The head shows the same combination of
regular textured patterns and soft naturalistic
modeling as other Gudea portraits, most of which
came from the site of Telloh. A master sculptor has
given the dense, difficult to work stone the appar-
ent responsiveness of clay. Gudea was well aware

that the durable and exotic material of his portraits
enhanced his status as a ruler, even after his death.
He boasted in a number of inscriptions that he
imported this stone from Magan, a region in what
is now modern Oman, as an illustration of his
economic status as well as his political reach.

PLATE 26

Foundation figure of
Shulgi, King of Ur,
Sumer, and Akkad

Iraq, Neo-Sumerian Period,
reign of Shulgi, 2094–2047 BCE;
bronze; H: 9 ⅜ in. (23.8 cm),
W: 3 in. (7.6 cm), D: 2 in. (5.1
cm); Virginia Museum of Fine
Arts, Richmond, Adolph D. and
Wilkins C. Williams Fund, 58.6.1.

This is also a foundation figure like those in Plates 2 and 4, but here the deity is replaced by a king. In this case the king is Shulgi, who ruled Ur and a large portion of southern Mesopotamia and southwestern Iran. Shulgi is shown carrying a small basket of earth on his head like a common laborer, in a symbolic gesture rather like that of a modern official turning the first shovel of earth at a building site. The inscription, which wraps completely around the lower, peg-like body, gives Shulgi's multiple titles and claims credit for the rebuilding of Inana's temple E-ana (House of Heaven), which was in Uruk. The substitution of the king for the usual foundation god suggests that Shulgi desired to appear a bit more than mortal. Shulgi succeeded his father-in-law Ur-Namma as ruler of Ur, and eventually expanded his realm into southwestern Iran. Foundation figures of the same type have been excavated at Susa. The inscriptions on the Susa figures follow the same formula as the Meso-potamian examples, only substituting the names of

other, sometimes local, deities for Inana. Shulgi's titles remain the same.

Foundation figures were produced in some quan-tity using a two-piece mold called a bivalve, and were only roughly finished. One can still see the mold marks at the inside of the arms and the sides of the head where the molten metal seeped between the seams of the mold. Fortunately the inscription was clearly cut into the original metal and remains quite legible, unlike the face which seems relatively unfinished. Perhaps the written word carried protective power for these little fig-ures, which carried out their magical work sealed in a brick box buried near the door of the temple.

Inscription:
To Inana, lady of E-ana, Shulgi, mighty man, king of Ur, king of Sumer and Akkad;
E-ana to its place he restored it; its great wall he built.

PLATE 27

Plaque with a royal
worshipper holding
a kid

Iraq, excavated from Tell
Diqdiqqeh, near Ur, Old
Babylonian Period, 2000–1600
BCE; clay; H: 3 in. (7.7 cm), W:
2⅝ in. (6.7 cm); University
of Pennsylvania Museum of
Archaeology and Anthropology,
Joint British Museum/
University Museum Expedition
to Mesopotamia, 1st Season,
1922–1923, B15182.

This fragmentary clay plaque shows the head and
torso of a bearded man with a round-brimmed
hat and off-the-shoulder robe like that worn by
kings from Gudea (Plate 25) to Hammurabi (fig.
2.17) and later. The man carries a small goat in
both hands as if it were an offering like that carried
by the worshipper in Plate 8, who also wears the
same cap and robe. Plaques of this sort are gener-
ally considered votive offerings and were produced
in multiples from an open-faced mold into which
a slab of clay was pressed. Occasionally details
could be added after the clay was removed from
the mold, but for the most part they were mass-
produced. It is unlikely that a king would himself
offer such a humble work, but someone wishing

to ingratiate himself with the king—or the king's
secretary—might dedicate such a plaque.

See C. Leonard Woolley, M.E.L. Mallowan, and T. C.
Mitchell, *Ur Excavations*, Joint Expedition of the British
Museum and the Museum of University of Pennsylvania,
vol. 7, *Old Babylonian Period* (London: British Museum
Publications, 1976), plate 73, no. 82.

PLATE 28

Vessel fragment with
a musical procession

Iraq, excavated from Bismaya,
Mid-to-Late Early Dynastic
Period, 2700–2500 BCE; chlorite
with limestone or marble inlay;
H: 4 ½ in. (11.4 cm), W: 7 ⅞ in.
(20 cm); The Oriental Institute
of the University of Chicago,
A195a, b, c.

This fragment of a round stone vessel is decorated along the base with four musicians—two string players, a drummer, and a trumpeter—and at least five additional though incomplete figures, one in the musical procession, four running toward it. All wear kilts or skirts that were once inlaid with white stone; only one of the inlays remains in the figure at the far left. A second noncontiguous fragment bears the upper portion of a figure with elaborate headgear. The oval eyes of all the apparently male figures as well as the leafy branches were also once inlaid, although the inlays are now missing. A tiny speck of blue lapis lazuli was noted in a leaf at excavation, but nothing remains now. When new, the vessel would have been very colorful. The discovery of a third piece in the Eski Şark Museum, Istanbul, connects the two Chicago fragments. As shown in the drawing, the Istanbul piece expands the scene considerably. It completes the two figures on the far left and adds two more figures and part of a lattice-like structure.

The absence of a register or horizon line, the varied postures of the plump figures, the leaves or

feathers in their hair, and the small branches of vegetation create a lively nonhierarchical composition quite distinct from the more organized linear Mesopotamian style. Although the relief was excavated in Mesopotamia, it was made elsewhere. The softstone from which the vessel was cut was a luxury material exported from various localities in the Persian Gulf in the third and early second millennium BCE. Fragments of vases with similar figures have been found at Mari and Khafaje in Mesopotamia, on the western shore of the Persian Gulf, and in southwestern Iran, though there is as yet no consensus as to where along the gulf they were produced. We do not know if the images on the Bismaya vessel had a particular meaning for the owner, or if it was merely valued for its rarity and exotic design.

See Karen L. Wilson, Jacob Lauinger, et al., *Bismaya: Recovering the Lost City of Adab* (Chicago: Oriental Institute of the University of Chicago, 2012), plates 55 and 105. Oriental Institute Publication 138.

Female figure

Iraq, excavated from Khafaje,
Mid-to-Late Early Dynastic
Period, 2700–2500 BCE;
alabaster; H: 12 ⅛ in. (30.8 cm),
W: 6 ⅛ in. (15.5 cm), D: 5 ½ in.
(14 cm); University of
Pennsylvania Museum of
Archaeology and Anthropology,
Joint Bagdad School/University
Museum Expedition to
Mesopotamia, 1938, 38-10-49.

In contrast to the often slablike figures from
Khafaje, this female votive figure is markedly
sculptural in its form. While the smooth robe
covers almost all the figure, the swelling shape of
the substantial body, the breasts, the elbow, and
the ample hips are fully rendered as if the hard
stone were malleable clay. The simplicity of the
general shape and the varied modulation of the
contours make this an outstanding piece of stone
sculpture even in its present damaged state. The
damage occurred at two different times. First the
statue lost its head. Then the hands and lower
arms of the statue were intentionally chipped off.
If the statue had merely fallen from a height suf-
ficient to break off the head and totally destroy
the hands, the breasts would also have been sub-
stantially damaged. Since they are not, and since
the arms and hands are completely gone but the
stone surface adjacent to them is not damaged,
one must conclude that the damage to the hands
was intentional. At a later time the broken neck
was roughly smoothed and a mortise was drilled to

secure a new head, but this head was subsequently
lost. It is possible that the hands were restored in
plaster when the new head was attached, but this
is speculation. At an undetermined point the stone
also suffered damage from heat, probably fire,
which can be seen on the opaque white area on
the front of the robe. Given the use of oil lamps in
Sumerian temples, an accidental fire would not be
unexpected.

We do not know enough of the internal history
of Khafaje to know exactly when and why these
varied damages occurred. But the "execution" and
rehabilitation of the sculpture suggest a high level
of social upheaval. Since there is no inscription on
the sculpture, we do not know who was intended
as the focus of this mutilation, but it is clear that
she was a prominent member of the elite.

See Henri Frankfort, *More Sculpture From the Diyala
Region* (Chicago: University of Chicago Press, 1943), no.
241, plate 24. Oriental Institute Publication 60.

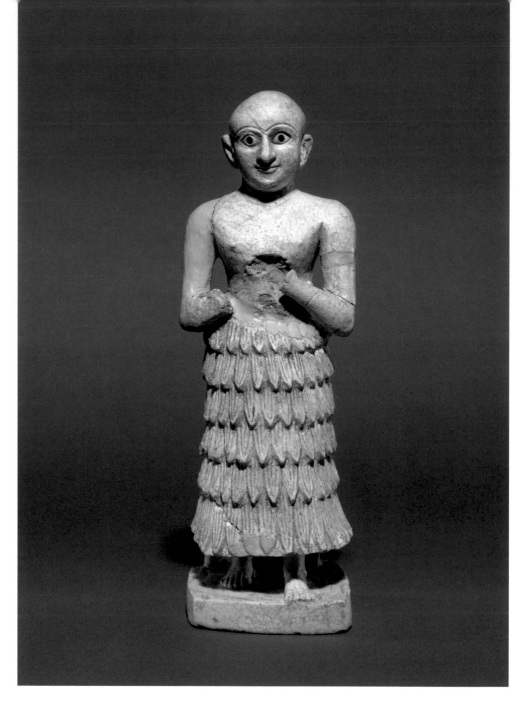

PLATE 30

Male figure

Iraq, excavated from the Nintu Temple, Level VI, Room Q 44: 151 at Khafaje, Mid-to-Late Early Dynastic Period, 2700–2500 BCE; alabaster, shell, and lapis lazuli; H: 9 in. (23 cm), W: 3 ⅛ in. (8 cm), D: 2 ¾ in. (7 cm); University of Pennsylvania Museum of Archaeology and Anthropology, Joint Bagdad School/University Museum Expedition to Mesopotamia, 1937, 37-15-28.

This votive statue was created to represent the patron standing in prayerful attention before a deity in a temple or shrine. The naturalism of the bare torso and the soft and subtle modeling of the head with its small mouth and round chin contrast with the regular rows of pointed tufts on the columnar skirt that obscures the body beneath. A profile view of the head shows how carefully the sculptor observed the plump jaw and the folds of flesh on the back of the neck. The inlaid eyes and slight smile evoke a lively presence and a distinct individuality. However, the damaged state of the sculpture is not random but was the result of intentional mutilation. The body was broken in several pieces that were found together, but the hands, which should have adhered to the torso, were struck off altogether and removed.

The individual who commissioned this sculpture was probably not available when the upheaval happened, but his statue was and so suffered a symbolic execution. This practice, of course, is not limited to the ancient Near East. One has only to remember how the Baghdad statue of Saddam Hussein was pulled down in 2003 to see a modern parallel. Three additional male heads having a very similar style were recovered from Khafaje indicating that this talented sculptor was quite productive.

See Henri Frankfort, *More Sculpture From the Diyala Region* (Chicago: University of Chicago Press, 1943), no. 232, frontispiece, plates 19, 20. Oriental Institute Publication 60.

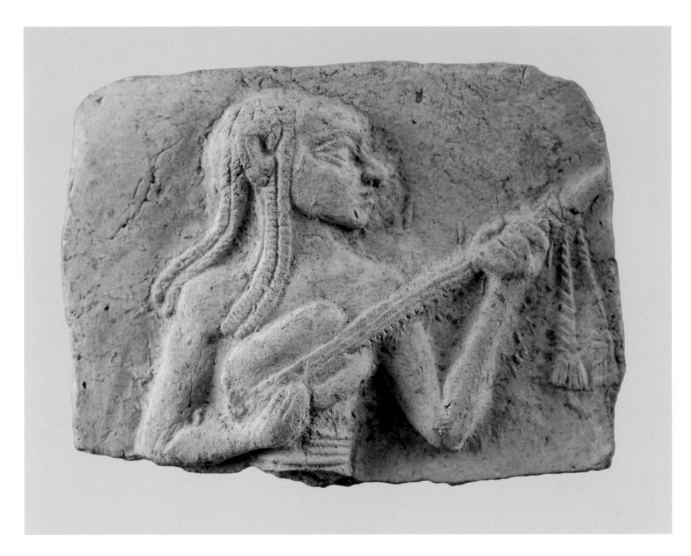

PLATE 31

Plaque with a lute player

Iraq, from Ishchali, Old Babylonian Period, 2000–1800 BCE; clay; H: 2 in. (5 cm), W: 2 7/16 in. (6.2 cm); The Oriental Institute of the University of Chicago, A9357.

This fired-clay plaque depicts a clean-shaven man playing a lute-like stringed instrument that has decorative tassels hanging from its neck. These tassels echo the player's ropelike locks of hair that fall over his shoulder and on his back. The image is distinctive for its subject matter as well as for the unusual hair arrangement, which has parallels in Egypt during the second millennium BCE. But long, wavy hair and clean-shaven faces are characteristic of Mesopotamian musicians of the third millennium BCE. Perhaps the coiled locks are a second millennium BCE equivalent, indicating a profession rather than an ethnic group. Music played a major role in both religious activities and secular celebrations, and a wide variety of stringed instruments are documented in texts. This plaque gives us a rare glimpse of one of the secondary, though necessary, figures in the rituals and festivities of the time.

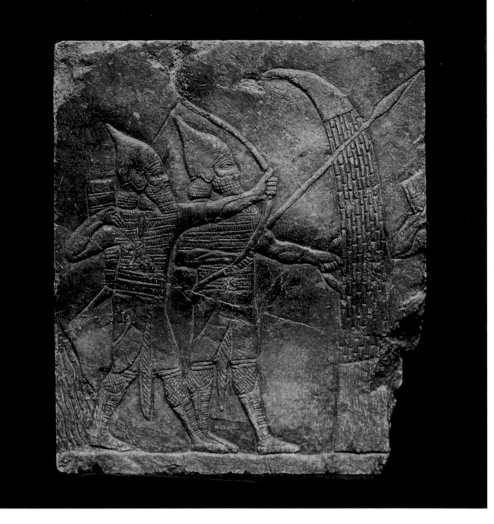

PLATE 32

Relief fragment with a battle scene

Iraq, excavated by William Kennett Loftus in August of 1854 from the Southwest Palace of Sennacherib at Nineveh, Neo-Assyrian Period, reign of Sennacherib, 705–681 BCE; limestone or gypseous alabaster; H: 10 in. (25.4 cm), W: 8 ½ in. (21.6 cm); Seattle Art Museum, Eugene Fuller Memorial Collection and Hagop Kevorkian, 46.49.

This fragment, cut from a larger wall relief in the nineteenth century, shows a pair of Assyrian soldiers in identical garb. One is an archer; the other wields a spear and with a large curving shield protects both fighters. This is not a random pairing but reflects Assyrian military practice featuring specialized combatants who work in concert with others (see fig. 3.5). On the right side of the fragment, the remains of the raised elbow of another archer indicate that the full relief showed a line of similar warriors. They would all have been part of a standard siege scene. The small bit of rippling water at the lower left would have been part of the landscape, indicating where this action took place. Unfortunately not enough details remain to link it to a particular room in the palace.

This fragment still bears on its reverse a handwritten note in nineteenth-century penmanship:

> This fragment was exhumed from the palace of Ashur.banipal II in the centre of the mound called Koyunjik at Nineveh, Aug. 1854. Dated about 670 BC

> Presented to Th. Radford Esq.
> By his affectionate friend
> The discoverer
> Nov. 29, 1856 Wm. Kennett Loftus

Loftus was a naturalist, geologist, and explorer who worked at Uruk, Nimrud, and Nineveh for the Assyrian Exploration fund from 1853 to 1856. At Nineveh he dug briefly at both the North Palace of Ashurbanipal, and the Southwest Palace built by Sennacherib that was later remodeled in part by Ashurbanipal. Hence the confusion as to which king was responsible for which relief in the early days of Assyriology. Thomas Radford was the fifth son of Thomas Radford, Esq. of Smalley Hall, Derbyshire. Loftus died on the voyage back to Britain in 1858 at the age of thirty-eight.

The Seattle relief would appear to be the only Assyrian relief in North America that still bears its gifting inscription. How the piece moved from its original owner to the great dealer-collector Hagop Kevorkian is unknown.

See William Kennett Loftus, *Travels and Researches in Chaldaea and Susiana, with an account of excavations at Warka, the "Erech" of Nimrod, and Shush, "Shushan the Palace" of Esther, in 1849–52* (New York: Robert Carter and Brothers, 1857), pp. 4–5.

PLATE 33

Furniture inlay

Lebanon or Syria, 9th–8th
century BCE; ivory; H: 1 in.
(2.5 cm), W: 1 ⅛ in. (2.9 cm);
The Jewish Museum, New York,
bequest of Anna D. Ternbach,
1996-71.

This small, delicate square, originally carved somewhere on the coast of the Levant, would have been inlaid into a larger work like a box, a chair, or a bed. The frontal female head has hair and head ornaments that show generalized Egyptian characteristics. The short, tightly wound—or perhaps beaded—locks of hair are a style most popular in the Third Intermediate and Late periods (the ninth to sixth centuries BCE), and so reflect roughly contemporaneous styles in Egypt. Yet the face, with its round shape and close-set eyes, is not Egyptian but Near Eastern. Syro-Levantine ivory carvers reinterpreted the Egyptian model for an elite market that stretched from the regional rulers of Syria to the warlords in the Zagros Mountains of Iran. Examples have been excavated throughout the Near East, but the largest hoards have come from the storerooms of the Assyrian palaces at Nimrud, Nineveh, and Khorsabad. A number of plaques of this type still retain their architectural frames, leading some to call this and similar images the "woman at the window." But as far as we can tell the motif has no specific meaning; it simply carries the general association of exotic, luxurious décor with a foreign flavor.

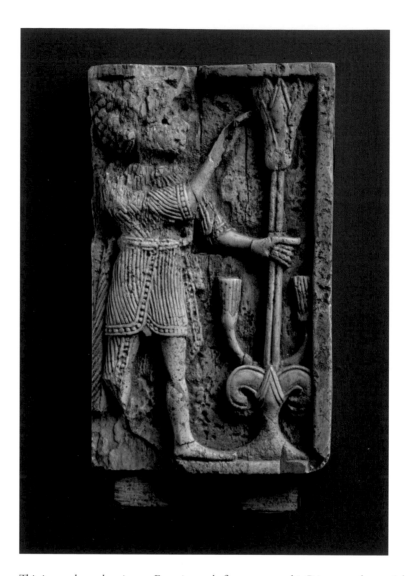

PLATE 34

Plaque with a man
holding a lotus flower

Levant, Phoenician, first half of
the 8th century BCE; ivory;
H: 3 5/8 in. (9.2 cm), W: 1 15/16 in.
(5 cm); Princeton University Art
Museum, museum purchase,
John Maclean Magie, Class of
1892, and Gertrude Magie Fund,
1956-88.

This ivory plaque bearing an Egyptian-style figure
who grasps a tall lotus with a fanciful base is the
sort of luxury item produced at several centers in
the Levant, and collected by the ruling elite across
the ancient Near East. The Egyptian details do
not mean that it was carved in Egypt nor even
that the craftsperson was Egyptian. Egyptian style
was merely the style expected of a certain class of
desirable ornaments. This plaque has two tabs at
the bottom, which would have allowed it to be
inserted into the framework of a piece of furni-
ture like a chair or a bed. The storerooms of the
Northwest Palace in the Assyrian city of Nimrud
yielded thousands of ivory plaques and other orna-
ments when they were excavated between 1845
and 1847 by Austen Henry Layard (1817–1894).
Some of Layard's plaques are virtually identical

to this Princeton plaque. A hundred years later
the British Museum renewed the excavations at
Nimrud under the direction of Max Mallowan.
While Mallowan's finds were split between the
British Museum and the Iraq Museum in Bagh-
dad, according to the formal excavation agree-
ments, Layard's earlier finds were dispersed in a
less orderly manner reflecting the less rigorous
practices of the mid-nineteenth century. The Princ-
eton plaque was given by Layard to a British fam-
ily, probably a supporter of his work, and in 1958
the heirs offered it for sale through the London
auction house of Spink & Son. It was purchased
for the Art Museum at Princeton, and thus moved
from a collection of ivories in an Assyrian palace to
a collection of art in North America.

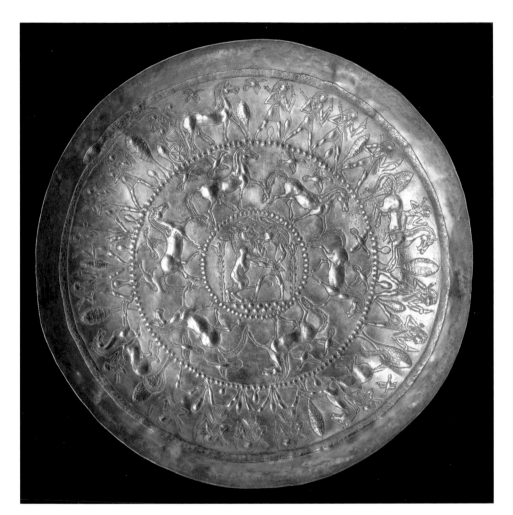

PLATE 35

Bowl with a princely hunting scene

Levant, Phoenician, 8th–7th century BCE; gilded silver; H: 1 ³⁄₁₆ in. (3 cm), Diam.: 9 ¹¹⁄₁₆ in. (24.6 cm); The Walters Art Museum, Baltimore, Maryland, 57.705.

This shallow silver bowl has three zones of decoration. In the central roundel an Egyptian-style figure with a sword grapples with a rampant lion between two tall lotuses and beneath a very simplified protective vulture. Encircling this scene is a band filled by slender prancing stallions with long manes and feathery tails. Above each horse flies a pair of ducklike birds. The third and outermost band features a procession or parade with a chariot followed by armed male figures, some striding, others on horseback. The striding men carry bows and arrows while the mounted men bear clusters of what are either rather short spears or very long arrows. The figures are Egyptian in dress and posture though they are rendered in a cursory manner, unlike most Egyptian metalwork. The military procession is punctuated by tall oar- or paddle-like trees; finally, a scaly snake forms the outer edge of the band. The decorative nature of the design

is underscored by the fact that the chariot horses have only reins but no other harness, and the riders have neither saddle-cloths nor bridles. The visual effect is one evoking princely triumphs or parades without specific details.

These highly decorative silver bowls, often called "Phoenician bowls," were produced in an Egyptianizing style in the Levant for patrons throughout the Near East, just as the carved ivory plaques of Plates 33 and 34 were. Like the carved ivories, the largest collections of these bowls have come from the storerooms of Assyrian palaces, though examples have been excavated as far west as Italy and east into Iran. It is not clear how these bowls functioned other than as an ostentatious display. Many of them are so broad and shallow that it would be difficult to drink from them without spilling the liquid, probably wine, on oneself.

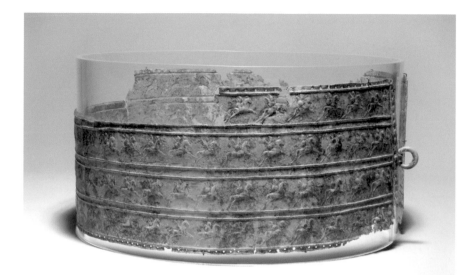

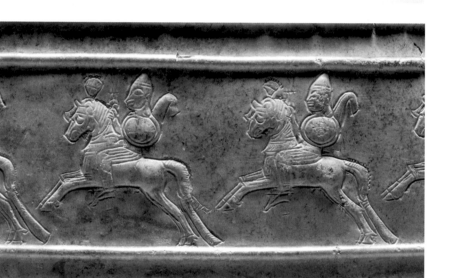

PLATE 36

Archer's belt

Eastern Turkey, Urartian, 8th–early 7th century BCE; bronze; H: 6 in. (15.4 cm); L: 39 ⅜ in. (100 cm); Museum of Art and Archaeology, University of Missouri-Columbia, Weinberg Fund, 84.2.

This wide bronze belt continues an Anatolian tradition of ornate belts known since Hittite times in the second millennium BCE. The belt has four bands of mounted warriors with helmets, small shields, and bowcases. The horses are richly decorated like Assyrian horses with plumes or crests on their heads and decorative bands around their necks and chests. In each band the riders begin from a center area at the back of the belt and progress to the front, with its fastening loop. At the front, each row ends in a striding armed figure holding a raised baton like a marshal. The sheet metal was once mounted on a leather backing secured by stitches through the row of small holes along the edges of the belt, and it is possible

that such belts were actually worn. But their role may have been ostentation rather than practical support. We know that large ornamental shields and weapons were dedicated in Urartian temples by kings and princes, and the same may be true of bronze belts. With its military imagery, this belt could have been a votive dedication to the national god Haldi, a war god. We know that Haldi's temples were full of donated metalwork. When the Assyrian king Sargon II looted the temple of Haldi at Musasir in 714 BCE it took fifty columns of cuneiform text to list the booty he carried off.

PLATE 37

Cylinder seal with a
Persian hero holding
two lions

Iran, Achaemenid Period, 5th
century BCE; chalcedony;
H: 1 ³⁄₁₆ in. (3 cm), Diam.: ⅝ in.
(1.6 cm); Kimbell Art Museum,
2001.05.

This beautifully carved seal is an Achaemenid Persian updating of the hero-with-conquered-beasts motif popular in Mesopotamia from the third millennium BCE onward; see Plate 12 for a later Assyrian example from the first millennium BCE, and Plate 21 for one from Iran. In this version, the hero who upends the lions by a hind leg like snarling cats wears the same robe as king Darius does in his great Susa sculpture in fig. 3.18. But now the hero wears a simple fillet or band on his head, not royal headgear. He stands on a pair of recumbent *lamassu*, the human-headed winged-bull guardians known earlier in Assyrian art (see figs. 1.20 and 2.18), and is flanked by a pair of similarly dressed figures who each hold a bow in one hand and a

pair of arrows in the other. They each stand on a striding winged quadruped with a raptor's beak, long ears, leonine forelegs, and birdlike hind legs, a composite creature seen earlier in Elamite art. The political message conveyed by this seal, whose owner was clearly among the ruling elite, was that the Achaemenid dynasty was the successor to the earlier Assyrian and Elamite powers who in this depiction literally support the Persian hero.

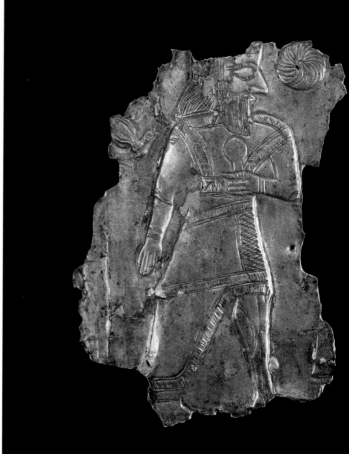

PLATE 38

Plaque fragments

Northwest Iran, 1100–900 BCE;
silver; H: 5 1/16 in. (12.9 cm),
W: 3 3/8 in. (8.5 cm); Arthur M.
Sackler Gallery, Smithsonian
Institution, Washington, DC,
gift of Arthur M. Sackler,
S1987.120a-b.

The principal scene on the plaque to which these two fragments once belonged had a row of striding male figures bearing weapons. The three surviving figures have long straight hair tied with a fillet or band, prominent almond eyes, sharply pointed noses, and long straight beards that almost obliterate their small mouths. They wear short-sleeved garments that have a *V*-shaped neckline, and a short, patterned skirt or kilt with a fringed or banded mantle that covers the rear leg. The garment is secured by a broad patterned belt at the waist. With their left hand, two of the figures hold a round form—perhaps a mace—close to the chest, while the right arm hangs free. The third figure holds an upright spear in his left hand and a long, slightly curved knife in his lowered right hand. Traces of another figure may be faintly seen along the torn and damaged edge behind the spear-bearer. Above the two men on the larger piece a pair of richly patterned vultures tears at the severed head of a gazelle, while a large fly hovers in the center. Two small round holes, one between the legs of the left-hand vulture and one on the upper portion of the spear shaft, are all that remains of what once allowed the plaque to be attached.

Placed behind the spear-bearer is a rosette-like whorl of fine lines, while on the smaller fragment a second whorl appears before the striding figure, and a small feline creature can be see behind him at shoulder level. The smaller piece also has a tiny round hole for attachment. Unfortunately the two fragments do not join, though it is clear that they are part of the same procession.

Rows of striding male figures, as well as feeding vultures and flies, occur on gold and silver metal vessels from the Marlik region of the Caspian littoral, and on an heirloom glass beaker and a metal vessel from Hasanlu in northwestern Iran (fig. 3.17). But none of the Marlik parallels offer a specific context for these two silver fragments. The subject matter is clearly military but nothing further has yet been learned about the intent of this piece.

Thomas Lawton, et al., *Asian Art in the Arthur M. Sackler Gallery: The Inaugural Gift* (Washington, DC: Arthur M. Sackler Gallery, Smithsonian Institution, 1987), no. 8, p. 34.

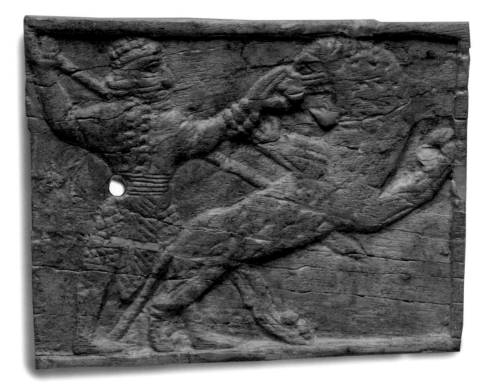

PLATE 39

Plaque with a hunter
and lion

Northwestern Iran, 8th–7th
century BCE; ivory or bone; H:
1 7⁄8 in. (4.8 cm), W: 2 3⁄8 in. (6 cm);
Sackler Collections, Columbia
University in the City of New
York, S0130.

The Mesopotamian theme of the fierce lion and
the heroic hunter was a popular one in Iran, even
if no felines of this kind existed on the Iranian
plateau. On this small plaque the motif has been
altered to fit the slightly irregular panel on which it
was carved. The lion leaps forward at an impossible
angle while turning back to snarl at the bearded
hunter, who appears to tweak its nose! In retalia-
tion the lion grabs the hunter's arm with its fore-
paw, just as the hunter's spear passes on the far side
of the hunter's body and by—or through?—the
lion. The scene is of course impossible to take liter-
ally, but it is effective as decoration. The carver has
arranged the figures to counterbalance each other,
with the diagonal of the spear echoing the hunter's
raised arm and the angled hind leg of the lion. So
the two figures, locked in combat, achieve an orna-
mental stasis.

Fragments of related lion-hunting scenes are
known from excavations at Hasanlu, Iran, which
fell in a siege sometime after 800 BCE. But none
of the Hasanlu pieces match this plaque exactly
in style, suggesting there were several production
centers in the region. Like the bulk of the Hasanlu
ivories, this plaque was a locally produced variant
ultimately based on Mesopotamian themes. The
apparent quotation it makes from the royal Assyr-
ian reliefs (see fig. 4.3) would have been appreci-
ated by the Iranians, who at various times were
Assyrian vassals, allies, or opponents.

PLATE 40

Cylinder seal with a mounted hunter

Iran, Late Elamite Period, 700–550 BCE; white chalcedony; H: 1 5/16 in. (3.3 cm), Diam.: 5/8 in. (1.6 cm); The Pierpont Morgan Library, New York, Morgan Seal 812.

The slender mounted hunter and his prey, a gazelle, carved into this cylinder seal, form reciprocal diagonals as they leap gracefully from left to right across the impression. The contrasting angle of the hunter's raised arm echoes the turned-back head of the quarry, providing a counterbalance to the primary lines of movement. Late or Neo-Elamite seals of this kind are distinguished by their use of empty space to set off the primary figures that are often characterized by their lithe, supple form and naturalistic action. Elegant horsemen appear frequently in Elamite glyptic art of the seventh and sixth centuries BCE. The subject matter reflects the horse-oriented culture of western Iran, which was a major source of horses for Mesopotamia through both tribute and trade.

Seals could remain in use over a long period. One Elamite seal was still in use in the Achaemenid bureaucracy at Persepolis over a hundred years after it was carved. The inscriptions for this one merely give the seal owner's name and that of his father.

Inscription:
Sunki-shup, son of Shamash-addunu.

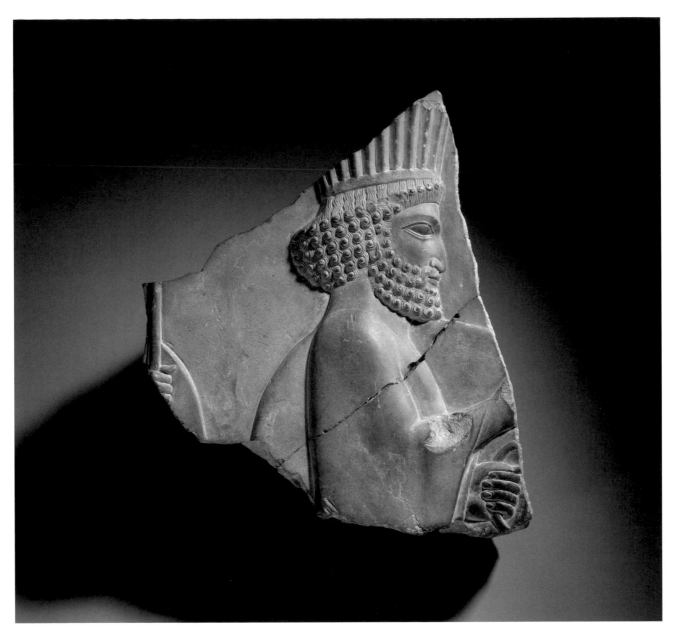

PLATE 41

Relief fragment with a Persian guard

Iran, from Persepolis, Achaemenid Period, reign of Xerxes, 486–465 BCE; limestone; H: 10 ½ in. (26.6 cm), W: 9 in. (22.8 cm); Brooklyn Museum, gift of the Kevorkian Foundation in memory of Hagop Kevorkian, 65.195.

This relief shows the head and upper torso of an Achaemenid Persian wearing a tall fluted headdress on his curly cropped hair. He grips the inner handle of a shield with his left hand and supports what was probably an upright spear with his now-missing right hand. Behind him is part of the right hand, spear shaft, and curved shield edge of a following figure. The subtle modeling of the arm beneath his smooth robe is elegant, but what is more significant, in art historical terms, is the fact that his shoulder is shown in true profile. The long Near Eastern tradition of human representation featured the shoulders shown frontally, and the Persian change from this may well reflect the presence of Greek craftsmen, who have been

documented in Persian sources as working on Achaemenid projects. Rows of identical armed Persians in long robes decorated the stone terraces and stairs of several buildings at Persepolis. Yet Persians carrying shields and spears are known only from the main stairs of the Central Building (often called the Council Hall). Even so, their size differs from that in the Brooklyn fragment, which may have come from another structure. From the eighteenth century on it was not uncommon for visitors to Persepolis to hack off a souvenir from the many reliefs at the site, making it difficult to identify the original location of a small piece.

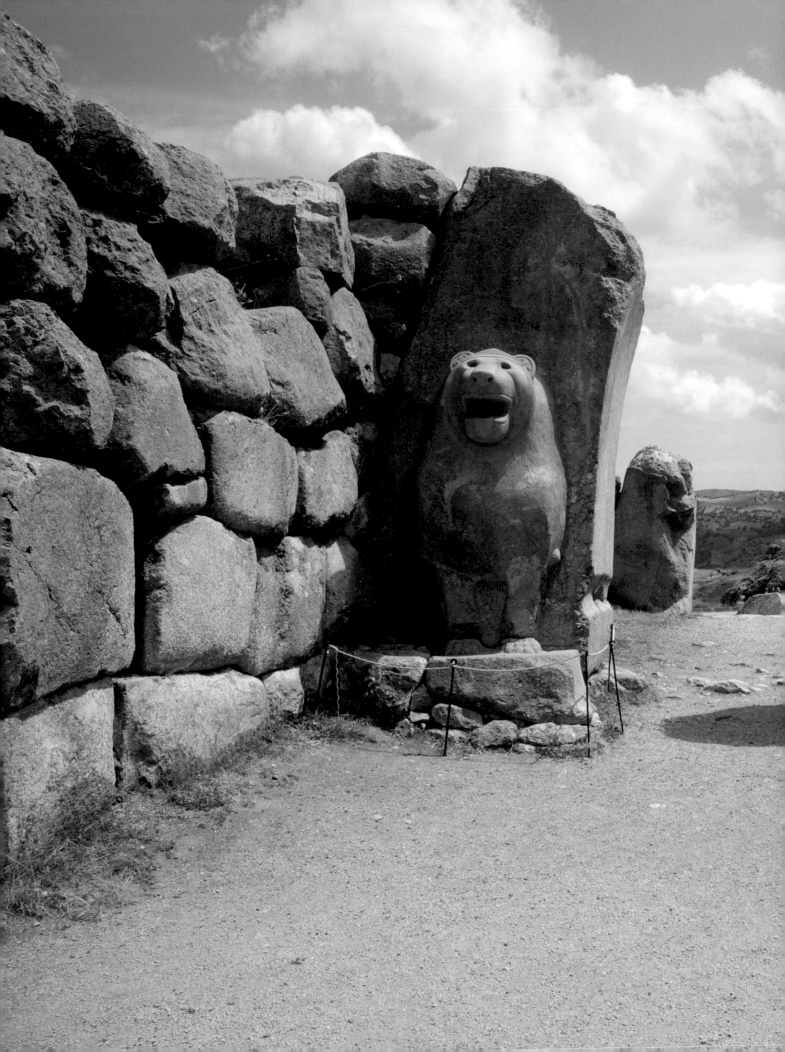

Part Four:
Breath of Heaven, Breath of Earth:
Ancient Near Eastern Art from
American Collections

The Animal Realm

The Animal Realm

Mesopotamia

In Mesopotamian art animals were usually shown realistically, with age and gender clearly rendered and details specific to each species carefully noted. The social and artistic practices that dictated conventional representations for human and divine figures did not restrict the representation of animals in the same way. But animals were never depicted merely for their own sake. They were symbols of secular power, well-being, strength, or sustenance, bearing a freight of metaphor and double and triple meanings that could vary from one time or place to another. As early as the third millennium BCE Sumerian literature included fables and jokes that portrayed animals as if they were humans, bringing even more subtle levels of meaning to animal representations.[1]

Both wild and domesticated animals were portrayed in all periods, but the domesticated species had pride of place in the animal parade of Mesopotamian art. First in status were cattle (*Bos taurus*), often depicted on cylinder seals and small stone sculptures of the late fourth millennium. These cattle were not the rangy, half-wild longhorns of the Neolithic Period (see fig. 2.12), but stocky, square-bodied milking cattle with short curving horns and small muzzles. In many images they were repeatedly represented, suggesting large herds. Often small calves were shown emerging from sacred enclosures identified with the goddess Inana (see fig. 2.13), thus crediting her as the source of flourishing herds. As early as 3100 BCE cattle figured in the propaganda of rulers, who showed themselves feeding cows and calves (Plate 24), a metaphor for the ruler's concern for the ruled. Calves meant reproduction, milk, and thus abundance. Milk and milk products were highly regarded and also carefully monitored by the bureaucrats who supervised the herds, whether they belonged to the temples or to the ruling elite. The large Sumerian vocabulary for dairy products, including words for various fresh cheeses and fermented yogurts, shows how varied these products were.[2] The impression made by the cylinder seal from Khafaje (fig. 4.1) depicts in miniature a herd being blessed by Inana. Perhaps the seal expressed a wish by the seal's owner for divinely assured well-being—or, more likely, it attested to his status in the administration of these herds.

The temple of Ninḫursaǧa at Tell al-Ubaid, when rebuilt toward the end of the third millennium BCE, was decorated with cattle imagery in works that look like bucolic genre scenes, yet these were actually statements about the power of the goddess who was worshipped there

Figure 4.1. Impression of cylinder seal with rows of cattle; Iraq, from the Sin Temple, Level II at Khafaje, ca. 3000 BCE; The Oriental Institute of the University of Chicago, Field # Kh.VII 260.

and the patrons who supported her temple. A long, copper-framed frieze with a dairying scene inlaid in shell is unique for its size and subject matter, as well as for the value of its imported material. Mesopotamia had no copper mines, and the shell came from the Gulf of Oman. The large, sensitivly modeled copper calf (Plate 45) and the beautifully executed row of striding bulls (Plate 46) speak to the wealth of the temple and its ability to comission the most skillful craftsmen for these works.

Sheep (*Ovis aries*) and goats (*Capra hircus*) formed the bulk of the herds in ancient Mesopotamia. These two related species, able to thrive in drier environments than cattle, were managed in mixed herds where they grazed together. Because each species preferred different plants, they were not in competition for food. Both also yielded dairy products, of course, and meat when they were slaughtered, but they were also bred to provide a source of renewable fiber for textiles. The wool sheep, which seems to have been developed between the fourth and third millennia BCE, could be plucked—and later shorn—of its insulating undercoat, which was shed once a year. The goat produced tough guard-hairs that were used for coarse fabrics like tents, bags, and ropes. Together these two species made up the most important animals of the Mesopotamian economy, a status confirmed in images showing them in the same cultic settings as cattle.

An early Sumerian joke plays off their close relationship at the expense of the predatory lion. The lion had caught a helpless she-goat, who said: "Let me go! I will give you my fellow ewe in return!" – When the lion came to the fold, the ewe answered him from the other side: "No sheep live here!"[3]

The rams, ewes, and lambs that appear on the ritual feed trough from the E-ana precinct at Uruk (fig. 4.2) are shown in the same format as the cattle are. And these animals were also sculpted in stone (Plates 42, 43) and cast in metal. More accessible or affordable than cattle, they were the basic sacrificial animal for several millennia, and frequently appear on the inexpensive clay plaques left as votive offerings (Plate 27). Practicality was not the only aspect of animal husbandry, however. Sometimes animals were also valued for their unusual appearance or color. The rams on the Uruk trough (fig. 4.2) and the bronze goat head (Plate 47) from Shuruppak (modern Fara) show animals bred for visual drama, not merely for their meat, milk, and wool. Their fantastically spiraling horns added nothing to the animals' practical activities and indeed could be a source of injury to other sheep and goats and to the herder, but they were a visual delight. The repeated representation of goats with such unusual horns suggests the breed's status was rare and thus desirable.

Figure 4.2. Trough; Iraq, from the E-ana precinct at Uruk (modern Warka), Late Uruk Period, ca. 3000 BCE; limestone; H: 6 in. (15.2 cm); L: 38 in. (96.5 cm); Trustees of The British Museum, London, 120000.

Domestic dogs (*Canis lupus familiaris*) were well-known in Mesopotamia and are portrayed on stamps and cylinder seals of the late fourth millennium BCE. A variety of types—or breeds—were recognized, ranging from lithe, long-legged coursing dogs like modern greyhounds (fig. 4.8), to small, fluffy, curly tailed pets. The dog was the companion animal of the goddess Gula, while stock-guarding dogs sometimes appear with sheep and goats on cylinder seals of the third millennium BCE. Large, smooth-coated guard dogs with big heads, thick necks, and solid bodies (Plates 48, 49) look to our eyes like modern mastiffs. Such big dogs would have required special care and feeding; their purpose may thus have been that of prestige. Ownership of these great guardians may have implied that the owners had substantial treasures. In the Assyrian Period, the earlier first millennium BCE, small clay figures of dogs were buried with other items in magical deposits under doorways. The protective aspect of the dog is made clear; one figurine is inscribed "Don't think, bite!"[4] A Sumerian proverb says, "The dog understands 'Take it!' " He does not understand 'Put it down'!"[5]

Many people think of the dromedary or one-humped Arabian camel (*Camelus dromedarius*) as the animal most characteristic of the Near East, but it rarely appears in art before the classical period. It was native to the Arabian Peninsula, but in Assyrian art it only appears as the animal being ridden by desert raiders.[6]

The horse (*Equus caballus*) was one of the last domesticates to appear in Mesopotamia, arriving in the world of art as a rare and prestigious creature in the third millennium BCE. Mesopotamia is not naturally horse country, and the animal was an import from the Eurasian steppes, perhaps via Anatolia or Iran. Representations of horses are more common than actual physical remains, and are always associated with the ruling elite. Horses were first used as draft animals (Plate 44); that is, they pulled the vehicles of the elite. It was only in the second millennium that they were ridden with any regularity. But by the early first millennium horses were an important part of the Assyrian military force, where they were valued for their speed, response to control, and easy maneuverability (Plate 51). However it was not until the reign of Ashurbanipal (ruled 685–ca. 627 BCE) that the king himself was shown riding a horse.

Until then, it had been considered undignified to ride astride, and Assyrian kings before Ashurbanipal are shown hunting lions and wild bovids from chariots. The Assyrians were keen observers

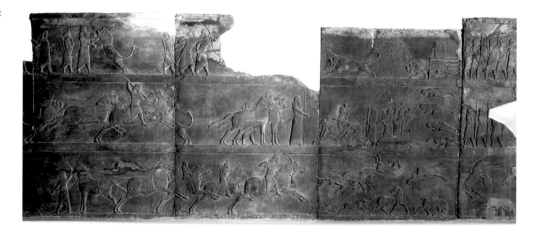

of horses and were well aware of different equine types, sizes, and colors.[7] The horses in Assyrian reliefs are strong-bodied animals with delicate heads and lean legs. Ornamented with decorated saddle-cloths, tasseled breast-bands, and what look like beaded and tufted bridles, the horses of Ashurbanipal's hunting party leap and snort, flicking their small pointed ears forward and back, aware of the dangerous prey their riders pursue. Note how the horse at the far left in the bottom register (fig. 4.3) stands with raised head, spooked by the upraised arms of the groom who holds him. The contrast between the lively naturalistic horses and the stiff, almost immobile human figures replicates the social and artistic conventions of Mesopotamian art.

Relatively few wild animals appear with any frequency in Mesopotamian art. Of them, the most common is the West Asiatic lion (*Panthera leo persica*) or Barbary lion (*P. l. leo*). It is the Barbary lion that most closely resembles the ancient depictions, which show its characteristic heavy belly fur as a continuation of its distinctive mane. Extinct since the late nineteenth century in Southwest Asia, the lion was probably never common.[8] As the largest predator of the region, it was the preferred quarry of rulers determined to demonstrate their prowess in the hunt. These hunts were not haphazard events, but carefully choreographed displays with political as well as social significance. A letter from Mari written in the eighteenth century BCE described how a lion was caught in a building and kept for five days until it could be caged and transported to the king. The lion wouldn't eat, and the writer of the letter was worried that the king would be upset if the lion died before it could be delivered to the royal menagerie.[9]

The Assyrian kings of the first millennium BCE decorated the more public rooms of their palaces with scenes of hunting as well as warfare. Ashurbanipal (ruled 668–ca. 627 BCE) commissioned the most sophisticated examples of these themes, which unrolled on multiple registers along the wall like illustrated scrolls.

Not only do the sculptors render the lions with an immediacy that is lacking in the static humans, but they also show the lions in a wide variety of poses and in direct proximity to the person of the king himself. In the upper register (fig. 4.3), the king and lion come face to face, a meeting of visual if not literal equals. In this context the lion is the king of beasts, a role the animal played throughout the ancient Near East.

Figure 4.4. Fish-shaped vessel; Israel, from Tel Poleg, Middle Canaanite Period, 19th–18th century BCE; ceramic; H: 4 5/16 in. (11 cm); The Israel Museum, Jerusalem, 68.32.150.

The delight that the artists took in depicting the various aspects of the lion hunt can also be sensed in the way they challenge the compositional conventions of the time. In the middle register, for example, the lance and right hand of the mounted hunter rise through the band that divides the registers and enter into the visual space of the register above. This violation of the standard practice, much as if a character were to break out of one comic book panel into another scene, punctuates one of the most original and inventive compositions in Assyrian art. This rider is Ashurbanipal himself, so perhaps his transcendence of pictorial space was also a subtle reference to his power as a king.

Syria and the Levant

The animal images of Syria and the Levant record a wide spectrum of species, from hares (see fig. 2.10) to cattle to fish. After the Neolithic Period, domesticated species predominate, with cattle being the prestige animal. Bovid figurines of clay and sometimes metal appear widely in most periods,[10] as do the ubiquitous sheep and goats. The simple clay figures like the one in Plate 53 were probably votive in function. Other animal forms are distinctive to the region, particularly fish-shaped vessels. The delightful ceramic fish (fig. 4.4) from Tel Poleg, a coastal site in modern Israel,[11] may initially have been inspired by Egyptian stone vessels having the same form. An Egyptian alabaster fish-vessel of this type was excavated at Tell e-Ajjul[12] on the coast far to the south of Tel Poleg. The fish not only evokes the role of the sea in provisioning the Levant, but also seaborne trade with Egypt, whose influence in the cultures of the Levant was profound. The amusing form of the Tel Poleg fish, whose mouth is shaped like its tail, recalls the playful qualities of Egyptian art, a characteristic not found elsewhere in the ancient Near East.

Figure 4.5. Stag; Turkey, from Tomb B at Alaça Hüyük, late 3rd millennium BCE; bronze and silver; H: 20 11/16 in. (52.5 cm); Museum of Anatolian Civilizations, Ankara, 11878.

Anatolia

While the animal imagery of Mesopotamia, Syria, and the Levant focused for the most part on domesticated animals, the art of Anatolia is filled with wild animals. The male red deer (*Cervus elaphus*), or stag, appeared frequently in the art of Anatolia, from the Neolithic Period at Çatal Hüyük[13] on through the first millennium BCE. Painted on walls, carved in stone, cast in bronze, or pictured on pots, the antlered red stag was rendered naturalistically as well as abstractly.

Stags with fabulous antlers (fig. 4.5) as well as long-horned bulls were deposited in the tombs of the elite of the late third millennium BCE at Alaça Hüyük in central Anatolia. These cast-bronze figures, each one different from the next, were buried with metal vessels, personal ornaments of gold, and other valuable objects.[14] Produced by the process of lost-wax casting, these "standards" (they were fastened on some sort of fixture, like emblems) were often embellished with inlays of silver, gold, or electrum, a naturally occurring amalgam of silver and gold. Anatolia was rich in metals, so it is not surprising that elaborate cast-metal works would be one of its major art forms. Yet because these cultures left us no written records we can only surmise the significance the animals had for them.

Large cats played a special role in the art of the second millennium. We often call these animals "lions" but they were instead leopards of various species. Spotted felines are represented in the paintings and reliefs at Neolithic Çatal Hüyük, and some appear on the standards from the tombs at Alaça Hüyük. By the second millennium they are the companion animal of the sun

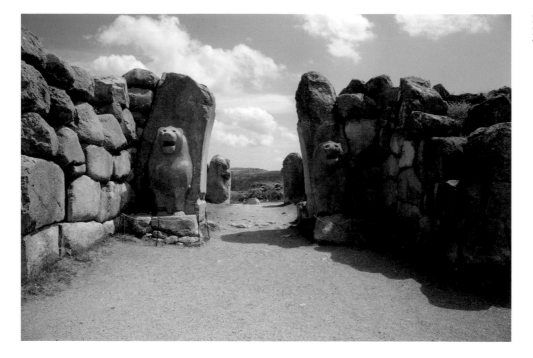

Figure 4.6. The Lion Gate at Hattuša (modern Boğazköy), Turkey, 15th–13th century BCE

goddess (see fig. 2.25), and a pair of roaring felines (fig. 4.6) flank one of the gates in the Hittite capital at Hattuša (modern Boğazköy), where they serve as a wild version of the Mesopotamian guard dog.

The bull was the other prominent animal image of Anatolia, but it is not always easy to tell if it is the wild bull (the aurochs, *Bos primigenius*) represented at Neolithic Çatal Hüyük (fig. 2.12), or the early long-horned domesticates that appear on some of the Alaça Hüyük bronzes. A thousand years after the tombs at Alaça Hüyük were sealed, the Hittites, a different ethnic group from the rulers of the third millennium BCE, continued the veneration of the bull at the same location. A stone relief at the entrance to a monumental gate (fig. 4.7) shows the royal couple worshipping the animal; we recognize the clean-shaven, short-haired king with his long curving staff, and the amply-robed queen behind him. Immediately in front of the king is a

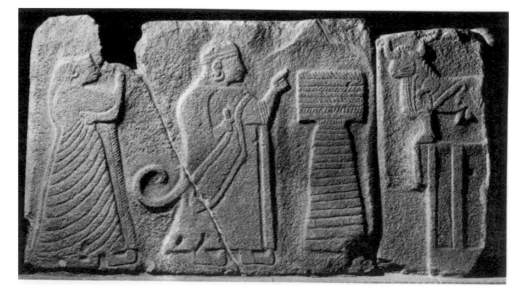

Figure 4.7. Relief of Hittite king and queen worshipping a bull; Turkey, from the western wall of the precinct entrance at Alaça Hüyük, 13th century BCE; stone; H: 50 in. (127 cm); Museum of Anatolian Civilizations, Ankara.

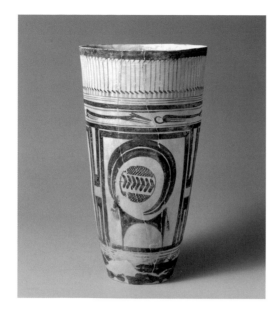

Figure 4.8. Beaker with mountain goat; Iran, from the necropolis at Susa, ca. 4000 BCE; ceramic with slip; H: 11 ⅜ in. (28.9 cm), Diam.: 6 ⅞₁₆ in. (16.4 cm); Musée du Louvre, Paris, Sb 3174.

banded altar table, and beyond it stands a sculpture of a bull on a pedestal. While the ruling elite changed, local cults and beliefs carried on.

In the earlier first millennium BCE the votive cauldrons of the Urartians, the masters of eastern Anatolia, were decorated with elegantly cast bronze bulls' heads (Plate 55). It did not matter if the bull was wild or domesticated; its burnished horns and elegantly curled forelock marked it as a supernatural animal, fit for a deity. The other animals found on Urartian metalwork, including lions, horses (Plate 36), and fantastic hybrid creatures—some with wings and scorpion tails, amalgams of Mesopotamian images—all provided protective power to those who used or wore the objects.

Iran

The animal art of ancient Iran also featured wild animals, with wild bezoar goats or ibex (*Capra aegagrus*)—current thinking does not distinguish between ibex and bezoar goat genetically—as the primary and most common image, while the ibex was a standard motif from the fifth millennium BCE through the Achaemenid Period (ca. 550–330 BCE).

The large painted beaker from a sixth to fifth millennium BCE grave at Susa (fig. 4.8) showcases the clever design sense of the painters. The central panel, with its design repeated three times around the circumference, displays an abstract goat whose body, formed of two joined triangles, is secondary in visual impact to the huge arching horns that form an open circle over the animal's back. Thin, tall-necked water birds form a vertical upper band, while a row of long, slender reclining hounds provides a strong horizontal counterpoint. The same animal is painted on pots (Plate 56) and cast in bronze as part of a temple fixture (Plate 59). Ibex images also form ornamental terminals for garment pins (Plate 62) and the fancy sockets used to hold whetstones (Plate 63). The sweeping, graceful horns are exaggerated, abstracted, and in a variety of exuberant ways transformed into decorative motifs. But the original identity of the animal is never lost.

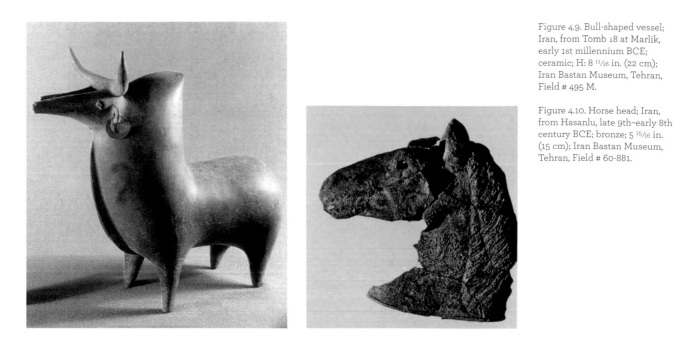

Figure 4.9. Bull-shaped vessel; Iran, from Tomb 18 at Marlik, early 1st millennium BCE; ceramic; H: 8 ¹¹⁄₁₆ in. (22 cm); Iran Bastan Museum, Tehran, Field # 495 M.

Figure 4.10. Horse head; Iran, from Hasanlu, late 9th–early 8th century BCE; bronze; 5 ¹⁵⁄₁₆ in. (15 cm); Iran Bastan Museum, Tehran, Field # 60-881.

Red deer (*Cervus elaphas*) are not common in Iran, since they are restricted by climate and range to the forested regions from the Caspian Sea littoral to the Caucasus. Yet in the fourth millennium BCE at Tepe Sialk[15] and again in the first millennium at Marlik and Hasanlu,[16] images of red deer in both bronze and ceramic have been found (Plate 58). At these sites the appearance of this animal, which occurs nowhere else in Iranian art, suggests connections to Anatolia, where the image of the red deer stag (fig. 4.5 and Plate 54) played an important role in art for over a thousand years.

Unlike the area's leopards (*Panthera pardus*), the West Asiatic or Barbary lion (*Panthera leo persica*) was not native to the mountains of western Iran. Nevertheless, leonine imagery from Mesopotamia was incorporated into Iranian art, especially during the first millennium BCE. Here, just as in Mesopotamia, the lion was regarded as a kingly beast (Plate 37), and hunting (Plate 39) or keeping lions was a royal signifier. Tamed lions were shown in the reliefs of the Apadana at Persepolis, the Achaemenid capital (see fig. 4.11), as one of the gifts brought by the Elamites.[17]

The two domestic animals that appeared most frequently in Iranian art were bulls and horses. The bulls range from wild-looking bovids with very long horns at Tepe Sialk[18] in the fourth millennium BCE to the curled locks on decorative faience bull figurines of the first millennium BCE Elamites at Susa.[19] The most unusual examples come from Marlik, the site of an early first millennium BCE cemetery in the mountains south of the Caspian Sea, where the tombs held small bronze bulls and large ceramic bull vessels (see fig. 4.9 and Plate 60).

These works are distinctive because they all depict the hump-backed zebu (*Bos indicus*), a domesticated bovid that originated in South Asia,[20] not the common domestic bull of Western Asia. This species (or subspecies, authorities differ) was well-suited to the warm, damp climate of the Caspian region, where their genetic marks can still be seen in the local cattle.[21] The means by which the zebu moved from India to the Caspian are not well understood, but may indicate some historical connection not yet found in the archaeological record.

Figure 4.11. A delegation of Babylonians (above) and Lydians (below), from a relief on the eastern stairway of the Apadana terrace at Persepolis, Iran, Achaemenid Period, late 6th–early 5th century BCE.

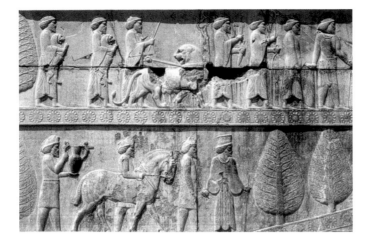

Horses were long appreciated by the inhabitants of the Iranian plateau, whose grassy valleys supplied mounts for the Assyrian Empire. We do not know exactly when Iranians began to ride horses, as opposed to driving them, but by the early first millennium BCE images of horseback riding were painted on ceramics, carved on wood, bone, and ivory, and incised on cylinder seals (Plate 40).[22] Elaborately cast bronze horse bits could also bear images of the horses they were used to control (Plate 61).

The bronze rhyton, or drinking cup, in the shape of a horse head (fig. 4.10) was excavated from Burned Building II at Hasanlu in northwest Iran. It is one of at least five animal-shaped vessels found in the remains of what may have been a temple that was destroyed, along with many inhabitants, in a fiery siege sometime after 800 BCE. The naturalism of the modeling of the animal's soft muzzle and chin, and its large eyes, once inlaid with a contrasting material, mark this as a masterwork of animal observation. When we compare the horse in this rhyton with the human or divine representations from the same site, we see the same distinction noted in Mesopotamian art: anthropomorphic representations are formulaic and static, animals are naturalistic and active.

Horses were also central to the identity of the Archaemenid Persians. Darius (ruled 522–486 BCE) was proud of his horsemanship, even bragging about it on an inscription: "As a horseman, I am a good horseman,"[23] and horses were a favored gift among rulers. Lydians from Anatolia, also horse country, are only one of several ethnic or regional groups shown bringing horses as tribute gifts to Darius on the reliefs carved at the Apadana terrace at Persepolis (fig. 4.11).

Good horses were also seen as a divine gift, as Darius stated in his Susa inscription: "A great god is Ahuramazda, who makes excellence in this earth, who makes happiness for man, who makes good horses and good chariots."[24]

The art of the ancient Near East explored the many facets of human civilization, the divine, the human and the animal. The gods were often shown as enthroned kings and the kings took on godly attributes. The animal world, portrayed most carefully of all, was tied directly to both the human and divine spheres, with animals serving as signifiers of the divine, as honorable opponents that allowed rulers to display their prowess, and as vehicles bearing the power and grace of human aspirations for well-being and the good life.

NOTES

1 See ETCSL, the Electronic Text Corpus of Sumerian Literature, at http://etcsl.orinst.ox.ac.uk/cgi-bin/etcsl.cgi?text=c.6.1*# (accessed 5-28-2013) for a comprehensive listing of Sumerian proverbs and fables.

2 For a discussion of the Sumerian vocabulary for milk, see Trudy S. Kawami, "The Cattle of Uruk: Stamp Seals and Animal Husbandry in the Late Uruk/Jemdet Nasr Period," paper presented at Harvard University, Cambridge, MA, July 7–10, 1998; in *Proceedings of the 45th Rencontre Assyriologique Internationale*, Part II, William W. Hallow and Irene J. Winter, eds., *Seals and Seal Impressions* (Bethesda, MD: CDL Press, 2001), 44.

3 J. A. Black, G. Cunningham, E. Fluckiger-Hawker, E. Robson, and G. Zólyomi, "The Electronic Text Corpus of Sumerian Literature" (Oxford, UK: Faculty of Oriental Studies, 1998–2003), at www-etcsl.orient.ox.ac.uk/ (accessed 4-11-2013).

4 John E. Curtis and Julian E. Reade, eds., *Art and Empire: Treasures from Assyria in the British Museum* (New York: Metropolitan Museum of Art), no. 75 (1995), 116–117.

5 C. J. Gadd and S. N. Kramer, *Ur Excavations: Texts.* Vol. 6, pt. 2. Publications of the Joint Expedition of the British Museum and of the Museum of the University of Pennsylvania, Philadelphia, to Mesopotamia (London: British Museum Press, 1963), no. 225.

6 T. C. Mitchell, "Camels in the Assyrian Bas-Reliefs," *Iraq* 62 (2000): 187–194.

7 Pauline Albenda, "Horses of Different Breeds: Observations in Assyrian Art," *Amurru* 3 (2004): 321–334.

8 Kristen Nowell, Peter Jackson, and IUCN/SSC Cat Specialist Group. *Wild Cats: Status Survey and Conservation Action Plan* (Gland, Switzerland: International Union for the Conservation of Nature, 1996), 38.

9 A. Leo Oppenheim, *Letters From Mesopotamia: Official Business and Private Letters on Clay Tablets from Two Millennia* (Chicago: University of Chicago Press, 1967), 108.

10 Amnon Ben-Tor, ed., *The Archaeology of Ancient Israel*, trans R. Greenberg. (New Haven, CT: Yale University Press, 1992), 256, 292.

11 Metropolitan Museum of Art, *Treasures of the Holy Land: Ancient Art from the Israel Museum* (New York: Metropolitan Museum of Art; Jerusalem: Muze'on Yiśa'el, 1986), no. 37, 102–103.

12 Ben-Tor, *Archaeology of Ancient Israel*, 171 and plate 30.

13 For additional illustrations of the animals accompanying the mother goddess figure, and other sculptures and paintings at Çatal Hüyük, see http://users.stlcc.edu/mfuller/catalhuyuk.html (accessed 3-20-2012).

14 U. Bahadir Alkim, *Anatolia I: From the Beginnings to the End of the 2nd Millennium* (Cleveland, OH: World Publishing, 1968), 124–126, and plates 63–69.

15 On red deer at Tepe Sialk, see Roman Ghirshman, *Fouilles de Sialk près de Kashan, 1933, 1934, 1937.* 2 vols. (Paris: Musée du Louvre, Département des antiquités orientales, 1938–39), plates XXI; LXXXI A, C; LXXXIII, A, D.

16 Trudy S. Kawami, "Deer in Art, Life and Death in Northwestern Iran," *Iranica Antiqua* 40 (2005): 107–131.

17 Pierre Briant, *From Cyrus to Alexander: A History of the Persian Empire,* trans. by Peter T. Daniels (Winona Lake, IN: Eisenbrauns, 2002), 175.

18 Trudy S. Kawami, *Ancient Iranian Ceramics from the Arthur M. Sackler Collections* (New York: Abrams, 1992), no. 4, 42–43.

19 Prudence O. Harper, Joan Aruz, and Françoise Tallon, *The Royal City of Susa: Ancient Near Eastern Treasures in the Louvre* (New York: Metropolitan Museum of Art, 1992), 210.

20 Paul Rissmann, "The Status of Research on Animal Domestication in India and Its Cultural Context," in Pam J. Crabtree, Douglas Campana, and Kathleen Ryan, eds., *Early Animal Domestication and Its Cultural Context* (Philadelphia: MASCO, the University Museum of Archaeology and Anthropology, University of Pennsylvania, 1989). MASCA Research Papers in Science and Archaeology. Special Supplement to Volume 6: 15–23. Note that pages 15–17 cover domestication in India.

21 Personal communication, Emma Finlay, PhD, Smurfitt Institute of Genetics, Trinity College, Dublin, January 26, 2007; Orang Esteghamat, "Milch- und Fleischproduktion im Iran: Massnahmen zur Steigerung der Milch- und Mastleitung bei einheimischen Rinderrassen," *Grosstierpraxis* 9 (2003): 15–19.

22 Oscar W. Muscarella, *The Catalogue of Ivories from Hasanlu, Iran* (Philadelphia: The University Museum, 1980. Hasanlu Special Studies, Vol. II; University Museum Monograph 40): 20–23.

23 Joseph Wiesehöfer, *Ancient Persia from 550 BC to 650 AD* (London: I. B. Tauris, 1996), 89; R. G. Kent, *Old Persian: Grammar, Text, Lexicon.* 2nd ed. (New Haven, CT: Yale University Press, 1953), 140.

24 For Darius's Susa inscription, see DARIUS, SUSA S. (DSs) and DSp in the Old Persian Texts at http://www.avesta.org/op/op.htm#dsa (accessed 5-24-2013).

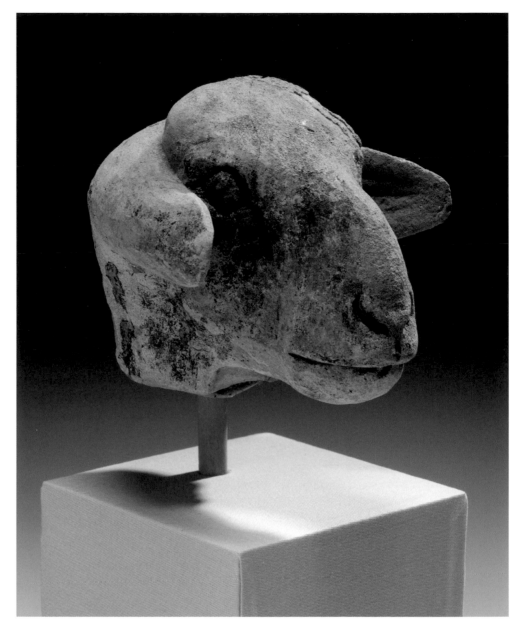

PLATE 42

Head of a ewe

Iraq, Late Uruk Period, 3200–
3000 BCE; sandstone; H: 5 ¾ in.
(14.6 cm), W: 5 ½ in. (14 cm), D:
6 ¼ in. (15.9 cm); Kimbell Art
Museum, 1979.38.

The soft stone and naturalistic modeling of the ewe's head are characteristics of Mesopotamian art at the end of the fourth millennium BCE. Our knowledge of the art of this period is for the most part limited to cylinder seals and low reliefs, but this head demonstrates that larger, three-dimensional animal representations were also made. Related animal heads are known in both ceramic and stone but unfortunately none have a clear archaeological context. This sculpture, and the other examples, like the ceramic head in the British Museum, would have been associated in some way with a temple. Archaeological finds suggest that the temple complex at Uruk was the center, or perhaps the source, of a major cultural force that was felt from Syria to southwestern Iran and that has been used as the identifying name for an entire period. Thus it is tempting to place this lovely sculpture at Uruk, as a three-dimensional version of the ewes on the Uruk Vase (fig. 3.1) or the Uruk Trough (fig. 4.2).

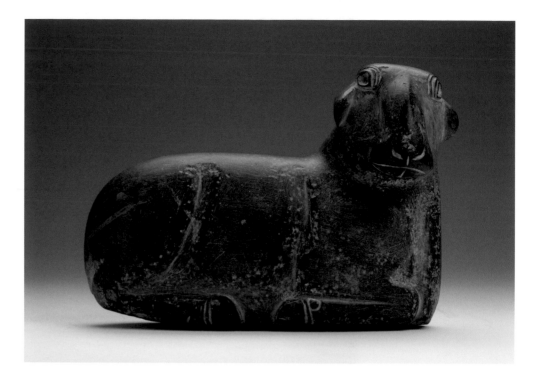

PLATE 43

Recumbent sheep

Iraq, Late Uruk Period, 3200–
3000 BCE; stone; H: 6 ⅛ in.
(15.6 cm), W: 8 ¼ in. (21 cm), D:
3 in. (7.6 cm); Yale University
Babylonian Collection, New
Haven, YBC 2261.

The compact form of this recumbent sheep has
only simple incised lines to indicate the curve of
the hindquarter, the folded legs, and the hoofs.
In contrast to the body, the head turns sharply
outward. The smoothly curving muzzle and the
soft, pendant ears are best appreciated in a profile
view. The smooth, dark stone was once enlivened
by inlaid eyes, probably white with dark pupils to
judge from other stone animal sculptures, some of
which had bodies that were hollowed so that they
could serve as vessels.

The Yale sculpture itself is conceived of as a three-
dimensional form, in that it can only be fully
understood visually from several points of view. Yet

although the sheep was carved completely in the
round it was not finished on all sides. The roughly
finished back has two sets of drilled holes that
form *V*-shaped openings to facilitate the attach-
ment of the sculpture in its setting. As with the
ewe of Plate 42, this ewe was probably made for
installation in a temple, and both share the curious
configuration of the ears that connect around the
back of the head in a continuous roll.

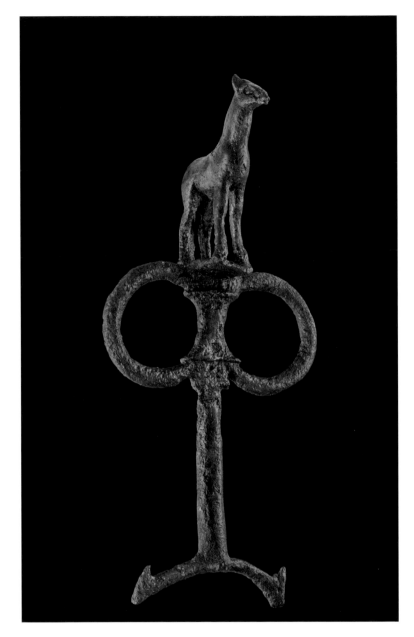

PLATE 44

Rein ring with horse

Iraq, excavated from Kish, Early Dynastic Period, ca. 2600 BCE; copper alloy; H: 8 in. (20.2 cm), W: 3 ½ in. (9 cm), D: 2 ¾ in. (7 cm); Field Museum of Natural History, Chicago, 236527.

A rein ring, or terret ring, is a device fixed to the pole of the cart or wagon with loops to separate and organize the reins running between the draft animals' heads and the driver's hands. It prevented the reins from being tangled in the rest of the harness and standardized the directional cues of the driver. Terret rings are unnecessary when the draft animals are oxen, but were useful for the speedier asses, onager hybrids, and horses that were favored by the elite for pulling war wagons and, later, two-wheeled chariots in Mesopotamia in the third millennium BCE. This rein ring from Kish was part of an elite burial that featured the entire wagon as well as other costly gear. It was a prestige accoutrement that bore an image of that most prestigious draft animal of the third millennium BCE, the horse. Excavated from a princely tomb almost one hundred years ago, the Kish terret ring is one of the earliest representations of a true domestic horse (*Equus ferus caballus*) from Mesopotamia. Unfortunately early excavation practices were not very precise and we know little of the exact circumstances of its discovery.

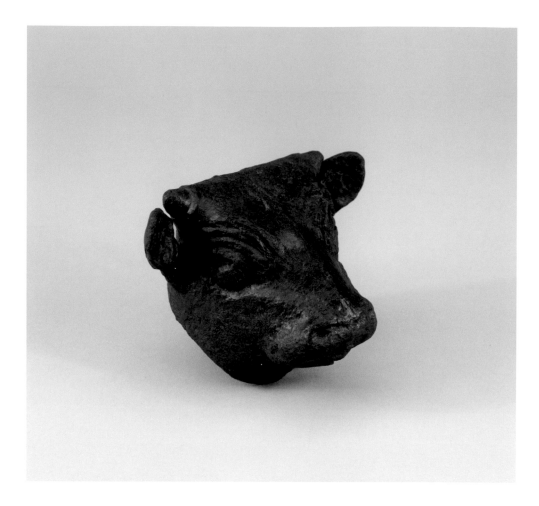

PLATE 45

Head of a calf

Iraq, excavated from Grave PG 1850, at Ur, Late Early Dynastic Period, 2600–2400 BCE; copper alloy and bitumen; H: 3¼ in. (8.2 cm), W: 5⅝ in. (14.2 cm), D: 4½ in. (11.5 cm); University of Pennsylvania Museum of Archaeology and Anthropology, Joint British Museum/University Museum Expedition to Mesopotamia, 10th Season, 1931–1932, 32-40-226.

The wide forehead and short, broad muzzle, the large eyes, and particularly the budding horns identify this lovely cast-copper head as a young calf, not an adult animal. The head was cast by the lost-wax process with bitumen—a naturally occurring asphalt—serving as the core instead of the usual clay. Only the ears were separately made and then attached. This appealing little head came from a well-furnished grave in the so-called Royal Cemetery at Ur. Other bovine heads of gold, silver, and copper alloy made in the same manner were mounted on the sounding boxes of lyres excavated from other graves in the cemetery. The wooden parts of the lyres had perished long ago but their imprint remained in the soil. It has been speculated that the size and maturity of the animal heads somehow indicated the tone of the musical instrument. The relationship, however, remains only speculation as small gold calves' heads also ornamented the burial cart of the Lady Pu-abi who had one of the more lavish graves at the site.

See C. Leonard Woolley, et al., *The Royal Cemetery: Ur Excavations*, Joint Expedition of the British Museum and the Museum of University of Pennsylvania, vols. 1, 2. (London: British Museum, 1934), vol. 2, pp. 212, 215, and Plate 143.

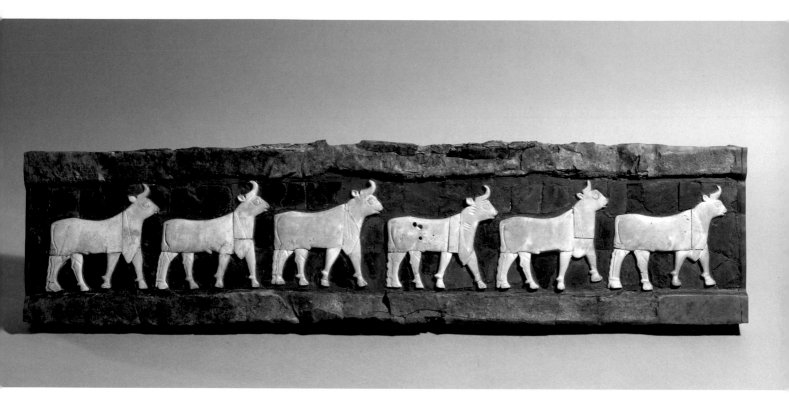

PLATE 46

Frieze with inlays of cattle

Iraq, excavated from the Ninḫursaǧa Temple at Tell al-Ubaid, Late Early Dynastic Period, 2600–2400 BCE; limestone, shell, copper, and shale; H: 9 in. (23 cm), W: 37 in. (94 cm); University of Pennsylvania Museum of Archaeology and Anthropology, Joint British Museum/ University Museum Expedition to Mesopotamia, 2nd Season, 1923–1924, B15880.

This hefty panel bears a row of striding bulls, their bodies cut from thick white shell set into a dark slate background that is supported by a thick frame of copper. It once decorated the temple of the goddess Ninḫursaǧa at Tell al-Ubaid in southwestern Mesopotamia. We don't know how the panel was installed because it was excavated with other decorative elements found in stacked piles at the base of the temple terrace. Apparently the temple was being desacralized and its luxurious décor assembled for transportation to another site when the activities were stopped. The resulting accumulation of stone sculptures, copper reliefs, inlaid mosaic columns, and shell friezes lay undisturbed until their excavation in the 1920s. The temple had been extremely prosperous and was patronized by officials from nearby Ur according to the inscriptions found nearby. Even the shell from which the bulls were fashioned attested to the wealth once centered there. It is from *Lambis truncata sebae*, called the scorpion shell, which comes only from the Indian Ocean, a good 1500 kilometers (some 932 miles) away.

See H. R. Hall and C. L. Woolley, *Ur Excavations,* vol. I, *Tell el-Obeid* (London: Oxford University Press, 1927), 94–99.

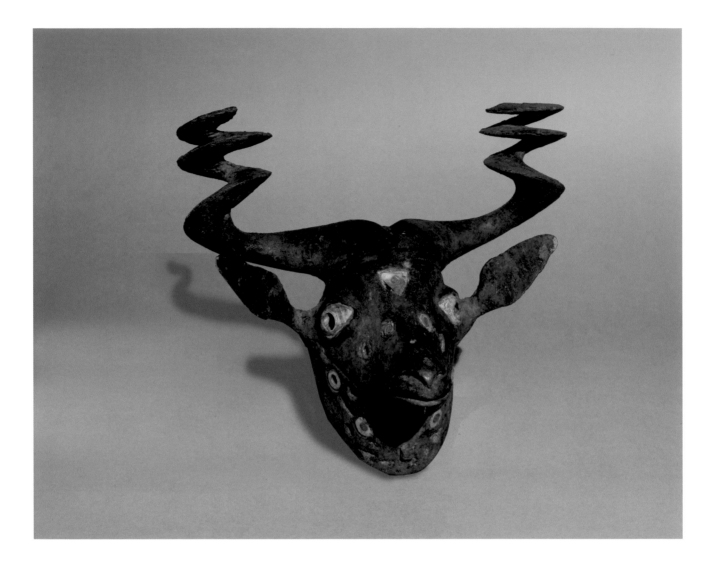

PLATE 47

Head of a goat-like
animal

Iraq, purchased at Nippur during
the 4th Babylonian Expedition,
1899–1900 (said to be from
Fara, Iraq), Late Early Dynastic
Period, 2600–2400 BCE; copper
alloy, shell, and red stone; H: 8 ¾
in. (22.3 cm), W: 9 in. (23 cm),
D: 3 ¹⁵⁄₁₆ in. (10 cm); University
of Pennsylvania Museum of
Archaeology and Anthropology,
gift of Sallie Crozer Hilprecht,
1929, 29-20-3.

This marvelous head is distinguished by its wide-
spread spiraling horns as much as by its protruding
white shell eyes and upright ears. These features
give the animal a manic quality that is enhanced
by additional inlays of white circular spots with
red centers around the neck and over the muzzle,
and a small white triangle with a red stone circle on
the forehead. It has been identified as a domestic
goat (*Capra aegagrus hircus*) and as a markhor goat
(*Capra falconeri*), but it lacks the typical beard (or
goatee) of a goat and the configuration of its horns
is as much bovine as caprine. Likewise the manner
in which the horns grow from the head and the
elongated ears argue against the identification as a
sheep. Perhaps this remarkable creature is not meant

to be a naturalistic image of a specific species but a
numinous embodiment of supernatural energy.

This hollow-cast head, and a similar example
acquired by the University of Pennsylvania
museum at the same time, are also distinctive in
that the openings for the colored inlays extend
completely through the metal. The spaces for
the inlays are not shallow slots, but deep holes
cast into the original form. Both examples were
mounted using vertical pins at the back of the
heads and were undoubtedly part of a temple's
elaborate décor.

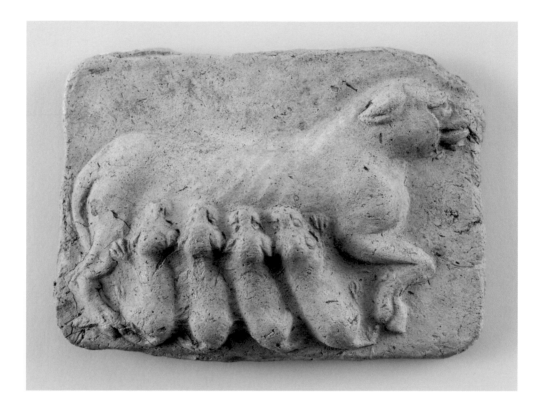

PLATE 48

Plaque with a dog
and suckling pups

Iraq, from Ishchali, Old
Babylonian Period, 2000–1600
BCE; clay; H: 2 ½ in. (6.4 cm),
W: 3 ⅝ in. (9.2 cm); The Oriental
Institute of the University of
Chicago, A9334.

The meaning of this charming clay plaque with its mastiff bitch suckling four puppies is a puzzle. The modern viewer would like to read it as a charming genre scene, but it is unlikely that it was made just because the image was appealing. In its own era, the dog was the companion animal of the goddess Gula, who oversaw the healing arts as well as legal agreements (see Plate 10). It is possible that the scene might refer to that goddess. Or perhaps the fat puppies illustrated a wish for well-being or abundance. We know from written evidence that dogs played an important role in life in the ancient Near East. They were not just hunters and guardians, but were companions as well. A Sumerian proverb states: "A dog which is played with turns into a puppy," a keen observation on the intimate connection between dogs and humans that continues to this day.

PLATE 49

Recumbent dog

Iraq, Old Babylonian Period,
19th century BCE; aragonite;
H: 5 ¹¹⁄₁₆ in. (14.5 cm), W: 8 ¾ in.
(22.3 cm), D: 3 ¾ in. (9.5 cm);
Brooklyn Museum, gift of Mr.
and Mrs. Alastair B. Martin, the
Guennol Collection, 51.220.

The large square head and thick neck of this reclining mastiff echo the compact form of the animal's body. A thin round collar encircles the neck, separating the jowly head with its abundant wrinkles from the smooth, muscular body. The rounded forms and rippling folds of flesh suggest clay rather than the hard stone from which this sculpture was carved. Yet the play of the finely cut lines on the furrowed brow and muzzle accentuates the smooth surfaces of the body. Mastiffs are usually tan in color and may be brindle—that is, have slender, wavy dark streaks running though the lighter base coat of their fur. Here the warm, pale color of the stone and its subtle variations suggest a brindled mastiff coat. Large guard dogs

of the mastiff type have always been an indication of status. Especially in the Near East they require more food and special care because their massive bodies are less well-adapted to the climate than the slender, lean-limbed greyhound types more common in the region. The blunt head and thick neck also suggest a little of the lion's compact forequarters, making the large dog a surrogate lion for its owner.

PLATE 50

Lion

Iraq, excavated from Nuzi (modern Yorghan Tepe), 15th century BCE; glazed ceramic; H: 10 ⅝ in. (27 cm), W: 7 ¹/₁₆ in. (18 cm), D.: 18 ½ in. (47 cm); University of Pennsylvania Museum of Archaeology and Anthropology, gift of the Harvard-Bagdad Expedition, 1931, 31-40-1.

This appealing little lion was one of two recumbent lions—or lion cubs?—excavated from the Ishtar Temple at Nuzi in southern Assyria. Both their mouths have a round opening, and their bodies are hollow with the bases left open to facilitate drying and firing. The ceramic body received a coat of strong red slip before it was partially covered with what was originally an intense yellow glaze. This is a relatively early use of vitreous glazed ceramics, and at Nuzi it was restricted to items in the temple. The two lions were mirror images, with tails curling over their hindquarters in opposite directions, suggesting that they were probably installed on either side of a door, an offering stand, an altar, or a statue. This would have been most appropriate, as Ishtar's companion animal was the lion (see Plates 8 and 9). At the same time, the recumbent lion suggests a guard dog (see Plate 49), implying that a mighty deity like Ishtar could turn even a lion into a domesticated animal. The Ishtar Temple must have been full of images of her feline

companion. A second pair of glazed lions at about the same scale but standing on a slablike base (below), and a smaller standing glazed lion were also excavated from the temple.

See Richard F. A. Starr, *Nuzi: Report on the Excavations at Yorgan Tepa Near Kirkuk, Conducted by Harvard University in Conjunction with the American Schools of Oriental Research and the University Museum of Philadelphia 1927–1931*, 2 vols. (Cambridge, MA: Harvard University Press, 1937–39), pp. 97–98, 433–434, and plate 111B.

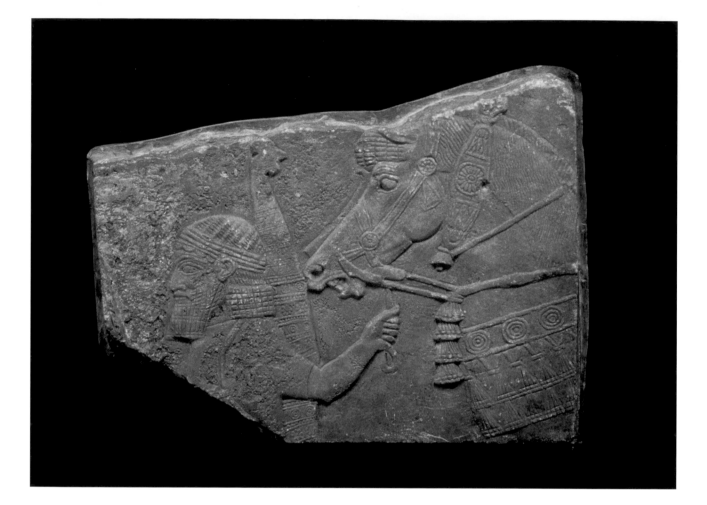

PLATE 51

Relief fragment with
a horse and warrior

Iraq, from the Southwest Palace
of Sennacherib at Nineveh,
Neo-Assyrian Period, reign of
Ashurbanipal, 668–627 BCE;
limestone or gypseous alabaster;
H: 7 ⅞ in. (20 cm), W: 10 ¼ in.
(26 cm); Seattle Art Museum,
Eugene Fuller Memorial
Collection, 57.54.

This fragmentary scene depicts a groom armed
with bow case and quiver leading a richly
decorated horse. The bridle has a beaded or padded
browband, rosette roundels at the strap crossings,
a thin frontlet extending from the animal's
forehead to its muzzle, and joined reins with a
tasseled weight. A wide, decorated band with a
bell encircles the upper neck, and an elaborately
decorated breastband with rows of circular and
floral forms (or perhaps more tassels?) covers the
chest. The stoic, stereotypical visage of the groom
contrasts sharply with the sensitive details of the
horse, who vocalizes with an open mouth, baring
its teeth as if disturbed by something the break in
the stone has put out of sight.

This fragment has been identified as belonging to
Room XXXIII in the Southwest Palace, which was
once covered with panoramic scenes of the battle
of Til-Tuba, an ultimately victorious one for the
Assyrians in their struggle with Elamites along
the Ulai River. The absence of a helmet suggests
that the groom is not a combatant, but his gear,
including the rooster-headed bowcase, as well as
the specific type of stone it was carved from, places
this piece with other fragments from that room.

Richard D. Barnett, Erika Bleibtreu, Geoffrey Turner, et
al., *Sculptures from the Southwest Palace of Sennacherib at
Nineveh*, 2 vols. (London: British Museum Press, 1998),
text (vol. 1), pp. 99–100; (vol. 2), plate 320, no. 417.

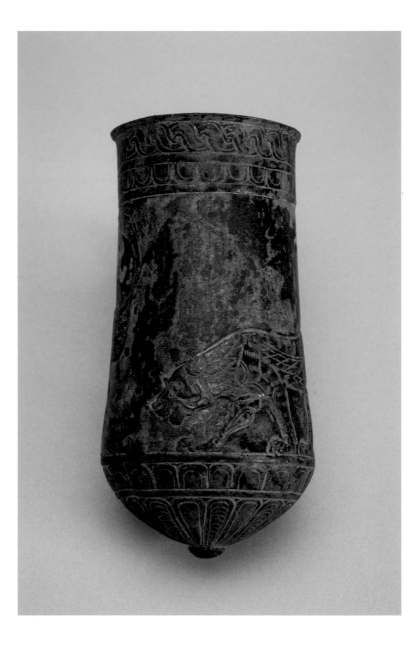

PLATE 52

Beaker with a lion

Iraq, Neo-Babylonian Period,
7th–6th century BCE; bronze;
H: 5 ⅛ in. (13 cm), Diam.: 2 ⁹⁄₁₆
in. (6.5 cm); Sackler Collections,
Columbia University in the City
of New York, S0145.

Bronze beakers of this form, often called button-base or nipple beakers, are primarily known from western Iran. Their decoration, however, usually reflects Babylonian styles, where stocky, rather static human figures are shown in banqueting and highly decorative hunting scenes. Thus they are now considered to be luxury objects made in Babylonia and exported to the Iranian elite. The Columbia beaker is unusual in that the single lion, striding with its head lowered as if stalking prey, is rendered with the sensitive line and naturalistic details of Assyrian animal art (see fig. 4.3). It is particularly close to the animal pieces carved during the reign of Ashurbanipal. This mixing of Assyrian and Babylonian styles in a beaker produced for the Iranian market illustrates the cosmopolitan taste in luxury goods among the ruling elite of various regions.

PLATE 53

Statuette of a bull

Probably Israel, 13th century
BCE; ceramic; H: 2 5/16 in.
(5.9 cm), W: 1 ¾ in. (4.4 cm),
D: 2 7/16 in. (6.2 cm); The Jewish
Museum, New York, gift of
Bernard and Tzila Weiss,
1994–667.

This perky little bovid is typical of the small votive figures deposited at shrines and holy places and used in domestic rituals all across the ancient Near East. These handmade figures were references to or substitutes for the ox or bull that would have been a very public and ostentatious offering. It is possible that the offering was intended for a specific deity, like Adad the weather god whose animal was a bull, but other deities could be invoked as well. It may also be that the making of such figures was the more important aspect, not the keeping of them. Many Mesopotamian healing and curing rituals involved the making of small clay figures that were later discarded. The fact that this little bull is fired ceramic suggests that it was meant to exist, and perhaps function magically, over an extended period.

PLATE 54

Sherd with stags

Turkey, excavated from Alishar Hüyük, 800–700 BCE; ceramic with slip; H: 6 in. (15.3 cm), W: 7 ⅜ in. (18.8 cm); The Oriental Institute of the University of Chicago, A10266.

The Phrygian-speaking people of central Anatolia continued the tradition of painted pottery after many adjacent cultures ceased to treat ceramics as a fine art. Their work was characterized by a strong design sense that used geometric forms to animate the surface of the vessels. This Alishar Hüyük fragment depicts red deer stags, long a favorite animal in the art of Anatolia, framed in a rectangular panel on the side of what was once a large open jar. The delicate abstraction of the constantly curving line shows a level of visual sophistication rarely seen in the ceramic arts of the first millennium BCE. Although the stags are stationary, the curves that form their bodies and slender legs, the extended ears, and their elongated muzzles echo the sweep of the antlers, producing a sensation of imminent motion. The dotted double circles that evenly fill the ground of the panel evoke falling snow for the modern viewer, though we cannot say that this was the intention of the ancient painter.

This fragment belonged to a type of large, open-mouthed jar (right) whose broad shoulders were painted with panels of stags, occasional does, and sometimes horned wild goats. Found in residential or domestic contexts at Alishar, they were called storage jars by the excavators. But their wide openings and exuberant decoration suggest a more public and perhaps ceremonial function.

See Hans Henning von der Osten, *The Alishar Hüyük Seasons of 1930–32: Part II* (Chicago: University of Chicago Press, 1937), pp. 351–352, 372–376, 404, 405, and plates II, X. Researches in Anatolia 8. Oriental Institute Publication 29.

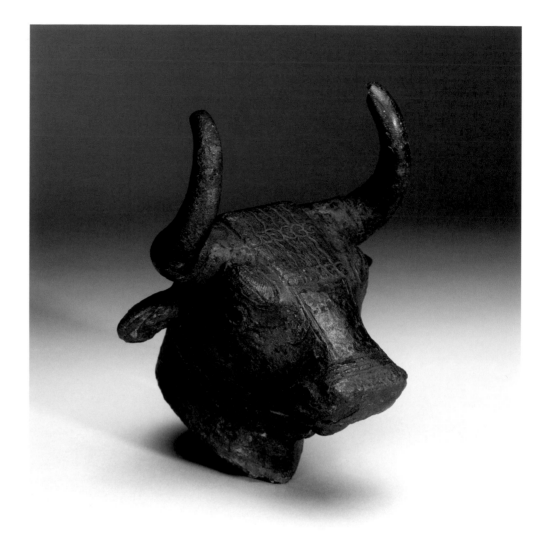

PLATE 55

Head of a bull

Turkey, Urartian, 8th–7th
century BCE; bronze; H: 4 3/16
in. (10.7 cm), W: 4 13/16 in. (12.3
cm), D: 4 7/8 in. (12.4 cm); The
Walters Art Museum, Baltimore,
Maryland, 54.791.

This bull's head is a fascinating mixture of natural-
istically modeled forms and highly stylized, incised
details. The bull has a forelock with two tiers of
long wavy locks, each ending in a small curl. The
circular eyes and wide, oval eyebrows are curiously
abstracted considering the realism of the muzzle,
the horns and ears, and the wrinkles of flesh under
the jaw, although the same combination of realism
and decorative detail is often found in Urartian art.
This cast-bronze bull head is one of many similar
excavated works, most of which appear to have
been used as décor on large cauldrons dedicated in
temples. The cauldrons have rarely survived intact
because the metal of their thin wrought surfaces
was less resistant to corrosion than the thicker
cast heads that were mounted on their rims. The
tripods that supported these cauldrons often had
cloven hoofs for feet, like those on the excavated
assemblage from Altintepe (right).

PLATE 56

Beaker with goats

North-Central Iran, from Tepe
Sialk region, ca. 3500 BCE;
ceramic with slip; H: 6 5/16
in. (16.2 cm), Diam.: 4 ½ in.
(11.4 cm); Arthur M. Sackler
Foundation, New York, 75.7.3.

The body of this fine wheel-thrown beaker tapers
to a precarious base while the rim flairs out
slightly. When full it cannot stand on its own
but must be held. The painted ornament of the
beaker is limited to the exterior, placing the focus
on the upper register. Here three wild goats with
small fringed beards and huge sweeping horns are
rendered with fluid, almost calligraphic strokes.
The legs of the wild goat, a favorite animal motif
in Iranian art, angle forward in a curious "skid-
ding" posture found only on ceramics in the region
around Tepe Sialk. Even the two-toed hoofs of the
goat are shown with tiny brushstrokes. Together,
the undulating horns and the slant of the skidding
legs evoke the sensation of movement, in contrast
to the static geometric patterns of the band below.
When holding this beaker, which is necessary
when it is full, the hand obscures the geometric
band, but the row of goats remains visible. Clearly
the potter was reserving his most elegant motifs for
the most visible portion of the vessel.

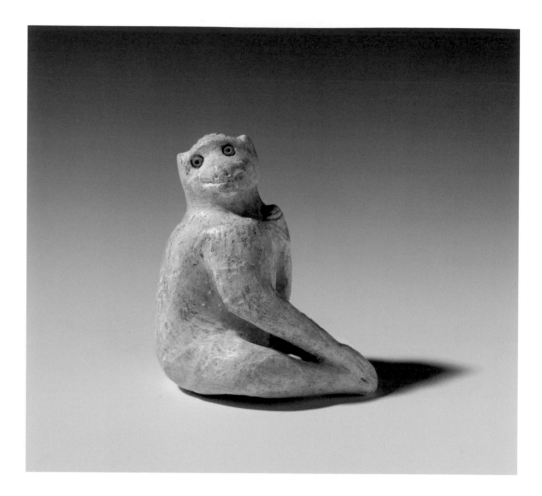

PLATE 57

Statuette of a
monkey

Iran, first half of the 3rd
millennium BCE; limestone;
H: 2 ⅛ in. (5.4 cm), W: 1 ⁷⁄₁₆ in.
(3.7 cm), D: 1 ¾ in. (4.5 cm);
Brooklyn Museum, purchased
with funds given by Shelby
White, 1991.3.

This charming little stone monkey with its inlaid eyes is an example of the naturalistic representation of animals in the ancient Near East from the late fourth millennium BCE onward. The slender limbs and inquisitive angle of the head mark this as a tiny, yet fully realized, sculpture in the round. Primates, of course, are not native to the Near East but have always fascinated people by their almost-human behavior. Small stone statuettes of primates drinking from beakers have been excavated from Susa in Iran, and may well reflect the trade in luxury goods and prestige animals that moved by ship from the Indus Valley via the Persian Gulf to Iran and Mesopotamia. This waterborne trade route was the conduit for several types of etched carnelian beads found in the Royal Cemetery at Ur, and for the carved soft-stone vessels like the one in Plate 28. Monkey images, probably signifying that the owner could afford an exotic pet, occur over the millennia in the ancient Near East, modeled on Old Babylonian clay plaques, engraved on Syrian stone cylinder seals, carved in ivory in the Levant, and occasionally appearing in the royal palace reliefs of the Assyrian kings as prestigious gifts.

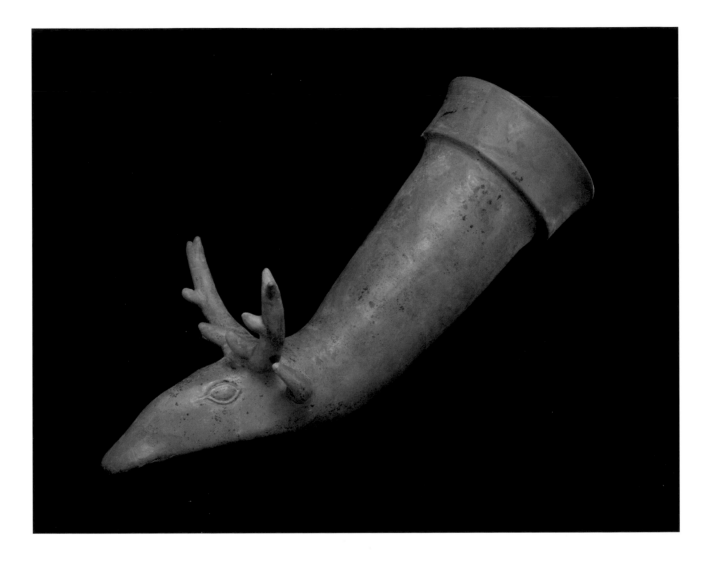

PLATE 58

Rhyton with a deer head

Northern Iran, 1000–550 BCE; ceramic; L: 13 ¼ in. (33.5 cm), Diam.: 4 ¾ in. (12 cm); Arthur M. Sackler Foundation, New York, 70.7.1.

This is a large drinking vessel whose base terminates in the head of a red deer stag (*Cervus elaphus*). Animal-head drinking vessels were popular in the ancient Near East from the second through the first millennium BCE and served as the source for the classical Greek animal-head rhyton. Many metal and ceramic examples are known from western and northern Iran, reflecting a culture that valued elaborate ceremonial activities focused on pouring and drinking. Wine was probably the preferred liquid, since the wine grape was domesticated in this region as early as the fifth millennium BCE. The choice of a red deer suggests that this rhyton was produced in northern Iran, as in the Near East the red deer's natural range is found only in that region and the adjacent Caucasus. The burnished reddish surface of the rhyton nicely mimics the deer, known for its red coat.

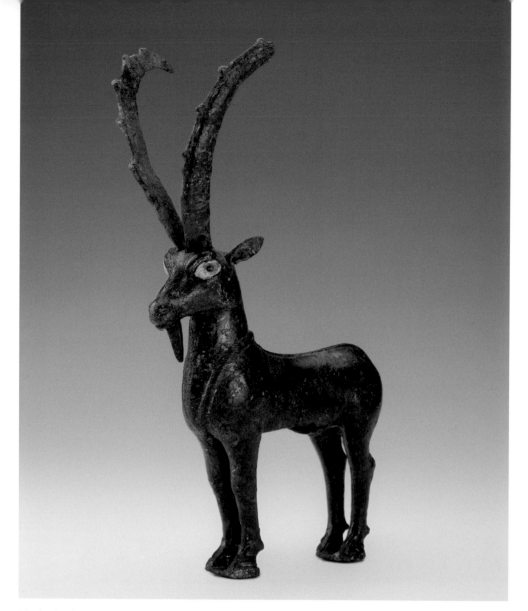

PLATE 59

Goat

Northwest Iran, 1000–800 BCE;
bronze with stone inlay; H: 10 ¼
in. (26 cm), W: 6 ¼ in. (15.8 cm),
D: 3 ⁷⁄₁₆ in. (8.7 cm); Arthur M.
Sackler Gallery, Smithsonian
Institution, Washington, DC, gift
of Arthur M. Sackler, S1987.18.

The body of this goat was cast in one piece; only
the horns, ears, and beard were added separately.
Most of the head and the lower legs are solid
metal. Made as part of a larger assemblage, the
sculpture has five holes for mounting. One hole
is between each set of hoofs, one is on the lower
chest above the front legs, a larger one is just
behind the front legs, and the last one is on the top
of the head just behind the horns. This hole is still
filled with the stub of a roughly square metal rod.
Clearly the statue supported something of greater
weight. The sculpture shows signs of wear or use
and the horns were repaired in antiquity. A second
near-twin of this goat (right), with the same num-
ber of holes and the same repaired horns, but a
larger part of the rod remaining behind the horns,
has also been documented.

We know that animal-shaped offering stands were
a part of temple furnishings in Mesopotamia in the
third millennium BCE, and that divine thrones of
the second and first millennia BCE could feature
animal forms as part of their construction. It is

tempting to see this goat and its mate as part of the
support for an Iranian deity whose symbolic crea-
ture was the wild goat.

Edith Porada and Deborah Schorsch, "Mountain Goat,"
in Dietrich Von Bothmer, ed., *Glories of the Past: Ancient
Art from the Shelby White and Leon Levy Collection*, (New
York: Metropolitan Museum of Art, 1990), No. 36, pp.
49–52.

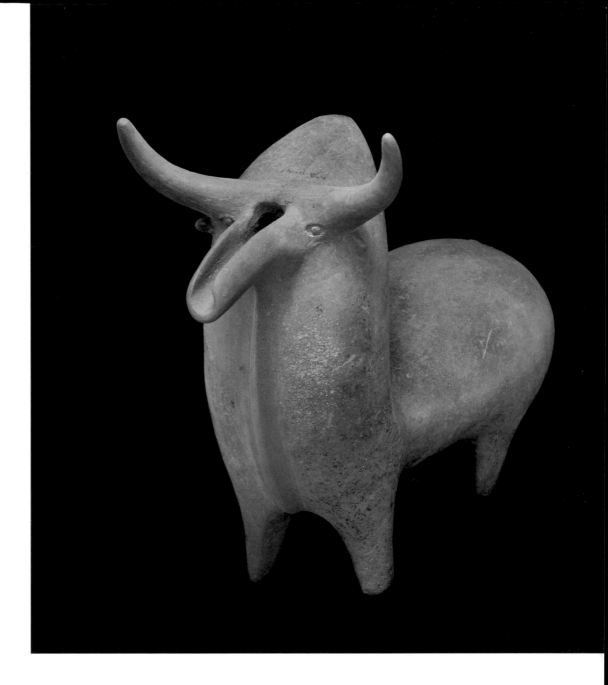

PLATE 60

Spouted vessel in the shape of a bull

Northern Iran, possibly from the
Marlik region, 1200–800 BCE;
ceramic; H: 11 ⅛ in. (28 cm), W:
6 in. (15 cm), L: 14 ¼ in. (36 cm);
Arthur M. Sackler Foundation,
New York, 82.4.2.

This sleekly stylized, bull-shaped vessel is made of
two voluminous forms cleverly joined to depict
the round body and exaggerated shoulder hump
of the zebu (*Bos indicus*), a bovid that was first
domesticated in South Asia (India). The elongated
muzzle forms a long spout that is balanced by the
wide arching horns. The only other details are tiny
ears and small round eyes. The function of this
vessel, and others in its excavated band of siblings
from Tomb 18 at Marlik (see fig. 4.9) was clearly
to serve a special fluid in a ceremonial manner, as
the long, beak-like spout would produce a dra-
matically arcing stream. Since the wine grape was
domesticated in northern Iran, it is possible that
these bull vessels were used to pour out wine at

funerary banquets. Red wine poured from a bull
vessel might symbolize the bull slaughtered for
the funerary feast. Yet because no writing has been
preserved from the Marlik culture we may only
speculate as to the meaning of these elegant ceram-
ics. Their visual significance, however, is clear to
the modern eye.

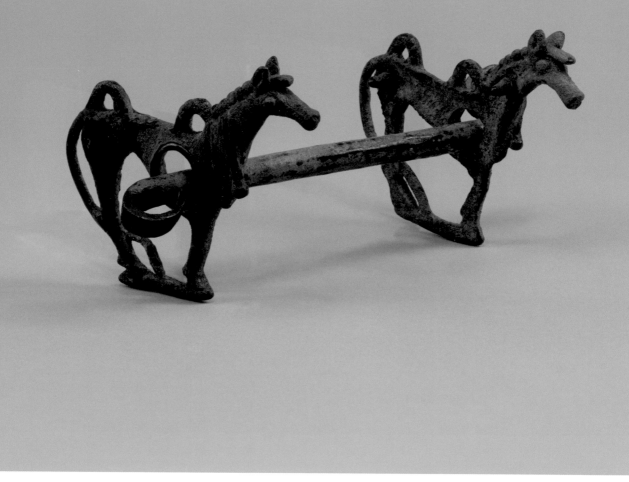

PLATE 61

Bit with cheek
pieces

Iran, Luristan region, 800–650
BCE; bronze; H: 3 ⅛ in.
(8 cm), W: 6 ⁵⁄₁₆ in. (16 cm),
D: 3 ¹⁵⁄₁₆ in. (10 cm); University
of Pennsylvania Museum of
Archaeology and Anthropology,
purchased from R. Y.
Mottahedah, 1931, 31-14-1.

Bronze horse bits with ornamental cheekpieces are best known from the Luristan region of western Iran, though most examples came from uncontrolled digging before the 1950s. Some of these bits show considerable wear on the mouthpieces and on the rings of the cheekpieces. Other bits show no wear and may have been made for public dedication at shrines and holy places. The Luristan bits were used to drive teams of horses, not in riding individual animals. Here, on the inner surface, one can see two large blunt knobs, one on the horse's neck, the other on the hindquarters; these would apply pressure to the horse's cheek to make the animal turn when the opposing rein was pulled. Similar devices are still used today on driving bits. The two loops on the back of each horse allowed the bit to be attached to the split-strap headstall, which can also be seen on the Assyrian horse in Plate 51. Assyrian bits almost invariably have simple, straight cheekpieces; only the Iranian examples feature animals and sometimes composite monsters. This bit was produced by casting the cheekpieces using the lost-wax method, then joining them via the mouthpiece, which was manually worked into a loop at each side for the reins after being inserted into the cheekpieces.

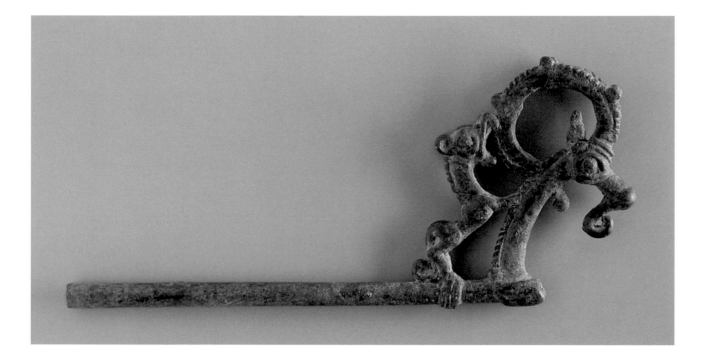

PLATE 62

Dress pin

Iran, Luristan region, 800–650
BCE; bronze; H: 3 in. (7.8 cm),
L: 7 ⅛ in. (18 cm); Los Angeles
County Museum of Art,
The Nasli M. Heeramaneck
Collection of Ancient Near
Eastern and Central Asian
Art, gift of the Ahmanson
Foundation, M.76.97.239.

This dress pin was made to have a horizontal orientation, unlike the vertical orientation of the dress pins in Plates 22 and 23. The head of this pin, cast in the lost-wax process, takes the form of the head of an ibex (*Capra ibex*) whose knobbed horns curve back in a circle. A small feline with an open mouth stands with his hind claws grasping the pin's shank and reaches upward to bite at the horns. But while this little carnivore threatens the ibex, it is only the secondary element in the composition. The ibex remains the central motif, seemingly unperturbed by the creature behind it.

Once thought to be used as garment fasteners, pins like these may have been made for ostentatious donation as votive gifts in deposits of religious items. We know that a number of similar horizontal pins with small ibex heads were excavated as deposits within the walls of the shrine at Surkh Dum-i-Luri in Luristan.

See Erich Friedrich Schmidt, Maurits Nanning van Loon, and Hans H. Curvers, *The Holmes Expeditions to Luristan* (Chicago: University of Chicago Press, 1989), plates 41, 44, 45, and 179. Oriental Institute Publication 108.

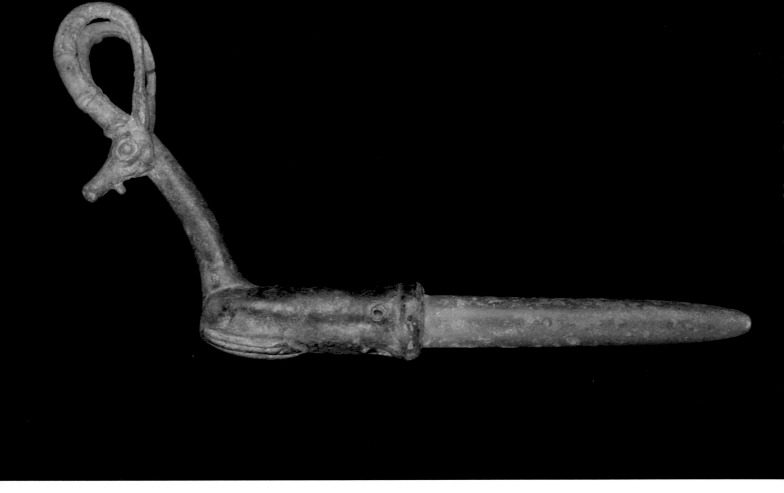

PLATE 63

Whetstone

Iran, Luristan region, 800–650 BCE; bronze and stone; H: 4 3/16 in. (10.7 cm), W: 15/16 in. (2.4 cm), D: 4 5/16 in. (10.9 cm); Arthur M. Sackler Gallery, Smithsonian Institution, Washington, DC, gift of Mr. and Mrs. John B. Bunker in memory of Dr. Edith Porada, S1996.75.

A whetstone is a fine-grained stone used for sharpening metal; this one is tapered to be used to sharpen knives and daggers. For a brief period in the eighth and seventh centuries BCE in western Iran, whetstone mounts, which were usually just a metal ring allowing them to be suspended for carrying, became ornamental. A variety of fanciful animals were created, but the most common creatures were felines and wild sheep or goats with great curving horns. This example features what is probably a stylized ibex with knobbed horns that curl back to touch the animal's head. The actual socket of the whetstone bears the forelegs, folded back against the underside as if the animal were lying down. One can see the small hole near the rim where a metal pin secures the stone in the mount. A practical tool has become an elegant abstraction of a familiar wild animal.

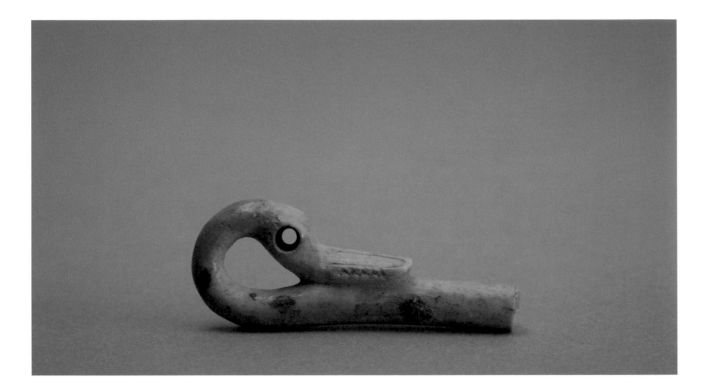

PLATE 64

Duck-headed
spoon handle

Iran, 8th–7th century BCE; ivory;
H: 1 ¹³⁄₁₆ in. (4.6 cm), W: ¹¹⁄₁₆
in. (1.7 cm), D: ⁵⁄₁₆ in. (0.7 cm);
Sackler Collections, Columbia
University in the City of New
York, S0128.

In contrast to the fanciful terminals associated with
the Luristan bronzes, the handles and terminals
of spoons and ladles in areas influenced by the
court cultures of Mesopotamia featured the simple
recurved heads of water birds, usually ducks or
geese. The duck head on this elegant little terminal
has a large round eye that was once inlaid, and an
elongated beak that runs along the stem, reinforc-
ing the graceful open curve of the neck. A similar
duck head is carved in relief on the side of a now-
fragmentary ivory handle excavated at Hasanlu in
northwestern Iran. Other duck heads have been
found on Assyrian stone weights, cut-stone per-
fume flasks, silver ladles, and other luxury objects.
Though reportedly found in Iran, this charming

piece could have been made in a number of craft
centers in the ancient Near East and later traded to
the region in which it was said to have been found.

About the Authors

Trudy S. Kawami is Director of Research at the Arthur M. Sackler Foundation in New York. A specialist in Ancient Near Eastern Art and Archaeology, Kawami has organized several traveling exhibitions from the foundation's collections. She is the author of *Monumental Art of the Parthian Period in Iran* (1987), *Ancient Iranian Ceramics in the Arthur M. Sackler Collections* (1992), and numerous articles.

John Olbrantz is The Maribeth Collins Director of the Hallie Ford Museum of Art at Willamette University in Salem, Oregon. A specialist in ancient and American art, Olbrantz is particularly interested in Roman art, the history of archaeology, contemporary American art, and the history of museums. Over the years, he has written about ancient glass, ancient mosaics, contemporary regional art, and the history of American Egyptology.

Selected Bibliography

Abt, Jeffrey. (2012). *American Egyptologist: The Life of James Henry Breasted and the Creation of His Oriental Institute.* Chicago: University of Chicago Press.

Ackerman, Andrew S., and Susan L. Braunstein. (1982). *Israel in Antiquity: From David to Herod.* New York: The Jewish Museum.

Akkermans, Peter M. M. G., and Glenn M. Schwartz. (2003). *The Archaeology of Syria: From Complex Hunter-Gatherers to Early Urban Societies (c. 16,000 300 BC).* Cambridge, UK: Cambridge University Press.

Albenda, Pauline. (2004). "Horses of Different Breeds: Observations in Assyrian Art." *Amurru* 3: 321–334.

Alkim, U. Bahadir. (1968). *Anatolia I: From the Beginnings to the End of the 2nd Millennium.* Cleveland, OH: World Publishing.

Álvarez-Mon, Javier. (2010). *The Arjan Tomb: At the Crossroads of the Elamite and the Persian Empires.* Belgium: Peeters. Acta Iranica 49.

Aruz, Joan. (2010). "Archaeology and the Department of Ancient Near Eastern Art." *Metropolitan Museum of Art Bulletin* 68(1): 6–11.

Aruz, Joan. (2002). "Power and Protection: A Little Proto-Elamite Silver Bull Pendant." In Hansen, Donald P., and Erica Ehrenberg, *Leaving No Stones Unturned: Essays on the Ancient Near East and Egypt in Honor of Donald P. Hansen,* 1–14. Winona Lake, IN: Eisenbrauns, 2002.

Aruz, Joan, with Ronald Wallenfels, eds. (2003). *The Art of the First Cities: The Third Millennium BC from the Mediterranean to the Indus.* New York: Metropolitan Museum of Art; New Haven, CT: Yale University Press.

Bacharach, Jere L., John W. Clear, and Cynthia May Sheikholeslami. (1977). *Near Eastern Civilizations Through Art.* Seattle: Seattle Art Museum.

Barnett, Richard D. (1982). *Ancient Ivories in the Middle East and Adjacent Countries.* Jerusalem: Institute of Archaeology. QEDEM 14, Monographs of the Institute of Archaeology, The Hebrew University of Jerusalem.

Barnett, Richard D., Erika Bleibtreu, and Geoffrey Turner, et al. (1998). *Sculptures from the Southwest Palace of Sennacherib at Nineveh.* 2 vols. London: British Museum Press.

Ben-Tor, Amnon, ed. (1992). *The Archaeology of Ancient Israel.* Trans R. Greenberg. New Haven, CT: Yale University Press.

Benoit, Agnès. (2007). *Les civilisations du Proche-Orient ancien.* Paris: Manuels de l'Ecole du Louvre; Réunion des musées nationaux, Art et archeology.

Black, J. A., G. Cunningham, E. Fluckiger-Hawker, E. Robson, and G. Zólyomi. The Electronic Text Corpus of Sumerian Literature [ETCSL]. (1998–2003). Oxford, UK: Faculty of Oriental Studies. See www.etcsl.orient.ox.ac.uk/ (accessed May 14, 2013).

Bogdanos, Matthew, "The Casualties of War: The Truth About the Iraq Museum." *American Journal of Archaeology* 109(3), 2005): 477–526.

Brackman, Arnold C. (1978). *The Luck of Nineveh: Archaeology's Great Adventure.* New York: McGraw-Hill.

Breasted, Charles. (1943). *Pioneer to the Past: The Story of James Henry Breasted, Archaeologist.* Chicago: University of Chicago Press. Reprinted Chicago: University of Chicago Press, 1977.

Briant, Pierre. (2002). *From Cyrus to Alexander: A History of the Persian Empire.* Trans. Peter T. Daniels. Winona Lake, IN: Eisenbrauns.

Budin, Stephanie L. (2011). *Images of Woman and Child from the Bronze Age: Reconsidering Fertility, Maternity, and Gender in the Ancient World.* New York: Cambridge University Press.

Canby, Jeanny Vorys. (1974). *The Ancient Near East in the Walters Art Gallery.* Baltimore, MD: Walters Art Gallery.

Caubet, Annie, and Patrick Pouysségur, trans. Peter Snowden. (1998). *The Ancient Near East: The Origins of Civilization.* Paris: Terrail.

Charpin, D., and J.-M. Durand. (1985). "La prise du pouvoir par Zimri-Lim." *Mari, Annales de Recherches Interdisciplinnaires* 4: 293–342.

Cohen, Ada, and Steven Kangas, eds. (2010). *Assyrian Reliefs from the Palace of Ashurnasirpal II: A Cultural Biography.* Hanover, NH: Hood Museum of Art.

Connan, Jacques, and Odile Deschesne. (1996). *Le bitume à Suse: Collection du Musée du Louvre* (Bitumen at Susa: The Louvre Museum Collection). Paris: Reunion des musées nationaux, 1996, nos. 136, 137: 204–205, and color figure 9.

Cuneiform Digital Library Initiative [CDLI]. At http://cdli.ucla.edu/ (accessed May 22, 2013).

Curtis, John E., and Julian E. Reade, eds. (1995). *Art and Empire: Treasures from Assyria in the British Museum.* New York: Metropolitan Museum of Art.

Curtis, John E., and Nigel Tallis, eds. (2005). *Forgotten Empire: The World of Ancient Persia.* Berkeley, CA: University of California Press.

Dyson, Robert H., Jr. (1957). "A Gift of Nimrud Sculptures." *The Brooklyn Museum Bulletin* 17(3).

Electronic Text Corpus of Sumerian Literature [ETCSL]. (1997–2006). For information on using the content of this research, see http://etcsl.orinst.ox.ac.uk/ (accessed 5-24-13).

Emberling. Geoff. (2009). "Views of a Museum: The Extraordinary Collection of the Oriental Institute, University of Chicago." *The Canadian Society for Mesopotamian Studies* 4: 29–35.

Emberling, Geoff. (2010). *Pioneers to the Past: American Archaeologists in the Middle East, 1919–1920.* Chicago: Oriental Institute of the University of Chicago.

Esteghamat, Orang. (2003). "Milch- und Fleischproduktion im Iran. Massnahmen zur Steigerung der Milch- und Mastleitung bei einheimischen Rinderrassen." *Grosstierpraxis* 9: 15–19.

Evans, Jean M. (2012). *The Lives of Sumerian Sculpture: An Archaeology of the Early Dynastic Temple.* Cambridge, UK: Cambridge University Press.

Fagan, Brian M. (1979). *Return to Babylon: Travelers, Archaeologists, and Monuments in Mesopotamia.* Boston: Little, Brown.

Fisher, Marjorie. "A Diplomatic Marriage in the Ramesside Period: Maathorneferure, Daughter of the Great Ruler of Hatti." In Gary M. Beckman, Billie Jean Collins, and Piotr Michalowski, *Beyond Hatti: A Tribute to Gary Beckman,* 75–120. Atlanta, GA: Lockwood Press.

Frankfort, Henri. (1939). *Sculpture of the Third Millennium B.C. from Tell Asmar and Khafjah.* Chicago: University of Chicago Press. Oriental Institute Publication 44.

Frankfort, Henri. (1943). *More Sculpture from the Diyala Region.* Chicago: University of Chicago Press. Oriental Institute Publication 60.

Frankfort, Henri. (1996). *The Art and Architecture of the Ancient Orient.* 6th ed. New Haven, CT: Yale University Press.

Friedman, Elizabeth S., A. P. J. Stampfl, Y. Sato, E. E. Alp, et al. "Archaeology at the APS: Illuminating the Past." *Advanced Photon Source Research* 2(1): 12–16.

Gadd, C. J., and S. N. Kramer. (1963). *Ur Excavations: Texts.* Publications of the Joint Expedition of the British Museum and of the Museum of the University of Pennsylvania, Philadelphia, to Mesopotamia, Vol. 6, pt. 2, no. 225. London: British Museum Press.

Gates, Marie-Henriette. (1990). "Artisans and Art in Old Babylonian Mari." In *Investigating Artistic Environments in the Ancient Near East,* 29–37. Washington, DC: Arthur M. Sackler Gallery, Smithsonian Institution.

Ghirshman, Roman. (1938–39). *Fouilles de Sialk près de Kashan, 1933, 1934, 1937.* 2 vols. Paris: Musée du Louvre, Département des antiquités orientales.

Godley, Alfred Denis, trans. (1948). *Herodotus.* Book I. London: William Heinemann, line 131: 171.

Goldstein, Sidney M. (1990). "Egyptian and Ancient Near Eastern Art." *The Saint Louis Art Museum Bulletin* 4.

Hall, H. R., and C. L. Woolley. (1927). *Ur Excavations,* vol. I. *Tell al-Obeid.* London: Oxford University Press.

Harms, William. (2004). "Archaeologists Review Loss of Valuable Artifacts One Year after Looting." *University of Chicago Chronicle* 23(14) (April 15, 2004), at http://chronicle.uchicago.edu/040415/oi.shtml (accessed 5-16-13).

Harper, Prudence O. (2001). "Department of Ancient Near Eastern Art, Metropolitan Museum of Art." In Beate Salje, ed., *Vorderasiatische Museen: Gestern, Heute, Morgen: Berlin, Paris, London, New York: Eine Standortbestimmung: Kolloquium aus Anlass des einhundertjährigen Bestehens des Vorderasiatischen Museums Berlin am 7. Mai 1999,* 53–62. Mainz: Verlag Philipp von Zabern.

Harper, Prudence O., Joan Aruz, and Françoise Tallon. (1992). *The Royal City of Susa: Ancient Near Eastern Treasures in the Louvre.* New York: Metropolitan Museum of Art.

Houlihan, Patrick F. (1996). *The Animal World of the Pharaohs.* London: Thames & Hudson.

Kawami, Trudy S. (2005). "Deer in Art, Life and Death in Northwestern Iran." *Iranica Antiqua* 40: 107–131.

Kawami, Trudy S. (1998). "The Cattle of Uruk: Stamp Seals and Animal Husbandry in the Late Uruk/Jemdet Nasr Period." Paper presented at Harvard Univesity, Cambridge, MA, July 7–10. In *Proceedings of the 45th Rencontre Assyriologique Internationale,* Part II, William W. Hallow and Irene J. Winter, eds., *Seals and Seal Impressions,* 31–47. Bethesda, MD: CDL Press, 2001.

Kawami, Trudy S. (1992). *Ancient Iranian Ceramics from the Arthur M. Sackler Collections.* New York: Abrams.

Kawami, Trudy S. (1990). In Dietrich Von Bothmer, ed., *Glories of the Past: Ancient Art from the Shelby White and Leon Levy Collection,* 29–33, 35, 39, 45, 46–48, 53, 61, 73–84, 267. New York: Metropolitan Museum of Art.

Kent, R. G. (1953). *Old Persian: Grammar, Text, Lexicon.* 2nd ed. New Haven, CT: Yale University Press.

Al-Khalesi, Yasin. (1978). *The Court of the Palms: A Functional Interpretation of the Mari Palace,* 37–45 and pl. 6. Malibu, CA: Udena Publications. Bibliotheca Mesopotamica 8.

King, Phillip J. (1983). *American Archaeology in the Mideast: A History of the American Schools of Oriental Research.* Philadelphia: American Schools of Oriental Research.

Kroll, Stephan. (2010). "Urartu and Hasanlu." *Aramazd* 5, pt. 2: 21–35.

Lawton, Thomas, et al. (1987). *Asian Art in the Arthur M. Sackler Gallery: The Inaugural Gift.* Washington, DC: Arthur M. Sackler Gallery, Smithsonian Institution.

Layard, Austen Henry. (1849). *Nineveh and Its Remains.* London: John Murray.

Layard, Austen Henry. (1853). *Discoveries in the Ruins of Nineveh and Babylon.* London: John Murray.

Lloyd, Seton. (1947). *Foundations in the Dust: The Story of Mesopotamiun Exploration.* London: Oxford University Press. Reprinted London: Thames & Hudson, 1980.

Loftus, William Kennett. (1857). *Travels and Researches in Chaldaea and Susiana, with an account of excavations at Warka, the "Erech" of Nimrod, and Shush, "Shushan the Palace" of Esther, in 1849 52.* New York: Robert Carter and Brothers.

Loud, Gordon. (1939). *The Megiddo Ivories.* Chicago: University of Chicago Press. Oriental Institute Publication 52.

Mallowan, M. E. L. (1947). "Excavations at Brak and Chagar Bazar." *Iraq* 9: 1–259.

Markoe, Glenn. (1985). *Phoenician Bronze and Silver Bowls from Cyprus and the Mediterranean.* Berkeley, CA: University of California Publications. Classical Studies 6.

Mayo, Margaret Ellen. (1982). *Ancient Art in the Virginia Museum of Fine Arts.* Richmond: Virginia Museum of Fine Arts.

Meyers, Peter. (2000). "The Casting Process of the Statue of Queen Napir-Asu in the Louvre." *Journal of Roman Archaeology, Supplementary Series* 39: 11–18.

Metropolitan Museum of Art. (1986). *Treasures of the Holy Land: Ancient Art from the Israel Museum.* New York: Metropolitan Museum of Art; Jerusalem: Muze'on Yi a'el.

Michalowski, Piotr. (1990). "Early Mesopotamian Communicative Systems: Art, Literature and Writing." In Ann C. Gunter, *Investigating Artistic Environments in the Ancient Near East,* 53–69. Washington, DC: Arthur M. Sackler Gallery, Smithsonian Institution.

Mitchell, T. C. (2000). "Camels in the Assyrian Bas-Reliefs." *Iraq* 62: 187–194.

Mousavi, Ali. (2012). *Ancient Near Eastern Art at the Los Angeles County Museum of Art.* Los Angeles: Los Angeles County Museum of Art.

Muscarella, Oscar. (2006). "The Excavation of Hasanlu: An Archaeological Evaluation." *Bulletin of the American Schools of Oriental Research* 342: 69–94.

Muscarella, Oscar W. (1980). *The Catalogue of Ivories from Hasanlu, Iran.* Philadelphia: University Museum, University of Pennsylvania.

Negahban, Ezat O. (1996). *Marlik: The Complete Excavation Report.* 2 vols. Philadelphia: The University Museum, University of Pennsylvania. Hasanlu Special Studies, Vol. II; University Museum Monograph 40, 20–23.

Negbi, Ora. (1976). *Canaanite Gods in Metal: An Archaeological Study of Ancient Syro-Palestinian Figurines.* Tel Aviv: Tel Aviv University, Institute of Archaeology.

Nissen, Hans J., Elisabeth Lutzeier, and Kenneth J Northcott. (1988). *The Early History of the Ancient Near East: 9000–2000 B.C.* Chicago: University of Chicago Press.

Nowell, Kristen, Peter Jackson, and IUCN/SSC Cat Specialist Group. (1966.) *Wild Cats: Status Survey and Conservation Action Plan.* Gland: Switzerland: International Union for the Conservation of Nature, 38.

Oates, David, and Joan Oates. (1976). *The Rise of Civilization.* New York: Dutton.

Oppenheim, A. Leo. (1967). *Letters From Mesopotamia: Official Business and Private Letters on Clay Tablets from Two Millennia.* Chicago: University of Chicago Press.

Oppenheim, A. Leo. (1943). "Akkadian pul(u)t(t)u and melammu." *Journal of the American Oriental Society* 63(1): 31–34.

Padgett, J. Michael. (1996). "The Collections of Ancient Art: The Early Years." *Record of the Art Museum, Princeton University* 55(1 and 2): 107–124.

Pearlman, Moshe. (1980). *Digging up the Bible.* New York: William Morrow.

Peck, Elsie Holmes. (2002). "A Decorated Bronze Belt in the Detroit Institute of Arts." In Hansen, Donald P., and Erica Ehrenberg, *Leaving No Stones Unturned: Essays on the Ancient Near East and Egypt in Honor of Donald P. Hansen,* 183–202. Winona Lake, IN: Eisenbrauns, 2002.

Peck, William H. (1973). "The Arts of the Ancient Near East in Detroit." *Connoisseur* 183(737): 28–32.

Pezzati, Alessandro. (2002). *Adventures in Photography: Expeditions of the University of Pennsylvania Museum of Archaeology and Anthropology.* Philadelphia: University of Pennsylvania Museum of Archaeology and Anthropology.

Porada, Edith, and Deborah Schorsch. (1990). "Mountain Goat." In Dietrich Von Bothmer, ed., *Glories of the Past: Ancient Art from the Shelby White and Leon Levy Collection,* No. 36, pp. 49–52. New York: The Metropolitan Museum of Art.

Porada, Edith, with R. H. Dyson and C. K. Wilkinson. (1965). *Ancient Iran: The Art of Pre-Islamic Times.* New York: Crown.

Potts, Daniel T. (1999). *The Archaeology of Elam: Formation and Transformation of an Ancient Iranian State.* New York: Cambridge University Press.

Reichel, Clemens. (2003). "A Modern Crime and an Ancient Mystery: The Seal of Bilalama." In Gebhard Selz, ed., *Festschrift Bürkhart Kienast,* 355–389. Münster, DGR: Ugarit. Alter Orient und Altes Testament 274.

Reisner, George A., Clarence S. Fisher, and David G. Lyon. (1924). *Harvard Excavations at Samaria, 1908 1910.* Cambridge, MA: Harvard University Press.

Rissmann, Paul. (1989). "The Status of Research on Animal Domestication in India and Its Cultural Context." In Pam J. Crabtree, Douglas Campana, and Kathleen Ryan, eds. *Early Animal Domestication and Its Cultural Context.* Philadelphia: MASCA, the University Museum of Archaeology and Anthropology, University of Pennsylvania. MASCA Research Papers in Science and Archaeology Vol. 6 supplement, 15–23.

Sanders, James A., ed. (1970). *Near Eastern Archaeology in the Twentieth Century: Essays in Honor of Nelson Glueck.* Garden City, NY: Doubleday and Co.

Schaunsee, Maude de, ed. (2011). *Peoples and Crafts in Period IVB at Hasanlu, Iran.* Philadelphia, PA: University of Pennsylvania Museum of Archaeology and Anthropology. Hasanlu Special Studies IV. Museum Monograph 132.

Schmidt, Erich Friedrich, Maurits Nanning van Loon, and Hans H Curvers. (1989). *The Holmes Expeditions to Luristan*. Chicago: University of Chicago Press. Oriental Institute Pubblication 108.

Seyrig, Henri. (1953). "Statuettes trouvées dans les montagnes du Liban." *Syria* 30(1-2): 24–50.

Silberman, Neil Asher. (1982). *Digging for God and Country: Exploration, Archaeology, and the Secret Struggle for the Holy Land, 1799 1917*. New York: Alfred A. Knopf.

Starr, Richard F. (1937–39). *Nuzi: Report on the Excavations at Yorgan Tepa Near Kirkuk, Conducted by Harvard University in Conjunction with the American Schools of Oriental Research and the University Museum of Philadelphia 1927 1931*, 2 vols. Cambridge, MA: Harvard University Press.

Stearns, John B. (1961). *Reliefs from the Palace of Ashurnasirpal II, vol. 15*. Graz: Weidner, Archiv für Orientforschung.

Terrace, Edward L. B. (1962). *The Art of the Ancient Near East in Museum of Fine Arts, Boston*. Boston: Museum of Fine Arts.

Terrace, Edward L. B. (1966). "Ancient Near Eastern Art." In *The Pomerance Collection of Ancient Art*, 22–23. Brooklyn, NY: The Brooklyn Museum.

Tuffnell, Olga, with Margaret A. Murray and David Diringer. (1953). *Lachish III (Tell Ed-Duweir): The Iron Age*. 2 vols. London: Oxford University Press.

Von der Osten, Hans Henning. (1937). *The Alishar Hüyük Seasons of 1930 32: Part II*. Chicago: University of Chicago Press. Researches in Anatolia 8. Oriental Institute Publication 29.

Walker, Christopher, and Michael B. Dick. (1999). "The Induction of the Cult Image in Ancient Mesopotamia: The Mesopotamian *mīs pî* Ritual." In Dick, Michael B., ed., *Born in Heaven, Made on Earth: The Making of the Cult Image in the Ancient Near East*, 55–121. Winona Lake, IN: Eisenbrauns.

Weiss, Harvey, ed. (1985). *Ebla to Damascus: Art and Archaeology of Ancient Syria: An Exhibition from the Directorate-General of Antiquities and Museums, Syrian Arab Republic*. Washington, DC: Smithsonian Institution Exhibition Traveling Service.

Wiesehöfer, Josef. (1996). *Ancient Persia from 550 BC to 650 AD*. London: I. B. Tauris.

Wilkinson, Charles K. (1949). "The Art of the Ancient Near East." *Metropolitan Museum of Art Bulletin* 7(7): 186–198.

Wilson, Karen L., Jacob Lauinger, et al. (2012). *Bismaya: Recovering the Lost City of Adab*. Chicago: Oriental Institute of the University of Chicago. Oriental Institution Publication 138.

Winegrad, Dilys Pegler. (1993). *Through Time, Across Continents: A Hundred Years of Archaeology and Anthropology at the University Museum*. Philadelphia: University of Pennsylvania Museum of Archaeology and Anthropology.

Winter, Irene J. (2002). "How Tall was Naram-Sîn's Victory Stele? Speculation on the Broken Bottom." In Hansen, Donald P., and Erica Ehrenberg, *Leaving No Stones Unturned. Essays on the Ancient Near East and Egypt in Honor of Donald P. Hansen*, 301–311. Winona Lake, IN: Eisenbrauns, 2002.

Winter, Irene J. (1999). "Tree(s) on the Mountain: Landscape and Territory on the Victory Stele of Naram-Sîn of Agade." In Milano, L., et al., eds., *Landscapes: Territories, Frontiers and Horizons in the Ancient Near East, Part I. Invited lectures* [History of the Ancient Near East, Monographs III/1], 63–72. Padova, Italy: Sargon.

Woolley, Leonard. (1982). *Ur 'of the Chaldees,' a Revised and Updated Edition of Sir Leonard Woolley's* Excavations at Ur, P. R. S. Moorey, ed. Ithaca, NY: Cornell University Press.

Woolley, C. Leonard. (1954). *Ur Excavations*. Joint Expedition of the British Museum and the Museum of the University of Pennsylvania, vol. 6. *The Early Periods*. London: British Museum and University of Pennsylvania.

Woolley, C. Leonard, et al. (1934). *The Royal Cemetery: Ur Excavations*. Joint Expedition of the British Museum and the Museum of the University of Pennsylvania, 2 vols. London: British Museum.

Woolley, C. Leonard, M. E. L. Mallowan, and T. C. Mitchell. (1974). *Ur Excavations*. Joint Expedition of the British Museum and the Museum of the University of Pennsylvania, vol. 7. *Old Babylonian Period*. London: British Museum Publications, 1974.

Yener, Aslihan. (2009). "Strategic Industries and Tin in the Ancient Near East." *Tüba-Ar* 12: 143–154.

Yon, Marguerite. (2006). *The City of Ugarit at Tell Ras Shamra*. Winona Lake, IN: Eisenbrauns.

Zettler, Richard L., Lee Horn, Donald P. Hansen, and Holly Pittman. (1998). *Treasures from the Royal Tombs of Ur*. Philadelphia: University of Pennsylvania Museum of Archaeology and Anthropology.

Chronology of the Ancient Near East

	6000 BCE	5000 BCE	4000 BCE
MESOPOTAMIA	Halaf Period 6100–5400 BCE Ubaid Period 5900–4000 BCE		Uruk Period 4000–3100 BCE
SYRIA AND THE LEVANT			
ANATOLIA			
IRAN			

Neo-Sumerian Period
2150–2000 BCE

emdet–Nasr Period
100–2900 BCE

Middle Babylonian
Period
1600–1000 BCE

Neo-Assyrian
Period
1000–605 BCE

Early Dynastic Period
3000–2350 BCE

Akkadian
Period
2350–2150
BCE

Old Babylonian
and
Old Assyrian
Periods
2000–1600 BCE

Middle Assyrian Period
1600–1000 BCE

Neo-Babylonian
Period
605–539 BCE

Canaanite Period
3000–1200 BCE

Divided Monarchy
920–586 BCE

United Monarchy
1200–920 BCE

Hittite Imperial
Hegemony or Hittite
Empire
1450–1180 BCE

Period of Urartian
Power (eastern
Anatolia only)
820–600 BCE

Neo-Hittite or Late
Hittite Period
ca. 1100–800 BCE

Old Elamite
Period
2000–1500
BCE

Achaemenid
Period
550–330 BCE

Middle
Elamite Period
1300–1000
BCE

Late or Neo-
Elamite Period
800–550 BCE

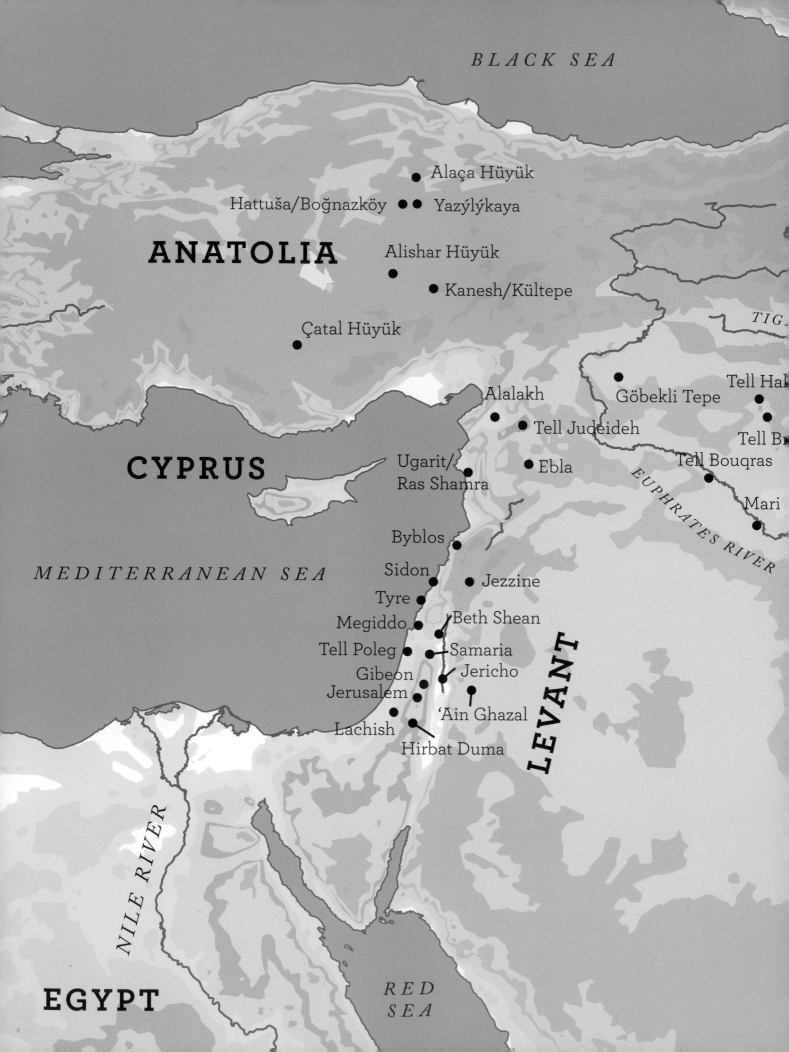

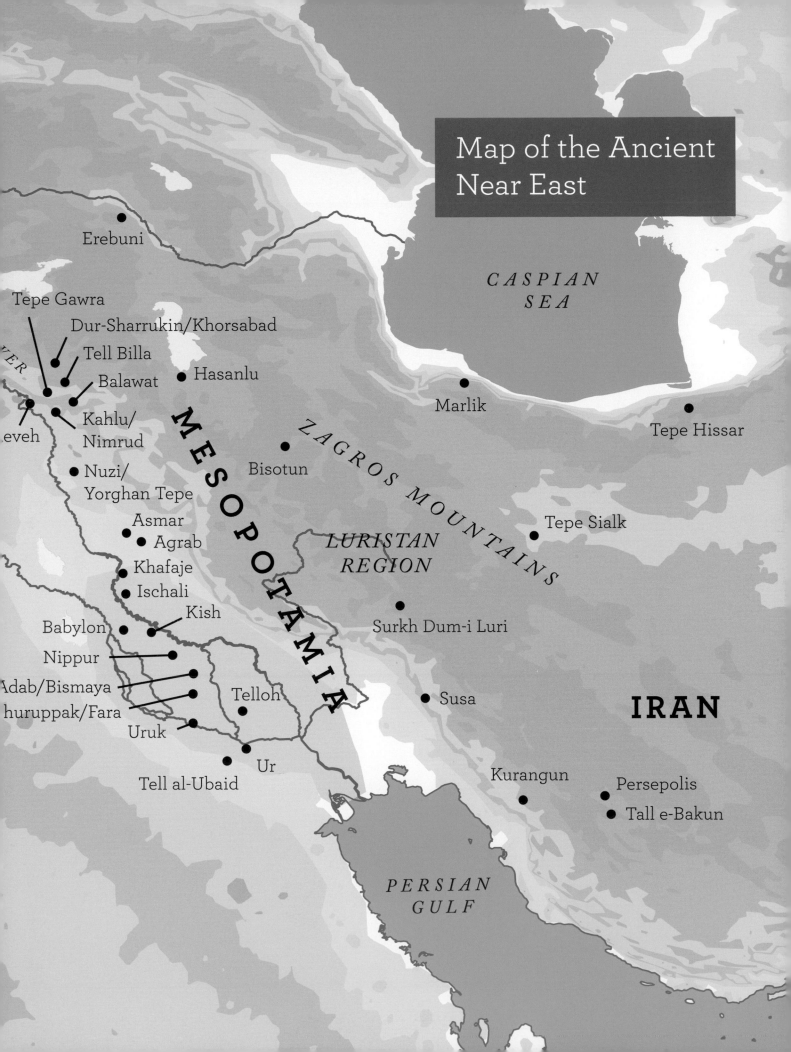

Map of the Ancient Near East

Erebuni

CASPIAN
SEA

Tepe Gawra

Dur-Sharrukin/Khorsabad

Tell Billa

Balawat

Hasanlu

Marlik

Tepe Hissar

...VER

...eveh

Kahlu/
Nimrud

Nuzi/
Yorghan Tepe

MESOPOTAMIA

ZAGROS MOUNTAINS

Bisotun

Tepe Sialk

Asmar

Agrab

LURISTAN
REGION

Khafaje

Ischali

Kish

Babylon

Surkh Dum-i Luri

Nippur

...dab/Bismaya

...huruppak/Fara

Telloh

Susa

IRAN

Uruk

Ur

Kurangun

Persepolis

Tell al-Ubaid

Tall e-Bakun

PERSIAN
GULF

Ackland Art Museum, University of North Carolina at Chapel Hill: p. 90.

After U. B. Alkim (1968), *Anatolia I: From the Beginnings to the End of the Second Millennium*: Plate 5, p. 67 (bottom right); Plate 9, p. 64 (right); Plate 70, p. 77 (left); Plate 107, p. 119 (left); Plate 119, p. 152 (bottom).

Courtesy of An Najaf al Ashraf: p. 60 (top).

www.arthistory.upenn.edu/smr04/101910/Slide2.28.jpg: p. 70.

After J. Aruz and R. Wallenfels, eds. (2003), *The Art of the First Cities: The Third Millennium BC from the Mediterranean to the Indus*, fig. 10: p. 109 (right).

After *ASOR Newsletter* 33 (1983): p. 2: p. 65 (left).

After A. Benoit (2007), *Les civilizations du Proche-Orient ancient*, fig. 127: p. 116 (left).

Bowdoin College Museum of Art: p. 22.

bpk, Berlin/Pergamon Museum, Staatliche Museen/David von Becker/Art Resource, New York: p. 117 (left).

www.britannica.com/EBchecked/media/138551/Haldi-detail-from-a-fresco-at-Erebuni-near-Yerevan-Arm: p.78 (right).

© The Trustees of the British Museum/Art Resource, New York: pp. 113 (bottom, left and right), 149.

Brooklyn Museum: pp. 12, 83, 84, 143, 164, 172.

Brooklyn Museum Archives. Records of the Department of Digital Collections and Services: Exhibitions. Selected Works of Ancient Near Eastern Art, including Assyrian Reliefs. [10/07/2009---/--/20 --]. Installation view: p. 47.

Ian J. Cohn (www.Diversity-NYC.com): endpapers, pp. 58–59, 60 (middle and bottom), 106–107, 144–145, 152 (top).

Columbia University in the City of New York: pp. 141, 167, 179.

DeA Picture Library/Art Resource, New York: p. 151.

Detroit Institute of Arts/Bridgeman Art Library International: p. 41.

© The Field Museum: #A113395c (seal), p. 85; #A113396c (impression), p. 85; #A114936d, p. 159; #CSA67093, pp. 16–17, 32.

Professor Michael Fuller, St. Louis Community College at Meramec, St. Louis, Missouri: p. 75 (left).

Travis Fullerton © Virginia Museum of Fine Arts: p. 128 (left and right).

www.gobeklitepe.info/: p. 67 (bottom left).

After P. Harper, J. Aruz, and F. Tallon (1992), *The Royal City of Susa: Ancient Near Eastern Treasures in the Louvre*, p. 128, fig. 42: p. 121 (left).

Courtesy of the Hasanlu Project of the University of Pennsylvania Museum of Archaeology and Anthropology: p. 154 (right).

www.hattuscha.de/English/yazilikaya.htm: p. 77 (right).

The Israel Museum: pp. 66 (right), 150.

The Jewish Museum, New York/Art Resource, New York: pp. 97, 100, 135, 168.

The Library of The Jewish Theological Seminary: p. 38.

Trudy S. Kawami: p. 63.

Hagop Kevorkian Fund, through the courtesy of Ralph Minasian: p. 43.

Robert LaPrelle, Kimbell Art Museum, Fort Worth: pp. 94 (top and bottom), 139 (top and bottom), 157.

Erich Lessing/Art Resource, New York: pp. 65 (right), 66 (left), 79 (right), 116 (right), 120, 148.

Digital image © 2013 Museum Associates, Los Angeles County Museum of Art. Licensed by Art Resource, New York: pp. 104–105, 177.

G. Eric and Edith Matson Photographic Collection, Library of Congress, Washington, DC: p. 28 (right).

After Metropolitan Museum of Art (1986), *Treasures of the Holy Land: Ancient Art from the Israel Museum*, fig. 45: p. 76.

Image © The Metropolitan Museum of Art: pp. 39–40.

Image © The Metropolitan Museum of Art. Image source: Art Resource, New York: pp. 73, 78 (left), 95.

Jamison Miller: p. 87.

Museum of Art and Archaeology, University of Missouri-Columbia: pp. 101, 138 (top, bottom, and right).

Photograph © 2013 Museum of Fine Arts, Boston: p. 74 (left and right).

© National Portrait Gallery, London: p. 21.

After E. O. Neghaban (1996), *Marlik: The Complete Excavation Report*, no. 88, color plate XXIII-D: p. 154 (left).

Maggie Nimkin: frontispiece, p. 96.

Courtesy of the Nippur Project of the Oriental Institute of the University of Chicago: p. 114 (right).

Courtesy of the Oriental Institute of the University of Chicago: back cover, pp. 26, 27, 28 (left), 29, 31, 117 (right), 130 (top left and bottom), 133, 147, 163, 169.

Penn Museum image no. 8735b, p. 33; image no. 8992, p. 34 (top); image no. 22429, p. 23; image no. 62640, p. 53 (top); image no. 76264, p. 53 (bottom); image no. 139034, p. 24; image no. 139049, p. 25; image no. 141589, p. 36; image no. 142730, p. 18; image no. 149013, p. 89; image no. 150480, p. 35; image no. 150838, p. 165; image no. 152346, front cover, p. 132; image no. 152355, p. 161; image no. 152357, p. 162; image no. 152768, p. 127; image no. 184897, p.176; image no. 190911, p. 34 (bottom); image no. 195755, p. 129; image no. 195756, p. 88; image no. 234226, p. 86; image no. 234227, p. 160; image no. 234228, p. 131.

The Pierpont Morgan Library, New York: pp. 98 (top and bottom), 142 (top and bottom).

After D. Potts (1999), *The Archaeology of Elam: Formation and Transformation of an Ancient Iranian State*, p. 183: p. 80 (left).

Princeton University Archives, Department of Rare Books and Special Collections, Princeton University Library: p. 48.

Princeton University Art Museum/Art Resource, New York: p. 136.

© RMN-Grand Palais/Art Resource, New York: pp. 71 (right), 75 (right), 110, 111, 113 (top), 114 (left), 121 (right), 153.

Arthur M. Sackler Foundation, New York: pp. 50, 171, 173, 175.

Arthur M. Sackler Gallery, Smithsonian Institution, Washington, DC: pp: 103, 140 (left and right), 174, 178.

After M. de Schaunsee, ed. (2011), *Peoples and Crafts in Period IVB at Hasanlu, Iran*, fig. 3.6: p. 123 (left).

Seattle Art Museum: pp. 6, 134, 166.

Jason Ur: p. 62.

Michael Wakely. Penn Museum image no. 174136: p. 51.

University of Washington Libraries, Special Collections, POR0035: p. 46.

© The Walters Art Museum, Baltimore: pp. 44, 45 (top and bottom), 99, 102 (left and right), 137 (left and right), 170.

After H. Weiss, ed. (1985), *Ebla to Damascus: Art and Archaeology of Ancient Syria*, color plate 9, catalog no. 8: p. 67 (top).

Yale Babylonian Collection: pp. 91–93, 126, 158 (top and bottom).